The Daughter of L'Arsenal

Jacqueline Regis

★ SterlingHouse Publisher, Inc. Pittsburgh, PA

The Daughter of L'Arsenal

SterlingHouse Books

ISBN-10: 1-58501-153-3
ISBN-13: 978-1-58-501153-7
Trade Paperback
© Copyright 2009 Jacqueline Regis
All Rights Reserved
Library of Congress #2009922484

Requests for information should be addressed to:
SterlingHouse Publisher, Inc.
3468 Babcock Boulevard
Pittsburgh, PA 15237
info@sterlinghousepublisher.com
www.sterlinghousepublisher.com

SterlingHouse Books
is an imprint of SterlingHouse Publisher, Inc.

Cover Design: Brandon M. Bittner
Interior Design: Kathleen M. Gall

All rights reserved. No part of this publication may be reproduced, stored in a retrieval system, or transmitted in any form or by any means...electronic, mechanical, photocopy, recording or any other, except for brief quotations in printed reviews...without prior permission of the publisher.

Printed in U.S.A.

To all children in the remotest corners of the world!
May they find the divine spark within!
To soar on eagle's wings
Beyond the reach of hatred, prejudice, and limitations!

And

To my mother

And

To my girls, Lara and Allie

The names,
identifying details of certain characters
and the sequence
of some events in this book have been changed.

...They that wait upon the Lord shall renew their strength;
They shall mount up with wings as eagles;
They shall run, and not be weary;
And they shall walk and not faint.

Isaiah 40:31

Acknowledgments

No idea ever comes to fruition without the collaborative efforts of many selfless heroes who often unknowingly give and support others. Many people from all walks of life made possible the idea of this book. It is impossible to thank them all. But a few stand out as immediately instrumental in bringing this project to this milestone. I recognize and celebrate their contributions.

The idea for writing this personal story came from my good friend, fellow church member, and walking buddy, Melissa Clendenen. You started me on this journey by convincing me to meet with you every Saturday morning at six-thirty at a coffee shop so I could tell you my story and begin to write it. We met for months, rain, snow, or shine, until I completed the first draft. Beyond friendship, our meetings expanded my concept of love through sharing, mutual support, and encouragement, stressing our similarities rather than our differences. You are a very special friend, Melissa, and I am blessed to have you in my life.

The initial phase of writing the story strengthened to fruition into its subsequent stages when I met Maureen Higgins, a special and unique person whose wisdom and expansive love unconditionally and enthusiastically embraces and supports humanity. Your tough guidance during the critical developing stages of this project contributed greatly to this significant milestone. Thank you, thank you, and thank you.

Thank you to my beautiful children, Lara and Allie. Each of the two of you has brought such incredible richness to my life and challenges me every day to just love the way each of you loves me unconditionally. I hope after you've read this story, you'll be able to

fill in some of the blanks and understand a little bit more about Mom's journey. A very special thank you to Allie for tirelessly printing the many drafts and for enthusiastically supporting me through the long years and months the two of us worked together on the manuscript.

I thank the wonderful individuals who contributed so generously to the successful parts of my story during the first few years of my life in the United States. You made the difference of a lifetime. The few that stand out in my mind include my brother, Deslandes, the Macfarlands, Helen Childs, and my long-time friend and college room mate, Delvine (DeeDee) Joseph Okereke. Each of you touched my life in a significant way and contributed to changing its course. Thank you.

I thank my friends from Second Church, Cathy Haukedahl, Terri and Gordie Buhrer, and Brian Clendenen. Your unfailing support and friendship, most of you over the last quarter of a century, provided me with a strong base and inspired my decision to write this book.

Finally, I cannot thank enough the staff at SterlingHouse Publisher, particularly Dr. Cynthia Sterling and Jennifer Piemme. At each stage of the project, you've patiently helped me past the initial anxieties and taken me beyond my often limited expectations to think more expansively. Thank you.

Part I

"And He will raise you up on eagle's wings"
—Michael Joncas

Blue Dress, Black Heels

One day an old woman, wearing a pale blue polyester dress, a black hat and carrying a large straw bag, entered the room where I sat waiting for my next appointment. I volunteered on occasion as a pro bono lawyer in addition to my regular work. She looked bewildered, out of place somehow in the setting of the room. As she walked toward me, her eyes rested into mine. I had never seen her until that moment, but she looked strangely familiar—as if I'd known her all my life. She said her name was Iris and reached to shake my hand, the sharp calluses of her palm rubbing against the inside of my hand and telling me the story of a lifetime of hard physical work. She seemed tired and weary. But with her presence came an air of sophistication, a powerful self-assurance blended with a hard streak, characteristic of women who've had to fight long and hard for the survival of their families and themselves. I invited her to take a seat. She hesitantly sat down across from me.

She seemed surprised that I occupied the lawyer chair, as if she expected a different sort of person—a man—, perhaps a tall white man in a suit, speaking with perfect American English intonation. Her hesitant eyes narrowed and seemed to tell me that I could not possibly be the professional she came to see. She was not expecting a middle-aged-five-foot-two-inch Black woman with a foreign accent. She searched a minute for another person or set-up in the room. Perhaps she thought my function was to lead her to the real professional. But there was no one else. She seemed confused.

I had become accustomed to these types of reactions after

twenty five years of practicing law in the American legal system, and Iris was no different from most people. She had internalized an image of role and place based on appearance, and I did not seem to fit that image. I sometimes create this initial confusion in people, but I long ago stopped buying into any stereotype of what I ought to be, or the idea that the way I look and speak has anything to do with my ability to think, reason, or provide assistance.

I shifted a little in my chair, tilted my head straight, and leaned forward with my hands folded and resting on the desk. *Mama would have been proud of me just now, if she could see me,* I thought. I smiled firmly at Iris with the intent of communicating to her that I indeed was the professional in charge, and if she needed a lawyer that day, she had better get used to it. A light seemed to switch on for her. She smiled back at me triumphantly with a proud motherly smile, as if enjoying herself and taking pride in my position. Her eyes hinted at her thought, *Oh you're the lawyer I am supposed to talk to.* I smiled back, thinking the fitting response, *Indeed, I am.*

Pen and notebook resting on the table in front of me, I sat erect in the office chair. I looked very official and dressed the part in my solid black suit and heels, with nylon-covered crossed legs. I felt seasoned and looked confident enough that I could assist or find assistance for Iris or any other client that sought help.

"What brings you to a lawyer's office today?" I asked her.

She mumbled something I did not understand. She had immigrated to the United States some years ago. I learned that from reading her file earlier. I was not familiar with her accent, and I felt embarrassed to ask her three times to repeat her response slowly so I could understand her. She must have felt stupid every time she repeated a word she thought she clearly enunciated the first time. I'd been there.

"I want to give my house to the child who'll take care of me until I die," I finally heard her say.

I looked through her eyes and no longer needed words to feel what she yearned for. Dark and brilliant, her scintillating eyes dominated her ebony heart-shaped face. Behind those eyes, I saw my mother. I could hear my mother's voice echo to me from long ago.

All I live for is to die with dignity and only you can help me do that.

The burden of these words rushed back into my thoughts and

chilled my body with guilt. Now ninety-eight years old, Mama lived in another state thousand of miles away among people she would call "strangers." Sitting across from me, just like Mama would, Iris looked and acted like the undisputed queen reigning over every detail in the lives of her offspring. Like Mama, she made everything possible for her children, and had the calluses on her palms to prove it. It was only fair that she expected one of them to make the same personal sacrifice and take care of her in old age. Iris did not understand a culture that puts work and rent before companionship with an elderly parent, and allows her to die among strangers it calls "caregivers."

Remaining close to family in one's golden years came with the status of being a parent. Women like Iris could not think of any other reason to suffer through the perilous journey of having and raising children. Iris had worked hard for the privileges she waited so long to finally earn. Now stripped, in her adopted culture, of her hard-earned right to remain close to family as she entered this most vulnerable phase of her life, she fell to the mercy of her children's goodwill. They might care for her if the realities of their lives permit.

So there she sat across from me, at this humiliating point, trying to play her last card, and gambling away her only remaining possession in order to hang onto the only thing that really mattered to her—her children. She was embarrassed that the insensitivity and selfishness of her children—as she perceived their behavior and motives to be—had reduced her to bribing them to love and care for her. The painful and bitter look on her face told the story of a vulnerable woman, terrified of losing her family in this new place she now called home. Yet deep down she knew she already had. Iris' fear pulsated through my body.

I wanted to say something to make her feel better, but whatever professional advice I had could not fix her problem. What she wanted she could not have in the reality she had created for her children. I could not tell her the truth; I knew she could never accept it from the cultural lenses of her past. Her sacrifice had already set in motion the cultural progress that could make a small positive difference in the world. In the process she had succeeded in transforming the lives of her children. That was probably the

only reward she'd ever reap for her efforts. She needed to accept that and move on with life as it had become. She paid a hefty price for her children's assimilation into the American culture. I understood that well.

Looking into Iris' eyes, I finally appreciated the price Mama paid to bring me to safety in the United States. Assimilation into American culture brought about change at every level, including the way I related to my family of origin. The painful and cruel process no doubt killed something precious in me. Nonetheless, in the situation I inherited when I entered this world, the alternative would have been a worse form of dying. Mama saved me from that when she found a way out. The memory of the long and difficult journey that brought me to this point in my life, as a professional in the United States, rushed to my thoughts. It all began those days long ago when I lived with my mother and siblings at L'arsenal, a rural community on the outskirts of the town of Cayes in southern Haiti.

L'arsenal became my mother's home when, eight months pregnant and with no place to call home, she went to live there in the early 1950s. After a bitter altercation with her oldest sister Elise, Mama left her parental home and her two teenage sons, Charles and Guy. Frightened and alone, she stepped on the front porch of an abandoned hut in the L'arsenal region, balancing a small suitcase in one hand and a pillow under her other arm. She placed her small suitcase on the porch's dirt floor and touched her pregnant belly, as if talking to her unborn child.

"This is going to be home for us for awhile," she said.

She was both scared and thrilled at the idea of having a family of her own and of raising her child her way. The front door of the hut looked condemned, covered with thick layers of cobwebs. An overgrown mango tree, in desperate need of pruning, stood to the west of the narrow path near the front of the hut. To the other side of the mango tree, two tall coconut trees, with a few dry branches hanging vertically against the trunks, danced to and fro while flirting with the hot breeze. The tropical air was hot that day. Mama peeked to the north side of the place. Overgrown banana trees mixed with wild brushes blocked her view beyond the porch.

Carefully watching her step, she walked over thick bushes

along the side of the hut to inspect the back.

"Should we have stayed at the house in town, you think?" Mama said out loud, still talking to her unborn child.

"No," she said, "every person has to grow up some time. It's high time for me to take responsibility for my life."

No Looking Back

"Look at you, Miss Marie. Looks like you'll be delivering any time now." The voice of a woman startled Mama as she wondered how she'd manage to pry open the condemned door and inspect the inside of the hut. She turned around and recognized Marguerite Manuel, a woman in her mid-forties. Dressed in a mended yet faded denim dress and wearing well-worn dusty sandals on her feet, Marguerite seemed rushed on her way to town. Her hair was wrapped to her forehead with a blue handkerchief and barely visible under a large straw hat that shielded her face from the sun. She lived on the adjacent property, a few yards to the east of where Mama stood.

When she spotted movement from a distance near the neighboring hut, Marguerite stopped, as she usually did, to investigate the otherwise deserted area. It was her job, she felt, to watch over the vacant property—self-protection one might call it. Her own family lived next door. For years now, her vigilant eye had so far kept away every intruder. As she moved closer to the hut, she was relieved as she stumbled upon Mama standing behind the back door of the abandoned hut. Showing her toothless upper gums and her protruding, decayed lower teeth, Marguerite greeted Mama with a smile. Seeing her alone in her condition, Marguerite immediately put off her rush. Mama welcomed the company.

"Oh, I have another month," Mama replied to Marguerite's comment about her condition.

Marguerite knew Mama's family well as townspeople, absentee owners of the neighboring property. Many years before, she met Mama's father, Joseph Tanabet, a light-complexioned man of

mixed racial heritage. Based on his manner of grooming—always in a suit, tie, and black shoes—Marguerite assumed that Joseph was a man of relative material means. Indeed, he was by L'arsenal standards. Ordinary L'arsenal residents could never afford such attire. Most L'arsenal men wore mended denim pants and shirts, and either went barefoot or wore old muddied sandals if on their way to town. Joseph frequented the property regularly over the years. Marguerite had often spotted Mama on the property, either alone or with other family members. Members of the Tanabet family regularly came to manage and attend to the details of running the farm. But they always returned to the family residence in town. When Marguerite first saw Mama that day, she assumed Mama came for a visit and would soon find her way home into town. But Mama's advanced pregnancy made her pause.

"What are you doing here all alone in your condition?" Marguerite asked. "You should be with your folks at a time like this."

"This is my home now," Mama announced to a stunned Marguerite, pointing to the abandoned hut. "I'm moving in. Someone needs to attend to this place and run the farm."

"How do you mean?" a bewildered Marguerite asked. "How can you fix this place in time for this baby? You're about to deliver," mindlessly pointing out the obvious.

"Well, I am going to find a way and it will be all right, Marguerite. You'll see," Mama said.

The sight of a local woman in the last stage of pregnancy seeking to move into an abandoned hut was as frequent to Marguerite as passersby in search of a spot behind a bush at the call of nature. Homeless women, pregnant and alone, regularly wandered and ended up giving birth, at nature's ordained time, wherever they happened to find themselves. To Marguerite and other locals, there was nothing strange or unusual about that. Mary and Joseph settled for a manger in the Bible. Homeless pregnant L'arsenal women were in good company. Birth in such humble conditions, close to nature, seemed wholesome somehow, the way it was meant to be. Close to the town's open market where hundreds of child-bearing age women congregated every day, L'arsenal folks came to expect sights of women in labor and giving birth.

When a transient expectant woman in dire straights and with

birth imminent stopped to ask for help, it would never occur to anyone in the region to turn her away. It was commonplace to watch a woman in labor bawling through the pain, either to deliver safely or to exhale her last gasp, ushering in with it a new life. If retrieved in time from the womb of a dying mother, this new life might eventually reach personhood. Otherwise the motherless newborn could itself only put off dying for a short while and inevitably followed its mother's footsteps. L'arsenal would then move on as usual, waiting to witness the next dance between life and death before everyone's eyes. And the old women went on passing time, gossiping about the young women's indiscretions or their own past wild escapades. That was the reality of life for women at L'arsenal, the life Marguerite knew.

But to Marguerite, Mama was not just any woman. She was Marie Tanabet, daughter of a well-known land speculator in the region and brought up in a standard of which ordinary L'arsenal people only dreamed. *She could not possibly mean what she just said*, a puzzled Marguerite speculated. *The stress of the last few weeks of pregnancy must be getting to this spoiled-uppity-woman. Marie Tanabet had become positively delirious*, Marguerite thought to herself.

She had to help Mama find her way back to her family home. That was the only sensible thing to do. Caught up in a situation she'd rather not meddle with and at the same time she could not ignore, Marguerite wondered how to break the news to Mama. She pondered a gentle way to cajole Mama into letting her accompany her back to the family residence. She moved close and gently reached for her arm.

"Come on, come with me, Miss. It'll be all right. Let's take you home," Marguerite said softly, as if talking to a little child.

Mama rudely rebuffed her faked gentleness, and made clear that she intended to move into the dilapidated hut with or without Marguerite's help. Her obvious condition and the little bit Marguerite knew about the status-conscious Tanabet family hinted at Mama's desperate predicament. Marguerite had often thought that if she ever needed to find employment in town someday, working for the Tanabet family as a housemaid offered a good option. Now the picture in front of her—one of the Tanabet girls in advanced pregnancy looking for shelter—did not fit the family's perfect

lifestyle that Marguerite imagined. But she was sure of one thing, in the middle of this life crisis, someone should look after Mama for awhile. Marguerite felt stuck with that job, at least until she could figure out who else might claim ownership to it.

Despite her stubborn protest, Mama, for her part, understood well Marguerite's bewilderment. She herself could not make sense of her own choices and the brewing storm of confused feelings inside her. For sure, the emotional upheaval any woman experiences just before childbirth clouds her judgment. She felt compelled to take responsibility for her life and, as she saw things, save it. She could not retrace her steps, as Marguerite suggested, to unworkable relationships and to her failed attempts at preserving unhealthy family ties. At the same time, part of her agreed with Marguerite—returning to her family home offered an uncomplicated solution to spare herself and her unborn child the hardships she surely faced on her chosen path of primitive existence at L'arsenal. If only she could just swallow her pride and put on the façade of happiness she has been taught. She had plenty of practice doing just that over the past forty years. Besides, it was not always bad.

Growing up a Tanabet, Mama carried the privileged attitude and traditional pride that went along with claimed middle class status. After all, she was once *Mademoiselle* Tanabet, poised and among the few educated in town. She often referred to herself as *gantée des deux*, meaning literally 'both her hands in gloves,' alluding to her impeccable standard of dressing in the tradition her family strived to maintain. She basked for years in the glow of this illusive image of herself. She was fortunate to have been born into a family whose name had earned the reputation and enjoyed the outward appearance of a respectable, stable, hard-working, and successful clan. The family's influence came about through a reputation of hard work and perceived consistent moral standard.

Reputed far and wide in the region as a man of his word, Joseph Tanabet, the patriarch of the clan, worked as a land speculator and for more than fifty years also as the only maker of leather horse saddles, bridles, and school bags. A man who paid his debts and never cheated anyone, Joseph's word counted for a lot among the oppressed majority in a community starved for fair-mindedness and justice. It did not take much from a person with even meager

means to earn goodwill and respect. A modicum of decency in giving a plate of leftovers here and there and a few spare coins to a destitute woman with hungry children will buy a reputation of goodness for years. If that was generosity, Joseph showed an abundance of it in his community. But most significantly, Joseph distinguished himself with the rare quality of being a one-woman man, admired in town as one of the few men who never cheated on his wife. A devout Catholic, Joseph, through a blind arrangement, married Julia Tanse, Mama's mother. He remained faithful to Julia until his death.

Julia, a dark-complexioned woman of small stature, was only seventeen when she married twenty-three-year-old Joseph, after their elders arranged the union without consulting them. Strong-willed, smart, and hard-working as a traveling merchant throughout her life, Julia turned out to be the power base of the family in a matriarchal structure that tolerated men as tools, but at the same time put them on undeserved pedestals. In the family, Julia stood at the top as a powerful figure, certainly more vocal, forceful, and feared than the taciturn and mild-mannered Joseph. Joseph trembled in Julia's presence and submitted to her will throughout their lifelong marriage. The two never really had much to say to each other. Yet, despite their fundamental incompatibility, each of them found in the home a niche suitable to their individual nature, and managed to rally behind their common goal of climbing the social ladder. Such an arrangement was actually quite typical in the strained bourgeois environment of the town at that time. Apparent stability and outward harmony in a marriage had a price. The Tanabet parents paid it, and so did Mama.

Other than his ten children (including Mama) born within his blessed union, no one could ever point to any offspring Joseph fathered outside of his marriage. That was unusual. Fidelity was a rare commodity that ranked high among qualities local priests in the two town churches lauded as indispensable to salvation in the afterlife. Yet very few men could live by any standard of fidelity. Women, including Mama, simply accepted that as a fact of life. Achieving fidelity as a virtue won Joseph admiration as a model in the community. No matter what other character flaw plagued his personality, Joseph was revered in the region.

Mama proudly reaped the benefits of growing up the daughter of such a man. As a young girl she carried her head high as one of the special Tanabet daughters and, along with her sisters, mastered the art of keeping up appearances and protecting at all costs the image their parents worked so hard to maintain in the community.

How could she have fallen from such a high standard?

Despite the family aura of long-standing respect and reverence, Mama experienced a far different Tanabet family undercurrent, sufficiently oppressive and destructive as to threaten her sanity and well-being. Her strained family relationships resulted from a complicated web of misguided social values her family embraced, and which were no longer relevant to the person she had become.

In particular, Mama found intolerable the family's double-standard in two significant areas. Despite her mother's authority over the family, Mama received silent messages that women's needs in the family were subordinate to those of the men. Tanabet women followed the matriarch's footsteps and advanced themselves to become reliable breadwinners, shouldering full financial responsibilities for their families. At the same time, all details attendant to raising large families and maintaining a home fell exclusively on these women. The family value system did not have comparable expectations of the men. Men carried no responsibility other than advancing to their liking and at their pace their chosen vocations, which they pursued as hobbies rather than with the urgency required of breadwinners.

Further complicating her family relationships, Mama could not reconcile her own instincts for fairness with the family's class-based thinking. The family related to those they perceived as beneath their social status only as lesser beings condemned to a subservient life. "As if they were God's stepchildren with no legitimate rights of their own," Mama would at times mumble to herself with indignation and sorrow.

Torn between her genuine attachment to family ties with the accompanying benefits and her desire to break free from the grip of misguided family values, she tried in her youth to resolve her perennial inner conflict with a nervous aura of buoyancy. To the dismay of her family, as a young girl with an infectious laugh, she

could attract a crowd in a matter of minutes and was reputed as the life of any party. When the fake attitude of happiness could not spare her from life crises that inevitably came her way, the conflict within her erupted, forcing her to choose between her genuine values and a family lifestyle she could no longer embrace in good faith.

She stood that day next to Marguerite at this strange point in her life, advancing in chronological years toward middle-age and at the same time feeling and behaving like a teenager. She had been waging alone for some time the battle between these two polarizing aspects of her personality. She reached a critical point when an internal push forced her to risk dying alone in childbirth rather than continue to submit to a way of life she should have abandoned long ago.

Her social *faux pas* that members of her family found so unforgivable originated from the dilemma the misguided family values created. She passed up early opportunities in her teens to land a suitable husband so she could pursue a career as a teacher. Like any Tanabet girl, she was conditioned to work hard and assume large responsibility for the financial well-being of her family. When unfortunate life circumstances forced her to return penniless to the family clan, the family's conflicted values eventually pushed her over the edge, and she found easy refuge among ordinary and uncomplicated folks like Marguerite.

Association with people her family considered below their social status further splintered the fragile family ties she so desperately tried to sustain. Despite her best conscious efforts, she simply could not submit to any rules that promoted the family's belief system. Her rebellion against the family's value system, coupled with her deep-seated need for companionship at some comfortable level, pushed her to life choices that led to the dangerous crossroad she stood in when she saw Marguerite that day. But she had come to believe that staying within her family circle, in the tradition her parents created several decades ago, was far more dangerous than the rough life at L'arsenal.

Marguerite stood beside her thinking that a pregnant woman like Mama should be with her family. At the same time it was precisely Mama's advanced pregnancy and her responsibility to her unborn child that opened her eyes, and forced her to make the

decision to save her sanity. At forty years old, she could make her own choices. Walking away offered an easy option. She did not know how it would turn out, but somehow she knew she made the right decision.

Mama welcomed Marguerite's friendship. Marguerite's normalcy and genuine non-judgmental love—something refreshing in her life at that moment—touched her deeply. God knows she needed a good friend, a true blue one, just about then. But to get a friend she had to start by being one herself. She had to let go of the uppity attitude that characterized the social milieu of her upbringing. Regardless of how the outside world might view their relationship and respective statuses, Marguerite was her equal and now her confidant.

She had not told anyone about the disastrous few years she spent in the prison of her own parental home. Nor had she revealed to anyone the identity of the man who fathered her unborn child. She had not been ready to face the wrath of her family once they discovered how low she'd stooped to bring down their social status. She needed someone to listen to this tale. Telling someone about this twisted story could loosen the grip of the mental pain, getting it away from the protection and secrecy of her thoughts. Words evaporating into the air and blending into a different set of thoughts and feelings have a way of rendering life less complicated, easing the guilt somehow, and making the real issues more universal, and that way more solvable. Talking to Marguerite was the only therapy session she'd have anyway. So she went for it.

In her eagerness to embrace Marguerite as a friend, Mama overlooked one important detail. Marguerite was so conditioned to her subordinate position that she could not accept her relationship with Mama as a friendship on equal terms. No matter how vulnerable Mama seemed at that moment, Marguerite's deference to her position as a member of an influential family defined how she related to Mama.

Marguerite looked up at Mama from the ignorant perspective of a person who never discovered her own true worth. She quickly accepted that Mama had moved to the property next to hers, and immediately embraced without question her duty to assist Mama in any way possible. She was pathetically eager and happy to help.

People of her social status catered and served anyone they'd been taught to perceive as superiors. She felt honored to be of service and assistance to someone she regarded as above her status. Marguerite was incapable of thinking or feeling any other way. That was how she understood herself and her life, and that was the way it had to be.

She invited Mama to her place on the adjacent property to sit and talk awhile until they could find help to open the doors of the hut. It looked from the outside that the doors had been nailed shut. It would take tools and strength to pry them open. Mama welcomed Marguerite's offer. The two women walked the few yards to Marguerite's hut on the east side of the Tanabet property. They sat together on Marguerite's front porch like two old friends. Marguerite made sure Mama settled as comfortably as possible in a chair with her feet extended on a low wooden stool. She served Mama a glass of water. And the two began to talk.

Buying His Respect

Caught in a web of poverty and lack of education, the Manuels were kind, gentle people, despite the hand dealt to them. Marguerite received no formal education, and could not recognize letters in the alphabet or write her name. She shared a two-room hut with her eighty-five-year-old mother, Yiyine, her three daughters, fourteen-year-old Rolande, sixteen-year-old Mirta, twenty-two-year-old Esmeralda, and Esmeralda's four small children. Marguerite was married to Ludovic, the father of her three daughters. They never formally separated, but Ludovic lived alone in a rural area far away from his family's home. He hardly ever returned to L'arsenal, except perhaps for a few days once a year. Marguerite dutifully made the two-day trip to visit him once a month. Living apart the way they did was their arrangement, and no one questioned it.

Marguerite chose to be a traveling merchant. It was either that or service as a housemaid for ten *gourdes* a month, the equivalent at that time of two American dollars. Had she chosen to work as a housemaid, she might have been able to feed herself from leftovers as a fringe benefit, in addition to the two dollars she'd earn a month. In a community where scarcity was the norm, Marguerite could earn fringe benefits if she was lucky enough to work for both a generous and sufficiently affluent household that had and could spare leftovers. With or without fringe benefits, for two American dollars a month, Marguerite would have to work around the clock away from her family. If she budgeted well, she could also feed her family for half of the month on her salary.

While Marguerite might not have cleared much more profits

than what she'd earn as a housemaid in a month, working as a traveling merchant offered her a better deal. She went away for days at a time to the rural area where Ludovic lived. There she purchased wholesale farm goods and transported them back to L'arsenal by mule. She retailed her farm goods in the town's open market where she rented space and displayed for sale raw potatoes, rice or beans, and hot cooked meals. On the days she was in town, Marguerite fed her family the excess or left over cooked meals that did not sell. She made the daily trips from L'arsenal to the open market, balancing over her head a wooden tray loaded with farm goods and meals. She left her hut every morning at six and stayed all day at her rented space, until sundown. This was her routine her entire life, far less complicated and colorful than Mama's life as a Tanabet girl.

Sitting on the front porch of her hut next to Mama, Marguerite listened as Mama gave her the details of her situation. With no place to go, Mama moved to L'arsenal because she could claim she partially owned the land. Her father had purchased farmland as an investment in the L'arsenal community when Mama was still a young girl. He hired a groundskeeper to watch over the property and frequently commuted there to oversee the management of the farm. He built on the property, as shelter for his groundskeeper, the two-room shack Mama was trying to move into.

When Joseph hit hard financial times several years later, to stay afloat he mortgaged both his town residence and the L'arsenal farm property. To Joseph's great shame, the local bank owned both properties for a time. The bank, however, never tried to repossess either. The threat of the loss of his family home tormented Joseph, and confirmed rumors in town that he was a poor businessman and could not support his family. It was well known in the community that Julia was the backbone of the family's financial stability and that Joseph's work was, in reality, his hobby.

Tears dropped from Mama's eyes as she recalled the slicing words her mother laid into her saintly father, graphically painting him as worthless. Julia found it incomprehensible that Joseph could not deliver on the one responsibility she gave him, and that was to pay timely the mortgage on the family properties. Julia frequently reminded him of this failure. Mama acknowledged that, all things

considered, her father was indeed weak. But to her, he was a good man. Without ever uttering an unkind word back, he took in all the insults Julia regularly dished out. Mama admired that about him.

When Mama turned eighteen and had completed her schooling, she began teaching elementary school in a rural community south of Cayes. With the money she earned and saved as a teacher after several years of working, she collaborated with her older sister, Clara, to pay off the bank loans on both properties. Mama's contribution made it possible to redeem both properties. Younger and living out of town, Mama allowed Clara to make all the arrangements with the bank to redeem the mortgages on the properties. Clara secured the title documents to the properties. Mama had a verbal agreement with Clara that, in consideration of Mama's contribution to redeem the properties, Mama would receive half of the L'arsenal property and the unimproved portion of the residence in town. Mama trusted Clara and never requested to see nor read the title documents.

Years later Mama counted as one of the happiest days of her life when she and Clara told her father they had redeemed the properties. She had bought back for him, she often said, his manhood and his dignity. Deep down, however, Mama was really buying his respect. She knew she ranked lowest on his list among his six daughters. At eighteen, she had already disappointed him for her failure to either enter the convent or land, as her sister Eve had, a suitable husband from one of the respectable families in town. After all, a daughter's job in advancing the family up the social ladder was to either lead a virtuous public life as a nun or to marry well. What else was a woman good for?

Mama's darker-skinned complexion, closer to that of her mother, and the thicker texture of her hair, from her point of view did not help her in the eyes of her father. Throughout her childhood, Mama so wished she could have been born with soft shoulder-length bouncy hair and that she could have inherited her father's skin complexion like her sister Eve. No one in the family ever said anything openly, but everyone knew well that Joseph's two most favorite daughters, Eve and Clara, were coincidentally lighter-skinned, closer to Joseph's own attributes. In the social context of Mama's upbringing, an unstated community belief valued

lighter-skinned people like Eve and Clara, as if somehow God anointed them with special assets denied to others.

Mama tried all her life to win her father's respect and admiration and to make up for whatever shortcomings she imagined he perceived in her. But her very identity as a woman and the choices she made alienated him more. She distinguished herself early as the most independent, industrious, and adventurous among Joseph's six girls. She excelled in school and at the same time took great interest in her mother's line of work. Like her mother and unlike her older sisters, Mama showed no interest in the daily details of running a home and day-to-day caring for her younger siblings. Medium dark complexion, brilliant eyes, and an outgoing disposition, Mama was the spitting image of her mother. Townspeople admired her as a very attractive woman and the most spirited and sociable among the six Tanabet girls. But Joseph found Mama the most intimidating among his daughters. He trembled in her presence in the same manner that he did in the presence of his wife Julia. He feared and resented Mama's independence, perhaps because he saw too much of his wife in her.

Mama accepted that she did not measure up and that at least two of the six daughters were better people in the eyes of her father. She spent much of her adult life trying to make up for shortcomings she could not even identify. Her compliant behavior, often against her better instincts, to appease family members clouded her judgment in every major decision. Now, Mama told Marguerite, she needed to change course and begin the journey of finding her own truth. Moving into the abandoned hut, learning to rely on her own judgment, and figuring out how to take charge of her life were the first steps. She decided, she told Marguerite, to move to the property because she had earned the right to live there. After all, she paid for part of the land.

"Pardon me, but you could say that for the house in town too," Marguerite commented sheepishly.

"I could," Mama said to Marguerite, "but I won't. It'd never work. I want to be as far away as possible. I gave it a try, Marguerite…God knows I did…When you ran into me a little while ago, I was just thinking about all that went on with my family."

Turn Back and Move On

Standing alone at the doorstep of the shelter her father built for his hired help, she felt like a teenage girl running away from home, Mama told Marguerite. The twist of fate and sequence of events that brought her to that point would have made anyone insane. Forty years old, she left behind her two teenage sons, Charles and Guy, in the care of the same family members she could not live with. Life could have turned out differently had Andre, her first husband, lived. Now it seemed like the faint memory of a dream, as if Andre never lived and they were never married. As a child, she was often told that bad things happened to sinners who disobeyed church rules. She must have done something really bad in the eyes of God to deserve this horrible fate. Nothing seemed to turn out right, no matter how hard she tried. But most importantly, how will she make things right for her two sons?

She loved Charles and Guy in different ways. But the relationship she had with their respective fathers colored in significant ways how she expressed her love for each of them. The man who fathered Charles, her firstborn, lived somewhere on the earth that Mama did not know about right then. In fact, she did not know much about this man other than the basics. She refused to utter his name, where he came from or what he did for a living. She might have known all that, but she did not want to tell Marguerite, or anyone else for that matter. She wanted to think that he did not exist. Charles' conception was virginal, she liked to pretend. Mary's conception of Jesus in the Bible was virginal. Why couldn't her conception of Charles also be virginal? So Marie Tanabet felt she was in good company for the unforgivable sin of

conceiving outside blessed matrimony. It was her way of coping with a set of circumstances her family taught her was socially unacceptable. When the world and its ways became too rough and overwhelming at times, Mama's vivid imagination helped her escape the worse parts, creating her own private reality. She liked to think of Charles' origin as purely divine, and saw him as an extension of herself. Relating to him that way allowed her to forgive herself for associating with the man who fathered Charles. She was proud that Charles belonged to her, and she'll never have to share her right to him with anyone else. He carried the Tanabet name to prove it.

Guy, on the other hand, represented to her the only legacy of her marriage to her beloved Andre, her deceased husband. When it came to Guy, she had to answer to Andre's memory, an added pressure she would have been better off without in this particular desperate time of her life. She promised Andre just before his passing that she'd take care of Guy. She began to feel tormented by the thought that she might not be able to keep this promise. Pushing back a gush of tears, Mama jerked her head upward toward the sky as Marguerite sat listening. Mama's eyes caught the sight of a puffy white cloud hanging just beneath the blue sky overhead. In the distance of her thinking, she could hear Andre's words of long ago.

You can do anything, Marie. That's what I love about you.

She lowered her head back down. Rejected and alone, Andre's words resonated in her thoughts as an empty line of a by-gone lover, an illusive romantic moment. Right then, she became painfully aware that she had failed Andre. She could not deliver on what he had considered to be the most important responsibility of his life, to watch over and care for their son.

Well, look at me now…what can I do? Her own voice echoed in her thoughts.

Tears rolled down her face, thinking about the boys and how she had failed them. Will they make it? Will they get through growing up in that house? How could she ask them to do at their age what she herself could not do at forty? She quickly regained her composure, becoming conscious again of Marguerite's presence.

"There is no point to crying over spilled milk," she told Marguerite. "What's done is done," she reasoned. "I have to move for-

ward and make a life for myself. Maybe someday Charles and Guy will finally have a home with me."

She hung onto that thought and wiped the tears off her cheeks. Her thoughts rested on Guy and the joy he brought to her and Andre on the happy occasion of his birth long ago. She gave birth to Guy shortly after her marriage to Andre. An only child, Andre grew up in a city on the northern coast of Haiti. She met him in her twenties, when she moved to the capital, Port-au-Prince, to find work. A kind mild-mannered, light-skin complexioned man, Andre reminded Mama of her own father. Andre admired her industrious ways and common sense, but more so he was intrigued by her unusually compassionate disposition and social conscience about the plight of the struggling masses.

His love and attention changed Mama's outlook on life. She considered Andre the love of her life. As she recalled the many stories about him, her enthusiasm, intrigue, and fascination with him showed a glimpse of a side of Mama that unfortunately had died with Andre. To the extent Mama could have been romantically in love with another human being, she appeared to have been in love with Andre. They married and began to raise together Guy and two-year old Charles.

Mama's marriage to Andre was short-lived. One day soon after the passing of his mother, Andre left Mama and the boys in the capital, and traveled to his hometown to settle his mother's estate. His father had died many years before, and as sole heir, Andre would have inherited his mother's estate. But he died suddenly in Mama's arms the same day he returned from his trip. Within a few hours of his return, he collapsed on the floor of their home in Port-au-Prince. Mama rushed to his side on the floor, resting his head on her lap and comforting him. Within minutes, Andre's head twitched back and his body became limp. Mama speculated that jealous relatives had poisoned him on the trip to keep him from inheriting his mother's estate.

Andre's untimely death rocked Mama's world. With Charles still a toddler, she had just given birth to Guy about three months prior. She faced the dilemma of either moving to her deceased husband's hometown or returning home to Cayes to her family. Neither option seemed viable. Moving to Andre's hometown

tempted Mama. He had planned on taking Mama and the boys to the northern coast shortly after his return from the trip. They had discussed plans for a permanent move once all matters became settled. Now that Andre had died, once again she was on her own and had to figure out how to find money and also care for their newborn and Charles. Packing her bags and the boys and heading north to claim Andre's inheritance made for an easy solution.

She had a strong intuition, however, that she should neither move nor even visit Andre's home. Yes, they were married for close to a year, but she knew next to nothing about Andre's family or his hometown. She had never even traveled to the northern coast. She told Raymond, Andre's first cousin, that she was deathly afraid of claiming Andre's inheritance. Raymond had helped Mama with the funeral arrangements and with financial details to help her transition. He confirmed her suspicion about Andre's untimely death and advised Mama not to go to Andre's hometown nor claim his inherited property.

Six months after Andre's passing, the path Mama was to follow opened up in front of her. She dreamt one night that, traveling on a donkey with little Guy bundled in her arms, she headed for Andre's hometown. A petite middle-aged woman with Andre's face guided the donkey, pulling on the rope around its neck. Andre walked side-by-side next to the woman ahead as Mama rode on the back of the donkey with baby Guy. Mama had never seen this woman other than in the dream. As they approached the gate of the city, the woman stopped. She turned the donkey around, flipped the rope over his neck and gave the rope to Mama. The woman then took baby Guy from Mama's arms and bounced him in the air three times. She put the baby back in Mama's arms and motioned to Mama with her hand to turn back and move on. She then grabbed Andre's arm, crossed the gate of the city and disappeared.

Loud banging to her front door awakened Mama from her dream. She jumped from her bed and rushed to the door. Her mother Julia, her older sister Elise, and her younger brother Leonard all stood outside her door. After Mama let them in, her mother Julia spoke first. They heard of Andre's passing and came to take Mama home.

"You should consider yourself fortunate, Marie, to have a family with formidable resources to help raise these two boys," Elise said to Mama as she nervously paced the floor of the living room.

Still not realizing she had no say in what was to transpire next, Mama threw a fierce glance at Elise as if to demand that Elise back off. Elise stared back at her with the domineering look of an adult annoyed at the mischievous conduct of a naughty child.

"You know you are not mature enough to raise two children under five in a city without family," Elise said.

Elise considered herself an expert on raising children and appointed herself as the family's chief executive officer when it came to rearing children.

"After all, I raised you, Marie, and your nine brothers and sisters," Elise reminded Mama with a smug attitude.

Mama's annoyance with this intrusion filled the room. As her rebellious side swelled up, almost ready to erupt, Leonard stepped in front of her with his imposing and intimidating male authority. Mama understood then why they had brought him. She realized her wishes did not count and she had no choice. Leonard ordered Mama to pack her things. Julia and Elise each grabbed one of the children, still asleep in an adjacent room. Despite her feelings of disgust, contempt, and anger at her family's overreaching and meddling behavior, returning to her parental home offered the best course of action at that moment. Angry and rebellious, she nonetheless did as she was told. She moved back home with Charles and Guy.

Soon after her arrival, Elise took over total care of Mama's two babies. Mama resented Elise's intrusive and opportunistic means of achieving motherhood. But she allowed Elise to care for her sons. Emotionally exhausted from the whirlwind of the events of the past year-and-half, she took time to heal. She loved her children and could not imagine life without them. But full time interaction with them did not come to her naturally anyway. That was Elise's thing. So what was the harm? If Elise wanted to be a mother so badly, let her be.

A few months after her return, Mama landed a teaching job in a rural village south of Cayes. She moved there during the week, leaving Charles and Guy in Elise's care. She came home when she

could on weekends. Charles and Guy slowly became estranged from her. They clung to Elise's every step. Elise enjoyed the boys' attachment to her, and flaunted it every chance she could.

"It was her way of getting even, somehow," Mama reminisced to Marguerite. "It hurt like hell. I felt smaller than a speck of dust around my boys."

The distance between her and the boys grew worse as Charles and Guy completely ignored her when she visited. They became Elise's sons until their teenage years. Mama felt like a distant relative to her own sons.

Ultimately, the pressure from within to claim her independence as an adult erupted. Now eight months pregnant, after a series of unpleasant events and facing the responsibility of raising another child, Mama made the difficult choice to leave the physical comfort of her family's home to take charge of her life and that of her soon-to-be newborn. Like most of her life-changing decisions, this one came at the most inopportune time.

"How did you make it all the way here by yourself?" Marguerite asked Mama.

"What kind of silly question is that, Marguerite?" Mama replied. "I walked."

The Black River

Mama's family home in town was within walking distance from L'arsenal. She walked easily, as she frequently did, the distance from her parental home in the heart of town to L'arsenal. Carrying a small suitcase, she followed *Grande Rue*, one of the two main streets in town, both less than a mile long, heading north. L'arsenal sat at the northern edge of town, just beyond the last paved street and within five minutes walking distance from the business district. Mama paced herself to enjoy the walk through her hometown and to think about the next phase of her life. She had all the time in the world, time she may never find again.

Flat and well-designed symmetrically, Cayes ranked then as the third largest city in population on the portion of the Hispaniola Island the Republic of Haiti occupied. Mama loved Cayes and, despite her load of troubles, she found pleasure in the uniqueness of her hometown and felt safe. She strolled along the sidewalk in front of the beautiful two-story houses aligned in perfect rows along *Grande Rue*. Hot pink bougainvillea flowers in bloom twisted around freshly painted white cement pillars. Residents of these houses used them both as homes and as places of business turning the lower front parts into business centers. Elegant boutiques in the front added an air of prosperity to the few blocks along *Grande Rue* in the heart of town.

Something about the elegance blended with the entrepreneurial use of these homes fascinated Mama. She often called the residents of these homes *la crème de l'aristocracie des Cayes*. Despite the perennial reproach of her family that she brought shame to them and acted no better than an ordinary member of the lower class,

Mama always considered herself and her family part of that upper crust.

She reached the iron market, her favorite spot in town. A vibrant busy block, the iron market sat in the square of four streets, buzzing in the open air like a perpetual fair. Peasants from rural farming communities as well as town-dwellers made the daily journey to the iron market to display and mingle, selling goods from cooked foods to sewing materials. She stopped to listen to the bartering of every item for sale.

"How much is a glass of your rice today?" she heard a woman ask.

"Fifty cents," the merchant replied.

"I am only paying thirty cents today. Right across from you I can get it for twenty-five cents," the woman retorted.

"Go ahead," the merchant said.

Calling the merchant's bluff, the woman turned away, knowing that the merchant can't afford to lose her sale. It was always a buyer's market. Townspeople with money called the shots, and knew that well.

"All right," the merchant yelled loud for the woman to hear. "For you it's thirty cents. I am losing money, but you're a good customer."

As she listened to this conversation, Mama continued to walk along the street that bordered the market until she reached the long cement sidewalk on the west side of the Sacred-Heart Church. The church, the last and most imposing edifice in town before crossing the bridge to L'arsenal, occupied an entire block from the north side of the iron market to the last paved street at the edge of town. She could see one block away in the distance the southern edge of L'arsenal past the Sacred-Heart Church.

Locals believed and perpetuated the myth that L'arsenal was used as a hideaway for arms and ammunition during the war for independence in the late eighteenth century, and inherited its name from this historic role. Irrigated with rivers and streams and well-suited for farming, the fertile land yielded strong harvests of assorted crops over the years. L'arsenal abutted the town boundary as the first rural community just north of Cayes. It began at the canal locals called the Black River (due to the color of its water)

just across the street from the rear entrance of the church.

The river, a man-made canal, originated from the sugar refinery beyond the western side of town. The dumping of molasses at the source and other assorted refuse along the way polluted the flowing water, and tainted it a permanent dark brown color. The water rolled uninterrupted downstream all the way east into the ocean as a bright line separating an illusive middle class life in town along *Grande Rue* from the harsh realities of rural life.

Mama stopped on the bridge for a minute and looked into the dark water. Two women merchants stood at the edge of the bridge, discharging bags of refuses they collected. She waved at them and kept walking beyond the bridge to the other side of the river. The smell of washed molasses mixed with human waste filled the air near the canal. In the crystal blue sky overhead, the hot sun stung the back of her neck and enveloped her head. The oppressive heat made her feel dizzy. Walking even a short distance under the tropical sun that day would have been exhausting for anyone. For a woman eight months pregnant, beyond exhaustion, she was nauseated. She kept walking to move away from the unsettling odor of the canal, knowing that she was nearing L'arsenal, and would soon find peaceful rest under the blissful shade of a tree.

A few steps past the bridge on the other side of the canal, she paused for a moment under the majestic flamboyant tree. The perfect spread of the tree branches in a gigantic umbrella high overhead soothed the sting of the hot sun for a brief moment. She moved quickly past the tree, through the foul smell of body waste along that narrow strip. For want of any public facility in the vicinity when nature called, merchants in the iron market liberally relieved their bodies behind the bushes along the public path, just beyond the river. This convenient outhouse for the merchants gave L'arsenal a bad name. Mama resolved to combat this image of the otherwise perfect sanctuary L'arsenal was to become for her over the following two decades.

The disagreeable odor slowly faded as she fought her way through mud and rocks to reach the farm her family owned beyond the creek. After crossing two makeshift bridges of palm tree trunks over muddy creeks, she reached the narrow path that led to the two-room hut that she would call home for the nearly twenty years

that followed. Once she crossed the last bridge and stepped on the path to the hut, she knew that she had also left behind *Mademoiselle* Tanabet. She had become an ordinary struggling peasant her family looked down on as low class.

Overgrown Trees

When Marguerite asked Mama about the father of her unborn baby, Mama finally told someone the circumstances that precipitated this new phase of her life. During one of her visits to L'arsenal she met a journeyman, named Miguel. She was not particularly attracted to Miguel, a simple man with less than a third grade education. But Miguel with his normal, uncomplicated way to approach life offered her relief from the stuffiness of her family. A carpenter by trade, Miguel came to L'arsenal to inquire about buying wood for use in his carpentry business.

He suggested to Mama that she consider clearing the overgrown trees on the land to make room for the other trees to thrive. She could sell the excess wood salvaged from the clearing to make some money. An intriguing idea, Mama had to admit. She had been unemployed for a few years since she lost her teaching job, and needed to figure out a way to earn money. Selling L'arsenal's excess wood for cash could certainly tie her over.

She promised Miguel she would think about it, and they agreed to return to L'arsenal in a week to meet in the fruit tree grove just west of the hut. Mama met Miguel a week later as planned, and she sold him wood salvaged from clearing the overgrown trees. Mama's association with Miguel evolved beyond just business. She later learned that she was expecting a baby. When family members discovered her most recent pregnancy, their anger and disappointment became unbearable. She had to leave; it was a matter of survival.

"No one has lived in the shed for years," Marguerite gently mentioned to Mama.

Mama acknowledged that the abandoned hut was in disrepair and unlivable, even by L'arsenal standards. The only groundskeeper her father had hired to watch over the property died many years before. With the help of neighbors like Marguerite, Mama planned within a few months to repair the walls, put a cement floor on the front porch, replace the roof with tin, and paint the doors.

Marguerite encouraged Mama, and reassured her that everything would turn out fine. After all, Mama was no stranger to L'arsenal, having frequently spent time there. As a young girl, she accompanied her father on many occasions when he came to inspect the property and supervise hired help. Later, when her father became too ill to make the trip, she occasionally accompanied her brother Nomis to help carry on her father's management of the farm. Most recently, in the years preceding her permanent move to L'arsenal and as the tension intensified with her family, Mama made frequent visits there, both to escape the discomfort with her family and because she so loved being there in the open air. Somehow she felt at home. But she admitted to Marguerite it would be tough for awhile.

"I don't believe there's even a bed in there. Could any of your brothers bring a few pieces of furniture for you? You know, a few essentials?"

"Nope," Mama replied quickly. "I'll have to make do until I can buy my own. I don't want anything from any members of my family. I walked away carrying this little suitcase. I don't intend to look back."

HOME

Mama did not look back and she stopped moping. A brand new life, however humble, lay ahead of her. One thing was for sure, roughing the primitive lifestyle at L'arsenal promised not to be boring. Opening the doors of the hut and cleaning it so she could move in happened the same day. Marguerite and Mama gathered a group from Marguerite's family members, willing passersby, and neighbors. Within a few hours of prying, lifting, washing, and dusting, by L'arsenal standards Mama's new home was transformed from an abandoned hut to more or less livable quarters, even with a few extras and luxuries.

Marguerite scrounged two wooden chairs and a small table from Gabrielle, Mama's old friend. Gabrielle lived just a few blocks south of L'arsenal, past the Black River and the Sacred-Heart Church, across from the iron market. With so many helpers, it was easy to transport the few pieces of furniture from Gabrielle's house to L'arsenal. Marguerite arranged them nicely in the front room. After sundown, Marguerite and Gabrielle, along with two men they summoned for help, made the trip to the Tanabet residence in town and brought back Mama's bed. They set it up in the back room. The Tanabet shelter was no longer abandoned. It became occupied when Mama set foot inside.

She first entered the furnished hut through the rear door of the back room. The single bed filled the entire space in the room with hardly any path to walk.

Claustrophobic! Mama thought. *I'm going to die in here....*

Mademoiselle Tanabet never factored into her dreams that someday she would call home a two-room hut with flimsy wooden

doors. The hut looked and felt like a square shoe box with six cut up openings on the sides. Shoe box or a queen's mansion, it was home-sweet home to Mama. Her new lifestyle would suit her just fine. She did not plan on spending much time indoors anyway. She could have accomplished that by staying put, cooped up inside the family residence in town. L'arsenal's open air would likely more than make up for the last few difficult years. She loved the outdoors and planned on spending her time there. A few hours of sleep inside her new place at night wouldn't kill her. She'd be too tired to feel claustrophobic.

The few days that followed passed quickly. Mama could not move too fast anymore, but she waddled at her own pace, and began organizing her new life as best she could. Her close childhood friend, Gabrielle, visited and brought her gardening tools, rosebushes, and leftover sewing materials and fabric. Mama put all of it to work. She rose early, before sunrise, and worked outside removing weeds and wild brushes from the front and side parts of her home. With the help of Marguerite's daughters, she cleared the front area and planted rosebushes in a garden along the border of the front porch. When the sun turned uncomfortably hot, she set herself under a mango tree with her sewing projects. A good seamstress in her own right, she sewed by hand a few pieces of essential clothing for her newborn and knitted socks, caps, and blankets.

Initially she did not have to worry much about finding food and preparing meals. Her sisters, strangely enough, made sure of that. One thing about Tanabet women, they'll kill you with food, even if they have to hide to do it. They wounded her spirit and exacerbated her insecurities enough to make her crazy. Since Mama's condition became public, the siblings stepped up their public treatment of her as an outcast. She was no longer welcome to sit in the family pew in the cathedral for Sunday Mass, and was not invited to receptions or celebrations that included people outside the family. The family excluded her from the ordination of her nephew into priesthood and the wedding of her niece. Despite all of these humiliating put-downs, Mama's three sisters decided they were not going down as responsible for starving her to death. Elise at the parental home and Eve and Clara at their home on *Grande Rue* assigned a house worker the duty to make daily trips to

L'arsenal to bring Mama baskets of cooked meals. With not much alternative, these baskets of foods during the few weeks after her move to L'arsenal before the baby's birth served their purpose. Mama regarded them as Providence's means of seeing her through the worst times. But once on her feet a few months later, Mama dramatically reduced the frequency of these baskets of food when she sent not-very-kind words to her sisters to stop the charade. Whatever the motives of her sisters, the baskets of foods got her through the roughest initial few months at L'arsenal.

Two weeks after moving into her new home, Mama gave birth to my brother, Joseph, in the front room. Her labor began at about three in the morning right after the church clock struck three times. It was pitch dark both inside and outside of the hut. Alone in a place she moved into just a couple of weeks earlier, she rose slowly from the bed and opened the east door of the front room. She managed to walk across the path in the dark through thick brushes and large banana leaves to the Manuels' place, and knocked on the door several times. Marguerite awoke, lit a kerosene lamp, and peered through a small opening in the door.

"It's me, Marguerite, I think this child is on its way here," Mama whispered through a splinter in the rotting flimsy wooden door.

Marguerite quickly opened the door. Mama stepped into the crowded front room, careful not to step on several children asleep on the floor on straw cots. There must have been five children on several cots on the dirt floor of the little room, ranging from three to ten years old, all Marguerite's grandchildren. Mama stood at the door as Marguerite whispered so as not to awaken the whole family.

"Look at you," Marguerite said. "You're not quite ready yet. Stay here with Yiyine. I'll get on the mule and fetch Estelle. Estelle has delivered every baby in these parts for the last twenty years. She knows what she's doing."

Yiyine, Marguerite's frail eighty-five-year-old mother, straddled slowly from the back room. Marguerite's daughters, Rolande and Mirta, asleep on a cot in the back room, heard the commotion and came out to the front. Yiyine asked the two girls to help Mama across the bushes back to her place. Yiyine took the tin kerosene lamp and led the way out of the door.

"We don't have much room here," Yiyine said gently. "You'll be more comfortable over there," she continued. "You girls stay with Miss Marie and take care of her until your mother returns with Estelle," Yiyine whispered as she stood on the Manuels' front porch.

She raised the lamp over her head as the girls and Mama tried to find their way toward Mama's place across the way. Mama walked slowly, carefully supporting her middle with one hand resting on her hips. Pressing her lips against each other and moaning faintly, Mama felt extreme discomfort as they reached her front room and she collapsed herself on a chair. Rolande and Mirta decided that the front room was more comfortable for people to move around. They set up a temporary bed on a cot in the front room for Mama and rested her head on several pillows, while they waited for the mid-wife.

Mama's labor continued intermittently for several hours. Outside in the back, Rolande and Mirta started a fire and made tea with basil leaves. With cold water from the creek, they helped Mama through the pain with wet cold cloths over her forehead. Estelle finally arrived on mule with Marguerite several hours later, and delivered Joseph safely at about noon. Rolande and Mirta moved in with Mama the day she gave birth to Joseph. "They were God-sent," Mama recounted years later. She did not know how she would have managed the first few months after Joseph's birth without them. They assisted her with the myriad chores for caring for a newborn, recuperating physically, and making her home livable.

HAPPY DAYS

The first few years that followed Joseph's birth brought stability to Mama's life. Surrounded by the ordinary uncomplicated folks who lived in the L'arsenal region, she focused on attending to what mattered to her the most. Nothing ever came close, Mama recalled, to bringing her more fulfillment than caring for Joseph without interference from meddling family members. She spent hours looking through his eyes, adoring him in awe. All the difficulties of the preceding years seemed to have melted away with Joseph's arrival. If the price for Joseph was public outcast by her family, he was well worth it to her. She'd do it again in a heartbeat.

The blissful moments she spent alone with Joseph in the pure L'arsenal air began to slowly transform her shame and feelings of worthlessness into love and wholeness. The intimacy a mother experiences with her newborn renewed her zest for life, and breathed new enthusiasm into her otherwise sorrowful outlook. She looked forward to each day under L'arsenal's blue sky so she could care for Joseph, listen to his endless babble, and sing lullabies to him. She had found herself happy again, something she thought impossible just a few months before. But how will she sustain the elements in her new life that made hope and happiness possible again?

As the days passed and the novelty of the awesome miracle of birth wore off, reality set in. She now had a family to feed every day and had to find a way to make good on her promise to herself to take full responsibility for her life and that of her children. At L'arsenal, feeding a family everyday was no small undertaking. It

meant work, work, and more work to come up with even one meal a day. Fortunately work at L'arsenal, however hard and difficult, was abundant and gratifying. Unlike many other L'arsenal residents, Mama had exclusive use and enjoyment of several acres of fertile and generous land. The farmland became Mama's primary source of support. She threw herself into work and filled her days to the brim with activities. She collaborated with local laborers as sharecroppers for half the yield, and produced at least two main crops every year. She could now afford, with the income from the crop yield, to pay for large expenses such as a tin roof, cement floors and other improvements for her new place, and later school tuition and associated expenses.

Still, she needed to find ways to meet day-to-day living expenses. She seemed to be in her element in the L'arsenal environment. She instinctively knew just how to hustle at every turn to earn a living. In those days gas or electric stoves and ovens did not exist anywhere in these parts of the island. Town-dwellers used charcoal to build fire for cooking. With excess wood Mama collected from pruning and clearing trees and with the help of laborers, she produced charcoal for wholesale. For half the yield she hired a laborer and his teams to cut trees, build the charcoal pit, cover it with earth, light the wood inside, and watch over the pit for days, until the wood turned into charcoal. Other times, instead of making charcoal she'd hire laborers to produce white paint or wash used to cover masonry. These laborers had been building charcoal and white wash pits all their lives. But they put up with Mama's micro management and detailed supervision of every step. She directed the production of these pits down to the last detail. She then sold her half of each pit wholesale to merchants for retail in the iron market.

With all the activities going on all the time, Mama was never alone at L'arsenal. The front porch of her place turned into a virtual stopping station. Merchants came and went daily to buy wholesale whatever Mama had for sale, depending upon the season. Or they stopped to ask for a drink of water, directions to various public offices in town or simply to chat with Mama over the latest news at L'arsenal. She befriended practically every laborer and worker in the region, always trying to arrange sharecropping

deals. They in turn hung out around our place and contributed to what was mostly a lively and vibrant atmosphere.

In the midst of all these activities, Miguel learned that Mama had moved permanently to L'arsenal, and returned to purchase more wood. Beyond business, Mama's relationship with him led to my birth two years after Joseph was born.

No Wedding Bells

Living in the backyard of the Sacred-Heart Church, as she often characterized the location of our home at L'arsenal, Mama longed to plunge back into the church work that made up the social and spiritual framework of her upbringing. The marginal treatment she now encountered in the church that once embraced her worsened the social stigma of an unwed mother. She yearned for her newest bunch of children to be anchored in the church in the same manner she once was. With a second child and a girl at that, Mama's discomfort with her social status began to interfere with her newfound peace at L'arsenal. She determined to do whatever necessary to restore her rights as a legitimate daughter in the church and pass that legacy on to her children. Marrying Miguel offered the only means to accomplish that.

During the year that preceded my birth, Mama convinced the church's pastor to baptize my brother, Joseph. Again her Tanabet connection gave her an edge with church officials to bide time and put off the inevitable. For a newborn to be baptized, the parents had to be married in the church. It was church policy, a parish priest reminded Mama when he baptized Joseph. He, however, sidestepped the policy for Mama that one time because of the Tanabet family's "past services" to both parishes in town. But if Mama came back with a second child, the priest warned her, there would be no more dispensations from the rules for her individual situation. She would have to marry the father or the next child would not receive the sacrament of Baptism.

My birth and church policy sealed my mother's fate to marry Miguel, a man she knew nothing about other than his fascination

with tree trunks and carved wood. She internalized without question the authority of the church. Her church taught her about the torment of hell, the bliss of eternal life in paradise, and the aimlessness of limbo. It was always crystal clear what hell was. Everyone understood paradise to be a desirable ultimate destination. While the state of limbo was less defined, Mama assumed that it had to be bad for a person's soul to be locked in limbo. It was neither purgatory nor paradise. A step above hell, limbo evoked a sort of eternal mindless wandering with no sense of roots or identity. Mama's religious education taught her that children younger than seven, considered innocent and not capable of sinning in the context of church beliefs, if they died without the benefit of Baptism, went into limbo. She accepted this belief without question. So she married my father to save my soul from limbo, she recounted to me years later.

"I'd marry the devil first and burn in hell forever before I let my child's soul stay suspended nowhere," she'd say to me, justifying her decision.

Despite her obvious gullibility, she tried to exercise control where she could. She carefully managed the details of the marriage ceremony. She insisted on a four o'clock in the morning church ceremony with no wedding bells and no guests. A parish priest officiated in the presence of Mama's closest friend, Gabrielle, and another priest as witnesses.

Frequent Visitor

At the point of her marriage to Miguel, well into her forties, romantic love no longer had a place in Mama's rationale as a basis for a union.

"Only your mother loves you, if you're lucky," Mama would say at times.

She did not marry Miguel for love, and romantic love between them did not seem possible. They did not interact with each other even casually let alone long enough for any meaningful relationship at the most basic level. They came from different worlds and operated with points of view not sufficiently compatible to sustain even a casual relationship.

The illegitimate son of an influential man in town, Miguel did not meet his father until he became an adult. His mother, a beautiful *marabou* (a blend of the best of at least two ethnic heritages, one of which must be African), died shortly after giving birth to the last of four children fathered by the same man, Redanx. Miguel, the oldest among his siblings, became totally responsible for himself at the age of eight after his mother's unexpected death. He followed a master carpenter in town and worked for a small fee. He eventually learned the trade, which he practiced his entire life.

Miguel took responsibility for no one, except himself. He lived by his wits and followed his instincts. He existed and never questioned or fussed about anything beyond that. He did not have, like the rest of us, a particular spot for sleeping every night. He lay down wherever his spirit moved him on a particular day. He was just as happy to sleep in the open air on a cot as he was in the storage hut or seated in a chair. He made no demands on anyone and

responded to none from others. Miguel took life in strides and never hurried.

Paradoxically, he lived by a very strict code of work ethic and excellence in his field of carpentry. If a particular piece of work failed to meet his standard of excellence, he would tear it down and rebuild it to his satisfaction, even if it took him weeks to complete it. He would redo work that didn't meet his standard at his own expense, even if his clients did not complain or could not even notice the difference. He worked every day. He enjoyed a great reputation in town as a particularly gifted and experienced carpenter. He was reliable to his customers and timely delivered his commitments. He built many rooftops, doors, and shelves in town. He made money and it was all his to keep, with no responsibility.

Mama and Miguel treaded different paths. Their priorities clashed even in something as basic as goals for the education of their offspring. Miguel could not relate to the notion that formal education served any useful purpose. Mama, on the other hand, viewed education as second only to salvation, and all her life she sacrificed everything to provide her children with an adequate education.

Even though Mama and Miguel were officially married, they never lived together in the same room as one would expect normal couples to do. Nonetheless, Mama gave birth to her last child, my brother, Bertrand, about two years following her marriage to Miguel. After Bertrand's birth, she decided not to produce any more children. With no concept of birth control in that era, abstinence provided the only means of avoiding an unwanted pregnancy. Mama succeeded in avoiding another child after the birth of Bertrand. For the remainder of her life, she focused her attention on practicing her religion and raising her family.

Miguel lived at his own place by the cemetery, but he came to L'arsenal almost daily. On occasion he stayed overnight in the smaller storage hut Mama built shortly after her arrival. He acted as a frequent visitor, much like the laborers and merchants who came and went every day. Mama had complete and absolute responsibility to manage the farm and to provide and care for us. Miguel liked it that way.

Fly Away

L'arsenal sustained the pulse and rhythms of Mama's new lifestyle. Her love for the soil fueled her enthusiasm during long, back-breaking days of cultivating the land as a means of providing for her three children. She split the cultivatable land into rice and sugarcane fields, and rented each part to a sharecropper in exchange for half of the crop yield. She administered, under this arrangement, the production of the crops from planting to harvest. Her relative education and entrepreneurial upbringing, compared to her illiterate associates, gave her an edge.

Rice harvesting was fun for us kids. Children in the immediate neighborhood, including Paulette's children, joined us early in the morning, and Mama would gather a group of neighbors, her sharecroppers, and their families at our place. With Mama leading, we headed for the field where we manually cut rice bunches one by one from each plant, working from dawn to dusk for a few weeks to complete the job. Once Joseph, Bertrand, and I became old enough, Mama gave us the job of keeping the *tourterelles* (small birds) from feasting off the maturing rice crop. Large flocks of *tourterelles* loved to plunge *en masse*, blanketing the rice field with their bodies. If we allowed them, their sheer numbers could peck away the meager yield Mama and her team had worked so hard to nurture.

The three of us and our friends sat under a tree in the rice field and screamed at the top of our lungs to scare the birds. We made up a song, repeating over and over as loudly as we could, "Fly away…fly away…don't touch, don't touch, don't touch down, please."

After a while, the birds became accustomed to our screaming. Then no matter how loud we yelled, they ignored us and continued feasting. Mama then trained Joseph to use a whip with a long cord. When our screaming no longer worked, Joseph would crack the whip over the flock. The birds lifted in unison at the crack of the whip and whooshed up to the sky. They then lowered almost immediately at a different spot on the rice field. We followed their movements and shooed them away again and again as best we could. The screaming was exhausting. At the end of each day, we had no voices left. But we all loved being outdoors, and the screaming and chasing made good work for children.

Sugarcane harvest created different, and more intense, disruptions in our family life. More than harvesting rice, the sugarcane harvest demanded intense planning and coordination from Mama and long days of labor, before she could see even a modest return for all the work. Timing was extremely tight and precise. Mama first had to secure, in person from the sugar refinery, an *ordre de coupe*, the "order to cut" the sugarcane. Mirta and Rolande, Marguerite's daughters, took care of us and watched over L'arsenal while Mama traveled. She left L'arsenal before sunrise on horseback (the horse rented or borrowed from a neighbor) for the journey west to the refinery. There she would meet with refinery officials, offer them her sugar crop, and secure the order. The *ordre de coupe* required Mama to deliver an estimated number of truckloads of sugarcane for a price per truckload within a strict timeframe. The order specified a start date, when the refinery truck would come to be loaded, and an end date a few days later to complete delivery. When she returned from the refinery with the order, Mama worked frantically to meet the deadline.

It was well understood that, if for some reason she was late, the order would be nullified and the sugarcane crop would go to waste. This meant that Mama would have to absorb the expenses she advanced for the planning and preparation. And worse, the sharecropper who partnered with her to produce the sugarcane would lose all his efforts. Failing to meet the conditions of the order was not an option.

The refinery allowed three to five days for the sugarcane delivery, start to finish. Mama had only that time to coordinate with her

sharecroppers, hire additional teams, and cut and load the cane. The work began with cutting and continued around the clock for several days and nights until we loaded the last batch on the last truck.

Mama kicked off the sugarcane harvest with a large meal of rice and beans cooked in coconut juice. She served everyone, both hired help and volunteers. The hired teams would immediately start cutting sugarcane with individual machetes, as Mama supervised transporting the cut sugarcane from the field to the trucks.

A rural, unimproved community with no paved roads, no electricity, and no running water, L'arsenal was accessible only by foot, horse, mule, or donkey. Cars or trucks could not drive the narrow paths. The refinery truck could come only as far as the cement bridge over the black river by the flamboyant tree. Located at the northern edge of Mama's property, the sugarcane field was a fifteen-minute walk to the bridge.

Mama arranged transport of the sugarcane in small loads on rented mules and donkeys, or hand-carried from the field to the loading area over the black river. She managed this by putting all of us to work. This included everyone from both her and the Manuels' households, and every willing and able person who offered to help. The sharecroppers also brought along a team of helpers. Once the word circulated that Mama had an *ordre de coupe*, neighbors, friends, and even passersby gathered and offered to lend a hand.

Once she had the teams, Mama began coordinating the mules, donkeys, and foot transport for the cut sugarcane to the loading zone. Volunteers did not mind lending a hand during the day. To meet the set deadline, though, the work had to continue through the night. After dark, Mama had to carry on the arduous work of transporting the cut sugarcane to the loading zone with only the help of the sharecropper and a few hired hands. Fortunately no cutting occurred during the night. It was too dangerous. With no electricity, the sugarcane field, like the rest of L'arsenal, was pitch dark after sunset.

The round-the-clock schedule of work continued for at least three days, sometimes five, until the last truck left for the refinery. My brothers and I stayed up and helped as long as we could.

Rolande or Mirta took us inside our place once we became too tired to carry on and fell asleep. Once the last loaded truck left the bridge, Mama would throw a party and crash into bed soon after the last guest left.

For all this hard work, the maximum yield I ever saw the sugarcane field achieve was six truck loads. The gross amount of money Mama netted in the best year did not quite reach forty American dollars. She shared this amount of money with her sharecropper. Every year she used all the money from the fields to finance our primary and secondary education.

Elephant Ears

Most days we children ate whatever we picked off L'arsenal's land. As long as we could find roots in the ground and leaves on the plants and trees, we never went hungry. Mama taught us to be resourceful and to feed ourselves from the land. Her work of managing the farm left her little time for planning and cooking several meals a day. Feeding the children during the day became Joseph's responsibility, with Bertrand and me as helpers.

Mama planted a variety of yams along the sides of the creek at the south edge of our property. To start the yams, she collected starter roots from the neighbors and used a machete to dig deep holes to plant them. Joseph, Bertrand, and I followed her, dragging along a large basket of roots. We placed one root in each hole until we made a row of yams along the length of the creek that formed our property line. Once planted, the yams needed no maintenance as long as the soil remained moist and cool. The creek guaranteed the right ground. Within a few weeks of planting, the yams thrived and became tall and bushy. They sprouted large, flat leaves, shaped like elephant ears. Any child could uproot the yams from the soft moist soil.

We learned how to pull, peel, and boil the yam roots in water for a meal. The yams tasted like a cross between the flaky texture of a regular boiled potato and the moist and pasty consistency of sweet potato. A typical mid-day meal was yam with fish caught in the creek. Joseph would plunge a large straw basket in the bottom of the muddy creek and lift it up. Bertrand and I stood on the side, watching. With each plunge, Joseph would catch small fish in the basket. He had perfected the art of cleaning fish, removing scales

and gutting with a knife. We seasoned the fish with lime juice, salt, and chives from Mama's herb garden. The limes came from trees in the grove behind the storage hut, on the west side of the property.

Cooking oil for all meals came from mature coconuts picked off trees in the grove. Mama asked Isidor, one of her sharecroppers and a regular visitor to our home, to climb the trees once a week to drop coconuts. Isidor got to take home half of what he dropped.

We broke the ripe coconuts with a hammer and removed the hardened core with a knife. It was my job from the time I was six to shred the core with a grater. We then added a bit of water to the shredded coconut and poured the mixture into a sieve to retrieve the coconut juice. After building a wood fire in the outdoor kitchen, Joseph would place the thick white coconut juice in a pan over the flame. Once the water evaporated, only the coconut oil remained in the pan. Joseph would sauté the seasoned fish in the oil. Within a few minutes, our meal was ready. For a beverage, we made a hole in an unripe coconut and drank the juice inside the core.

When we were tired of fish, we would cook eggs in coconut oil and eat them with the yams. Mama always had a pair of chickens, a hen and rooster, and a pair of ducks. The chickens ran loose on the farm, and the ducks lived in the creek. The ducks and chicken produced eggs at different times of the year.

When we didn't have eggs and were tired of fish, we'd pick a wild spinach-like plant Mama called *épinard*, if it was in season. We boiled it and sautéed it in coconut oil and ate it with yams. When yams were not in season, we'd cut a bunch of plantains (large green bananas) from plantain trees along the east side of our home. L'arsenal fed us plentifully most of the year.

On the days that followed the rice harvest, suppertime at our house felt like a feast every night. When Mama had plenty of fresh foods from the land, she loved to cook and entertain. She'd prepare freshly harvested rice with beans in coconut juice served with wild spinach mush. At sundown as Mama served supper, merchants passed on their way home from a long day at the iron market. A number of regular visitors, calling themselves "friends of the family," conveniently timed their visits to coincide with supper. Charles and Guy walked to L'arsenal from Elise's house most nights to visit Mama and eat supper with us.

Mama also shared whatever she cooked with any of the Manuels' children and grandchildren or other neighborhood children who'd come over. If the Manuels had no food on a particular day, Mama would send over a plate for the adults. If we could see smoke coming from their fire pit, the Manuels had food. No smoke meant a dry day at the Manuels, and Mama would share what she cooked. The Manuels reciprocated to the extent they could.

In the back between our place and the larger field, a grove of mature tropical fruit trees flourished every year. The trees required no care and yielded fruits like manna from heaven—mango, apricot, lime, and more. We ate these fruits in season whenever we wanted a snack. During the summer months, teenage boys from town, either bored or hungry, would wander in search of food or adventure. They crowded L'arsenal and assaulted our fruit trees by throwing large rocks at the mangoes. Mama thought it unsafe and would chase the boys off the property.

Despite the bountiful harvest from the fertility of the land that fed us so abundantly for most of the year, and the generous back-up of our neighbors, we encountered a dry spell at some point every year. If fruits and vegetables were out of season and if Mama had run out of money, it was a dry day. On those few dry days, we would wake up in the morning with nothing to eat, not even a fruit. The day would end the same way. During those times, Mama was spent and helpless. She would sit on the front porch until dark, when she would finally move from her chair, mix water with salt, make us drink the mixture, and order us to bed.

Mama would never let us go hungry for more than one day. After a dry day, she'd rise very early the next morning, dress up, and leave for town. She'd usually return around seven the same morning with a basket of both cooked and dry foods. She alternated during these times going to one of her friends in town like Gabrielle or to one of her sisters. After feeding us, she'd return to her usual enterprising self, planning, thinking, and scheming new ways to earn cash until the next harvest.

I often wondered whether those dry spells had to do with my mother's sheer exhaustion after a particularly busy time. She worked so hard to plan and to nurture crops until harvest. Then she fought to sell the crops. Still, she could not make ends meet in

the relentless, daily fight for something as basic as food. But the reality that her children would go hungry if she did not stay alert would snap her out of any fatigue or self-pity. She then used her natural ingenuity and resourcefulness to keep us rolling. We made it somehow.

A Long Dry Day

One summer evening at suppertime, shortly after I turned six, I squeezed on the narrow bench between Mirlande and Rose and across from Joseph, Bertrand, and Paul. All six of us waited patiently as Mama scooped rice and beans on plates from a hot dish. She then splashed a single scoop of vegetable mush over the rice.

Waiting for Mama to serve supper always seemed like an eternity. By suppertime, we were usually so hungry that we wished Mama would hurry up and give us the food, skipping all the hosting, socializing, and talking she did with everyone who swarmed around the kitchen. When she finally handed a plate to each of us, we dug into the rice with our spoons as quickly as we could.

After serving us, Mama would then serve all the adults. They sat in a large circle on straw chairs outside the kitchen. That particular evening, Paulette had come over with her children. She was the mother of Mirlande, Paul, and little Luke, and they lived next to the Manuel hut across the way. Paulette couldn't cook that day because she had no food to cook. An occurrence a few times a year for us, this shortage happened frequently for her family.

"This was a long dry day," Paulette commented to Mama as she dropped herself into a straw chair, putting Mama on notice to count her as a supper guest.

"Make yourself at home, dear," Mama replied in a familiar tone, indicating they understood each other well. Guy and Charles had arrived just before Paulette. They motioned to her to sit next to them. I wondered what would happen next. A visit from Paulette never occurred uneventfully.

As a child, Paulette had shadowed her grandmother to the open market to sell cooked rice. When she turned fourteen, she became pregnant with her first child. Since then, she had given birth to a child every other year, if she continued to nurse for at least a year. If for some reason she cut down her nursing time, the time between babies was even shorter.

After the birth of her second child, Paulette stopped shadowing her grandmother, and decided it was time to earn a living on her own. No one really knew what Paulette's business was. Every day she left at the crack of dawn and did not return until well after sunset. She would leave again around eight in the evening and return close to midnight. While at work, Paulette left her small children with Yiyine, Marguerite's mother, who lived next door to the family.

There never was much opportunity or time for gossip at L'arsenal, but Paulette's lifestyle generated all kinds of rumors. The worst rumors accused her of murdering her last-born little girl right after giving birth by crushing the skull of the baby with her thigh. We all knew the baby girl had died after birth, and that Paulette had buried the baby herself. It was impossible, though, to verify anything more than that in a community like L'arsenal, with no required processes such as autopsy or even legal inquiry into suspicious deaths.

Despite all the hours working, Paulette often could not afford to feed her children. Mirlande and Paul spent most of their time with us, and Mama fed them regularly. Luke, Paulette's three-year-old, would also come running as soon as he spied Mama serving a meal. As the six of us sat around the cramped bench and began to eat on that summer evening, a naked Luke sheepishly emerged from the back of the kitchen. He moved rapidly and sat on an empty straw chair Mama had intentionally pulled next to her, as if waiting for him. The little boy's hair had turned reddish brown. His thin legs and arms dangled around his small body as he pushed forward a swollen round belly.

"Luke, here you are. I was wondering where you were. I knew you could not have missed seeing me serve dinner," Mama spoke gently to little Luke.

As she talked to him, she scooped a large wooden spoon full of

rice and beans on a small plate and covered the rice with a scoop of vegetable mush. She offered the plate to Luke. He quickly grabbed it from her hand, got up from the chair, ran as fast as he could, and disappeared behind the kitchen.

Once Luke left, I asked Mama if we could have more rice. All six of us were so hungry that we had wolfed down everything on our plates. The boys chimed together after me, asking, "Can we have more…please?"

"None left," Mama answered. She explained that we always have to leave a little bit for Luke. Most days he only ate if we fed him.

"Isn't Luke your child?" An adult guest sitting in the circle outside of the kitchen turned to Paulette.

Paulette answered straightforwardly, "Yes." She added that two of the children at the table were also hers.

The woman continued to pry. "How many children do you have?" she asked Paulette, emphasizing *how many* in a sarcastic manner.

Paulette replied calmly that she had eight. She explained that four of her children were living with her stepfather in a rural village far away because she could not take care of them. Paulette added that it was difficult to feed them every day, and that Mama helped when she shared whatever she cooked.

"Have you considered giving your children to families in town?" one of the guests suggested to Paulette. "At least they'll get fed every day and have a roof over their heads."

When Paulette heard these words, she straightened herself in the straw chair and leaned toward the woman. "What did you say?" Paulette demanded. "I don't think I understand what you said." Without letting the other woman answer, Paulette became increasingly agitated, and jumped from her seat. "How dare you? You want me to give my children away to be *restaveks!*" Paulette thundered like a roaring lion.

This was quite a thing to throw on the table.

Restavek is a Creole word—Creole is the main spoken language in Haiti, in addition to the French taught in school. The word is derived from the French term, *rester avec*, which means "to stay with." *Restavek* described the accepted social practice that allowed

poor parents, unable to feed and shelter their offspring, to give their children to more affluent families to work in exchange for food and shelter.

Restavek could refer to the children living in these arrangements, as well as the process itself. To be called a *restavek* was also a horrible insult, a fighting word that could start fists flying. It had come to be used as demeaning and pejorative slang to describe a person, with no sense of self worth, who simply executed the whim of another more powerful person in exchange for small material favors. *Restavek* described, too, a subservient state of mind in someone who internalized and accepted an inferior position dictated by others perceived as more powerful.

In a typical situation, a *restavek* child was on duty from the time the first family member woke in the morning until the last family member retired in the evening. Any break from *restaveks'* chores during the day came totally at the whim and discretion of the family. *Restavek* children worked cleaning, doing laundry, cooking, fetching, and transporting drinking water for the families they served and were often subjected to physical abuse.

The quality of life for *restavek* children varied based on the degree of decency or moral commitment of each family. Families were not required to send their *restaveks* to school or to church, and many did not. Some families allowed *restaveks* to eat at the dinner table or wear their own, relatively fresh clothing. Other families relegated *restaveks* to uncomfortable servant quarters, and made them wear ragged hand-me-downs.

Some parents, like Paulette, equated placing their children as *restaveks* with giving them into slavery. While Paulette did not fit into the category of devoted parents by any stretch of imagination, she felt strongly against the *restavek* practice. The suggestion of the guest that evening at Mama's supper gathering awakened Paulette's deep fears that she might not be able to protect her children from a fate she considered worse than death.

Paulette lunged at the woman's face with such fury that she would have ripped her apart, had Guy not quickly stepped between them. Mama jumped out of her seat and ran to put her arms around Paulette. Paulette, no matter how angry or out of control, always submitted to Mama's gentle ways. Mama lovingly patted

Paulette's shoulder and coaxed her to walk away. Paulette sobbed inconsolably as Mama continued to comfort her. Mama told her that the woman did not mean any harm, and that Paulette did not have to listen about giving her children away.

Paulette abruptly stopped sobbing and said to the woman in an enraged voice, "My children will never be *restaveks* as long as I live. I'll sell my body to men if I have to. I'll steal for them. I'll starve them and let them die first. I will never give my children away to be *restaveks*. You got that?"

Without waiting for a reply, Paulette turned to go. She then stopped again and looked back at Mama. "If you don't feel like feeding these children anymore, don't feed them," she snapped.

As Paulette slowly walked away, we heard her repeating deliriously, "My children will never be *restaveks*, not as long as I live."

After Paulette left, everyone became quiet. I could hear the intermittent chirping of crickets nearby and the regular groggy chatter of the frogs in the creek. The usual lively party Mama hosted at suppertime turned uncomfortably serious. Everyone looked pensive and sad. Mama finally broke the silence. She commented that she could not blame Paulette for feeling the way she did. Mothers should not have to make the choice between not feeding their children and giving them away.

"I say we shouldn't stay here helpless and just talk about this problem," Guy burst forth with his usual impetuosity. "We have to do something. The people in power should—"

"Stop that talk right now, young man," Mama interrupted Guy in a frightened voice.

Guy had violated one of Mama's cardinal rules: no words of politics of any kind. Worse, he had done it in front of guests Mama knew she should never trust. When it came to words, the slightest bend of political overtone could bring awful trouble. A seemingly innocuous comment among friends and family could result in tragic consequences, like death or torture. One tiny criticism misconstrued or misheard could turn into an offense resulting into a missing person in the night. And no one ever discussed these happenings openly.

At L'arsenal, no one ever criticized the establishment, not even in a whisper. Mama had ordered us, even as small children, to

never even utter the name of anyone in any ostensible position. She explained that she never wanted anyone to misinterpret anything we said. It was better to say nothing than to be sorry.

Guy had already distinguished himself in his teen years as a brilliant natural leader. A shining, promising youth, he seemed destined for some leadership role. But Guy had also exhibited early a revolutionary streak, critical of the establishment. Mama had trouble redirecting his leadership abilities into safer channels because she did not directly raise him for many of his formative years.

When she became aware of Guy's potentially revolutionary penchant, it was too late. He always wanted to make things better for other people. He felt that it was his responsibility, but he could be so focused on what he believed was right that he was blind to caution. Mama feared for him, and feared to lose him.

Mama jumped and moved closer to Guy. "I have enough problems. We don't need any more complications than we already have," she told Guy sternly.

This warning ended an eventful suppertime at Mama's place. Mirlande, Rose, and I quietly snuck out of the kitchen to the front porch for our fun play time.

Moonlight

One beautiful summer evening under the moonlight, I learned about Rose's biggest fear. When it turned pitch dark at L'arsenal, we looked forward to full moon days. Moonlights brought us comfort and soothed the unexplainable fear of inescapable darkness as we waited for daybreak. Shining brightly overhead, the moonlight enveloped the farm. I could see better in the moonlight, it seemed, what lurked hidden in the trees and leaves than I could in the daylight.

Our imaginations ran wild as we watched the elongated shadows of trees and leaves dancing in the gentle breeze. We lost ourselves in riddles, trying to outdo each other with stories passed down from generations. When we became tired of riddles and story telling, I loved just sitting there with Mirlande and Rose watching the silhouettes of the fruit trees. Sometimes, we'd get up and dance in a ring-around-the-roses circle until we became delirious with our singing, turning, and twisting. Other times, we'd dance with our own shadows. Nighttimes at L'arsenal under a full moon brought us warmth and joy.

One evening, after supper as the sunset was complete and darkness began, Mirlande, Rose, and I sat on the front porch to play for a little while until Mama proclaimed it was bedtime. The boys took off to the side field to play ball. A large pregnant moon perched from the east in the sky, so close overhead, it felt as if we could reach and touch it. Mama often told us that the same moon that brightened our darkness at L'arsenal brightened everyone else's at the same time in other parts of the world. I had trouble imagining a world beyond L'arsenal. But if such a world existed, I

felt a connection with it through the moon.

We sat at the edge of the porch, following the movements of our shadows. It was quiet, except for the intermittent sounds of crickets, fireflies, and frogs in the creek. We kept silent for a moment until we heard movement of footsteps stuck in the mud on the other side of the creek behind the elephant ears-shaped yam leaves. We could see in the moonlight the shadow of a figure hiding behind the leaves while spying on us. Mirlande became frightened and reached for my arm. She squeezed it tight, letting me know she was terrified. She slowly moved behind me. Rose, too, straddled backwards on the floor to huddle closer to me.

"It's Leon over there," Rose whispered.

Twelve year old Leon and his younger brother Theophile lived with their father and stepmother across the creek in a hut southwest of Mama's place. They had no adult supervision. Their mother died while giving birth to Theophile. Their father worked as a journeyman-sharecropper and was never home. Their stepmother suffered from an undiagnosed debilitating illness, and remained in their little two-room shack all the time behind closed doors.

Both Leon and his brother were the neighborhood terrors. Leon in particular had a reputation for being ruthlessly mean for his age, particularly to animals. It was even rumored (without confirmation of course) that before his twelfth birthday Leon was paid by people in high places to murder a man. They said he had thrown the body in the outhouse of the church's parish school by the black river, a few yards from our house. Mama had forbidden us to ever set foot across the river alone during the day and never at nighttime. L'arsenal for the most part felt safe during the daytime. We never saw Leon or his brother in the daytime. We did not know how they spent their daytime hours, but they were not at L'arsenal.

We were all terrified of nighttime because it seemed that whatever mischief (stolen pigs, mules, chickens or goats) that happened at L'arsenal always occurred under the cover of darkness. No one was ever sure who perpetrated these mischiefs. We never saw anyone stealing or hurting our animals during the daytime. They must have waited until we went to bed, because on a regular basis in the daytime we'd discover that one of our animals was missing.

Everyone always suspected Leon and Theophile and blamed them for all kinds of mischievous acts. I was certain, however, that there were a host of other people from faraway places that came out at night and lurked in the darkness to do the ravage the daylight exposed the next day. However illogical that supposition seemed, I don't believe it was far-fetched.

That night as we sat on the front porch under the moonlight, Rose was right this time. It was Leon out there spying on us.

"Let's run and hide inside your place," a frightened Mirlande whispered.

"No," I said. "I am not letting him chase us away."

"I am scared," Mirlande mumbled under her breath, squeezing my arm and hiding behind me. "He always carries a machete."

"Let's ignore him," I said. "We can't let him think we're scared."

"What do we do then?" asked Mirlande.

"Let's play the riddle game and pretend he doesn't exist," I said.

We straddled backwards toward the front wall and sat, leaned against the wall, in a row so we could watch the movements behind the leaves across the creek. Mirlande began the game in her normal voice.

"Crick," Mirlande said.

"Crack," I responded.

"What's small, small, small, but fills the house," Mirlande asked.

"A lamp," I responded.

"Seven colors in the sky," I said quickly.

"Rainbow," Rose retorted. "That's too easy," she continued. "Here is a tough one: Who's small, beautiful, and strong but gets slapped and spat on?"

Mirlande and I looked at each other. We did not recognize Rose's riddle.

"I don't know this one," I said. "Rose, you are not supposed to do that. You made this riddle up."

"I did make it up," Rose replied with a grin. "What's the answer?"

"I don't know," I said.

"A *restavek*," Rose said with a curious look on her face.

"A *restavek*," I repeated incredulously, astonished at Rose's answer to the riddle. "Not all *restavek* children are small and not all of them get slapped and spat on."

"Being a *restavek* means your mother does not care about you and just gives you away...Nobody cares about you," Rose said.

Mirlande quickly pointed out that Rose was not a *restavek* now. She told Rose that she did not have to worry about being a *restavek*. I thought about Christiane, the ten-year-old girl who lived at Mama's family house in town. Christiane became a *restavek*, when her parents left her there to serve the family. No one in the family had ever slapped, spanked, or whipped Christiane. But that was not the norm for many other *restavek* children. Slapped or not, *restaveks* lived under humiliating conditions. It was clear to me that night, Rose was terrified of becoming a *restavek*.

Deadly Tick...Deadly Fall

Little Luke did not make it far past his fourth birthday. Although typical for many children in the region, his fate was seared in my thoughts as a constant reminder of how extremely fortunate Joseph, Bertrand, and I were to have the devotion and care of Mama as our protection. One early evening, Mirlande, Rose, and I played ring-around-the-roses in the back near the kitchen after supper. I heard the whimper of a child from across the way, behind the kitchen. We stopped for a moment. Little Luke was crying.

"It's just Luke," Mirlande said.

"He must want food. He's always hungry," Rose added.

Luke's whimper did not sound like a hungry cry to me. He was a resilient and resourceful little guy who learned early how and where to find a meal everyday. He watched Mama's cooking activities and showed up at the right time expecting a plate. Mama always fed him. He'd run back across the pathway as soon as Mama gave him a plate. I've never heard him cry for food before. He knew how to find it.

"Let's go find out what's wrong," I said. "Luke does not usually cry."

We walked the few steps past Mama's kitchen to Paulette's hut. Luke lay alone in the fetal position on Paulette's dirt porch. Pitch dark inside Paulette's place, no adult appeared to be nearby. The Manuels' hut, a few steps away from Paulette's, also looked dark. Yiyine likely lay in her bed inside the Manuels' place. Advanced in years, Yiyine usually retired to bed early.

"Luke, what's the matter?" I asked as I touched his shoulder gently.

He rubbed one of his ears vigorously.

"His ears must be hurting," Rose said.

Luke seemed very ill and in pain. We needed an adult. I ran back across the way to fetch Mama. Mama lifted Luke and carried him to our place, trying to comfort him. Luke's discomfort seemed to worsen. Mama lit the kerosene lamp and looked into the ear Luke pulled on. She asked Joseph to make a swab with a matchstick and a cotton ball. She placed Luke face down on her knees and gently inserted the swab into his ear. Luke screamed. Mama gently pulled out the swab.

"Goodness," Mama exclaimed. "A tick got into the child's ear."

Luke slept on a straw cot on the dirt floor of his mother's hut. *A tick must have entered his ear while he lay asleep*, I thought.

"He's burning with fever," Mama said in a concerned tone of voice.

Mama asked us to fetch water from the creek to try to lower his body temperature. As Mama prepared to give him a bath, Paulette walked on the path by our place on her way home. Mirlande ran and told her about Luke, and Paulette rushed over.

"He was asleep when I left this morning," Paulette said. "Yiyine was supposed to watch him."

Mama explained that we found a tick in his ear. It looked like the tick had been there for awhile. She told Paulette with urgency in her voice that Luke had a very high fever. Mama asked Paulette to leave Luke with us for the night so we could take care of him.

"Thanks, but we'll take him home. We don't want to impose," Paulette said.

"You must lower his body temperature, Paulette," Mama warned her. "His little body is burning."

Paulette picked up Luke from Mama's lap. With Mirlande following, she disappeared in the darkness behind the kitchen. All four of us became concerned for Luke after they left.

"Do you think she'll take care of him?" Joseph asked Mama.

"She's his mother. She wanted him home," Mama replied.

The next morning after breakfast, Mama, the boys, and I strolled across the path to find out if Luke's condition had improved. As we approach Paulette's front porch, we noticed Paulette and a few other people, including Mirlande, all standing on the

front porch, weeping.

"How's Luke? Why is everybody crying?" Mama inquired.

"Luke is gone. He's dead!" Paulette replied through tears.

"Dead? When?" Mama exclaimed.

Paulette explained that after they left our place the night before, she put Luke to bed. She thought he was asleep all night. She didn't hear him make a sound. When she awoke that morning, she touched him to see if the fever had gone down, but he was as cold as a piece of ice. Mama held my hand as I wept. It seemed so fast and easy for someone to die. Luke would not be running from behind the kitchen to share our supper anymore.

Deaths or bad news always seem to come in pairs. Soon after Luke's death, we mourned Yiyine, another very special pillar in the L'arsenal community. A few weeks after Luke's passing, we resumed our playtime at night. A few more kids from the neighborhood joined in the fun. With more children to play, Joseph organized a hide-and-seek game every evening. Playing hide-and-seek, our favorite game, turned into a tragic accident one night.

We played in and around Mama's and the Manuels' places and on the pathway between the properties. We hid behind the large banana leaves, in Mama's kitchen, behind the pig pen, in the storage shed and any place we could find. A high point of our days, hide-and-seek kept us as happy children for a few years.

The girls (including Mirlande, Rose, other girls from across the creek, and me) made up one team that night. We took turns with the boys' team as hiders or seekers. Ten-year-old Yves, eight-year old Joseph, five-year old Bertrand, and five-year old Paul made up the boys' team. We ran wild in the dark, trying to find clever hiding places the other team would not think of. Most of the time, the girls' team discovered hide-outs the boys always overlooked. Sometimes, we hid in the most obvious places. We'd laugh hysterically when the stupid boys could not find us, even when we stood right in front of their noses.

All this fun came to an end one night. I looked forward all that day to our playtime in the evening. Joseph organized the game shortly after supper. Rolande and Mirta, already both in their twenties and too old to play with us, sat in straw chairs in front of Paulette's hut, burning the idle early evening hours watching our

game. When it became the girls' turn to hide, I had the brilliant idea to take cover inside Marguerite's front room. I thought the boys would never find us there. I was right. It was pitch dark both inside and outside Marguerite's place. We waited there for quite some time. When the boys did not come and we could not hear them, I whispered to Mirlande that we should give up.

"They were too stupid to find us," I said. Mirlande agreed.

We emerged from our hiding place through Marguerite's front door. It was pitch dark. I could, however, see from the front door the frail silhouette of Yiyine. She stood just below the front porch in an area near the three rocks that framed Marguerite's fire pit. The boys spotted us in the dark from the pathway where they kept watch a few yards away from Yiyine. In a boisterous rush of laughter, the boys, with Yves leading, bounded toward us. In the dark, they did not see Yiyine standing in the way between them and us. Yves collided into Yiyine with such force that Yiyine fell sideways on the rocks framing the fire pit. Yiyine screeched faintly and an uncomfortable silence followed her feeble moan.

Rolande and Mirta witnessed the entire event. They dispatched right away across the pathway and told Mama. Within minutes, Mama, carrying above her head a tin kerosene lamp and followed by Rolande and Mirta, emerged from the pathway. Mama looked and acted furious. She ordered us, her three children, back inside our place immediately. The other children, neighbors and guests, dispersed in the dark to find their own homes.

"Not a word from any of you. I'll be there soon enough to deal with you," Mama said in a tone of voice that always terrified me.

The three of us walked back on the pathway in the dark. We went inside our place, waiting and dreading our sentence. Mama, Rolande, and Mirta must have managed to lift Yiyine. They carried her inside and took care of her in the dark.

We waited, it seemed, an eternity inside the dark room before Mama finally returned. The wait was tortuous. I didn't know how badly Yiyine was hurt or how much pain the fall inflicted on her. I knew that Yiyine, in her nineties, could hardly walk. *Falling as hard as she did on the hard surface of a rock must have killed her or will for sure*, I thought. I was afraid. Sitting in the dark room with my two brothers made worse the horrible guilty feeling that we might have

killed Yiyine. *It was my brothers' fault*, I thought. They and their friends hurt Yiyine. They bumped into her because they were too stupid to pay attention. I so wanted at that moment to tell the girls how I felt about these two delinquents. Instead, I sat just like them on a straw chair as a delinquent myself, waiting to be sentenced for something they'd done.

Everyone dreaded Mama's anger. When she became angry or frustrated, until she calmed down several hours or days later, she turned into an unpredictably irrational being. She'd spew forth the most vitriolic words that would cut open anyone on the receiving end. She did not use corporal punishment, as other parents at L'arsenal freely and regularly did. She often reminded us how lucky we were to have her as a mother because she could never hit anyone, much less a child. The Manuel children and grand-children, even Rolande and Mirta in their twenties, received regular whippings. Mama did not resort to corporeal punishment. But when she became angry, she'd forget we were children. She'd say angry words for hours and didn't care what impact they might have on whoever was listening.

She frightened us the most when, in extreme frustration, she would threaten to leave us at L'arsenal for good and return to her family. It took me years to realize that when she made this threat, it never even crossed her mind to carry it out. It was just a way to relieve her anger or to control our behavior. Unfortunately the unnecessary anxiety it created for us children seemed a hefty price for her temporary relief.

When Mama opened the east door with the tin lamp in her hand the night of Yiyine's accident, my heart leapt with terror. Mama's eyes swelled with fury. I knew my brothers and I were in for those turbulent, difficult times with Mama's temper. As soon as she opened the door, she told us how irresponsible, intrusive, and ungrateful we were. She talked as if she believed we hurt Yiyine on purpose to cause trouble. She threatened to leave us there alone to deal with the situation. Her tirade went on through the night, and none of us ever went to bed. At sunrise the next morning, Mama went over the Manuels to see how Yiyine fared overnight. She came back a short while later, angrier than ever, but less verbally aggressive.

Exhaustion had set in for all of us. We dozed off for a while. When we awoke around noon everyone, including Mama, felt better. She had returned to her normal self, capable of appropriately communicating with children under ten. She calmly informed us that we could no longer play hide-and-seek in the dark because it was too dangerous. She then required each of us to take turns to go over the Manuels' place and take care of Yiyine. She gave us the job of taking over the meals she'd prepare for the Manuel family until Yiyine recovered. Yiyine never walked again after this accident, and she passed away a few months later. We never again played hide-and-seek, not even during the day. Of course, all three of us as well as the other children who played with us that night wanted to do everything we could to help Yiyine recover. We felt awful about the role we played that night in causing her accident. We sure did not need Mama's terrible words and anger to teach us how we exercised poor judgment when running with such force in the dark. Like hundreds of other even more trivial happenings at L'arsenal, the anger Mama displayed that night inflicted deep wounds to our already traumatized young spirits. It complicated circumstances already troublesome for anyone, let alone children.

Flying Colors

A new chapter in our lives began shortly after Charles turned twenty-one and Guy eighteen. They both had completed the course of study offered at the local *lycée* and passed with flying colors both parts of the national *baccalauréat* exams. They had distinguished themselves as outstanding students, each gifted in different ways. Based solely on their academic accomplishments, family members and friends expected much for their future.

Guy had exhibited exceptional leadership and organizational abilities, particularly through Boy Scout activities and as a student leader. But Mama worried much about Guy because of his stubborn, naïve, and even reckless tendencies to confront whatever he perceived as injustice, regardless of the consequences. Charles exhibited strong intellectual prowess in the arts and literature. Throughout his childhood, in addition to all his daily responsibilities, Charles led the boys' choir during Sunday Mass. For years, he was acclaimed for his angelic solo rendition of a certain Latin hymn during a Sunday Mass.

Mama's face and smile radiated with pride in her grown boys. She engaged in heated philosophical debates about ethics and morality with them when they visited every night at suppertime. She came alive around them in a way that was not possible with anyone else at L'arsenal. With the passage of time, the early distance between her and the boys had narrowed considerably. Once the blush of cute babyhood had vanished and Mama had relinquished her desire to be her sons' primary caregiver, Elise's motherly interest in them waned to the same degree. Elise's relationship with the boys became very much that of a mistress of the house to

restavek with one major difference: The boys were the children of her sister. That meant, for the eyes of everyone else, Elise had to treat them as part of the Tanabet family. This unjust point-of-view worked to Charles' and Guy's advantage in one significant respect. It allowed them to receive the best formal education available in the town at that time.

Inside the Tanabet family, for all intents and purposes, Charles and Guy were *restaveks*. They were required to perform daily chores Elise assigned to them at both the Tanabet and Eve's and Clara's households. No one in the family expected Mama's nieces and nephews to perform chores other than their schoolwork. Charles and Guy, on the other hand, always at the beck and call of Elise, shouldered responsibilities for core household chores. This included mopping and waxing floors in both houses, washing and cleaning the water drain at least weekly, mopping cement walkways, cleaning wells, operating the wood oven Elise used to bake batches of cakes and cookies for her business, marketing and selling Elise's baked goods business. Along with Elise's two official *restaveks*, Hermando and Michel, Charles and Guy performed daily chores of fetching pails of drinking water for both houses. Despite all their responsibilities, the two boys managed to remain at the top of their class throughout most of their school careers.

As their lives in the Tanabet household grew more unjust compared to their cousins, Charles and Guy drew closer to Mama. They visited her almost daily at L'arsenal. They loved her cooking. She enjoyed feeding them fresh foods every day from the farmland. She laundered their clothes by hand and ironed them. She was proud of their handsome features.

Despite the late start, the bond between Mama and her two oldest sons strengthened every day. The love between them in their daily conversation after supper was palpable to everyone. She felt reinforced by them and gained strength through the hope that they would provide her with what she never had—a support system, emotionally then, and financially later when they finished their education. In that sense Mama unconsciously pressured them. She encouraged their expressed desire to help her improve the circumstances of her life. These boys perhaps did not realize at the time the mighty fight for their own lives that awaited them,

and could not appreciate the toll that lack of adequate emotional nurturing would ultimately exact on their lives.

Charles' and Guy's disposition toward Mama reflected her delight in them. They enjoyed her pride in them. It motivated them to commit to doing more to lift Mama to better living conditions, ones more consistent with her upbringing. One familiar line I heard Guy repeat at different times to Mama in the course of their interactions: *Maman, comptez fortement sur moi.* Translated literally Guy meant "count on me strongly." Mama did count on him.

Charles dreamed to finish his education, find work, and finance the best education for the three of us. Of the two, Charles seemed the most frustrated with the lack of nurturing throughout his childhood. He, nonetheless, exhibited most consistently throughout his life his love and dedication to every member of the Tanabet family. He saw and accepted the best qualities in each family member. While he remained devoted and loving to Mama, he showed equal devotion and love for Mama's siblings, particularly Stuart and Elise. His genuine love for every family member never allowed him to utter a word of criticism against any of them.

The next phase of their experience pointed to a move away from Cayes to further their education or travel abroad. One night after supper, after everyone had left, Mama, Guy, and Charles sat together in the back under the moonlight. It was the night before Charles' and Guy's departure to attend school in Port-au-Prince.

"Well, sons, this is it for awhile. You're leaving tomorrow," Mama said.

I could hear in the vibration of her voice how heartbroken, but mostly guilty, she felt. She wondered where the years had gone. It seemed like just yesterday she had given birth to each of them under difficult circumstances she was still trying to sort emotionally. While she remained preoccupied with her emotional difficulties, these babies had become men, right in front of her eyes. It all happened while she continued to nurse her wounds. She still felt stuck in the same place, struggling to find herself so she could grow from a little scared Tanabet girl running away from home into full womanhood with responsibility for her own life and that of her three younger children. She felt embarrassed in the eyes of her two older sons. She had failed them. As the only one who could have

made a difference for them, she abandoned them when they were most vulnerable. She sensed that her emotional and physical absence, whatever the excuse might have been, caused them irreparable harm. Now there was nothing more she could do, except watch, pray, and hope for the best.

"It's going to be hard," she said. "I so look forward to seeing you every day here at supper time, even if it's just for a short time," Mama told the boys sadly.

"It will be hard for us too," Guy commented.

"I so wished I could have made a home for you two and could have been there every day when you came home from school," Mama reminisced.

"Ma," Guy said, "you did the best you could. It was not so bad at Aunt Elise's."

"It could not have been easy growing up without a mother and father," Mama continued.

"Yes, it was hard. It is hard. But life goes on. Sitting here feeling bad about what could have been helps no one," Charles snapped sternly.

Mama mustered the strength to stand up from her chair. She reached for two packages she had placed on an empty chair nearby. She handed one each to Charles and Guy.

"I have packed up a few things in here for each of you," Mama told them.

She had written a letter to Raymond, Guy's godfather, and sent him a little money to cover some of Guy's food expenses. Raymond had promised Mama long ago that he would take Guy into his home, if Guy decided to pursue post-secondary education. Raymond could not offer Charles a place to stay, so Mama contacted a long time and asked her to give shelter to Charles. Mama gave Charles a letter with some money to cover some of his food expenses as well.

"Hopefully, I won't be at her house for too long," Charles commented in a frustrated tone of voice. "If all goes well, I'll be joining Aunt Bella in Florida in a few months," he continued.

"That would be nice," Mama cautioned, "but don't get your hopes too high yet. Visa applications for admission to the United Sates can take months, if not years, from what I've heard lately.

Enjoy your time in Port-au-Prince and see what else develops."

Mama then moved closer to both of them and hugged them tightly.

"Remember," she said, "why you're going away. It's to further your education. Don't let anyone or anything make you lose sight of what you need to do to reach your goals.

"Guy, please son, try to keep your thoughts to yourself, especially about people in the government," Mama continued, turning to Guy. "Don't let anyone talk you into organizing or planning anything for them just because you can do it. These are dangerous times we live in. You can't help anyone if you're dead. Keep your mouth shut, and use your energy to finish your education. And most importantly, stay alive."

"Bye, Ma," a teary-eyed Guy said as both he and Charles disappeared in the dark toward the small bridge. Mama stayed on the front porch for a few minutes after they left. A crow flew overhead and made a disturbing screeching sound.

"Heavenly Father, protect them as they embark on this dangerous journey," she mumbled as she put her hands together and bowed her head in prayer.

She then entered the home and closed the door. With Charles' and Guy's departure, a significant chapter in Mama's life had closed. The two boys had reached maturity sufficiently to move away on their own. They had become adults. However apprehensive Mama might have felt for their future, they had reached a significant milestone, and she acknowledged that. But she had to now turn her attention in earnest to raising the three of us. She knew she faced formidable obstacles along the road ahead to ensure us safe passage to adulthood.

Bittersweet News

Just about the time Charles and Guy left town, I turned six years old. Joseph had been attending kindergarten at the Christian Institute. I watched Mama every morning walk him to school in his uniform, carrying his school bag containing his books, notebook, and pencils. No other children in the L'arsenal area beyond the black river attended school every day like Joseph. But Mama made clear that the three of us were different. She set the uncompromising expectation that the three of us must attend and finish school as the single priority of our lives. Amazingly, while none of our playmates and neighborhood friends attended school or contemplated any plan for an education, the three of us could never conceive of accepting life without it. Mama set that tone and it became the blueprint for my life.

One July evening as I sat in the kitchen with Mama, helping with chores as she prepared supper, I began to feel excited at the prospect that I soon would be starting school. It was a rare moment for me, alone with Mama, having a heart-to-heart talk.

"You'll be going to kindergarten at *Sémiramis Télémaque* in October. You're six now," she said to me.

My heart leapt with excitement. But as Mama continued to lay out her plan to make school possible for Joseph and me, I quickly sobered once I realized that Mama's plan included sending me away for awhile. She began by talking about how it was important for me to learn early not to be too attached to anything, person, or place. I should be ready, she emphasized, to move with whatever flow life threw my way. If I could dance with life rhythm, detached from anyone or thing except the trust that I followed the best and

most logical path that opened in front of me, her words seemed to imply I would never feel stuck in any rut.

I must have internalized a vague intuitive concept of what she said, because, as it turned out, I somehow lived this perspective throughout my life. I realized now with the wisdom of hindsight that, despite the emotional cost, this perspective probably saved my life. But at the time of the conversation with Mama that summer evening when I was six, I could not make sense of what she was saying and planning.

She then explained that she needed to raise money over the summer months to pay tuition, buy uniforms, shoes, and school supplies for Joseph and me. She had to work very hard, she said, to raise this money. With teams of laborers, merchants, and passersby stopping at the house, a lot of people would be coming and going all the time. She could not watch and care for me, I recall her implying, and also handle all the business of running the farm and caring for Joseph and Bertrand.

"I'll need you to stay at Elise's for awhile," she finally said.

At first, I did not believe I heard her correctly. Mama had left me at Elise's before for months at a time when I was even younger. I always hated it there. Mama knew that. I sobbed every time on the way to Elise's. But as if my sobbing and her taking me there were one and the same thing, she would just take my hand and walk me inside Elise's house. She did not acknowledge or did not seem to notice my fear. Sometimes she even tricked me into staying there,—like the time after morning Mass when she took me for a visit. She said she was just stopping for a cup of coffee at Elise's to see how things were going with the family. Once there, Mama slipped out the back and left me with Elise without saying goodbye. It was one way to avoid seeing me sob.

That July evening as we talked about school and money and her work, I really did not want to go stay at Elise's. I wanted to stay with Mama and just like Joseph and Bertrand be part of all the work and excitement to raise money for school. I became particularly worried for some unexplained reason that Mama planned on leaving me at Elise's for good that time. I tried to talk her out of sending me.

"I can help around here," I said. "I can carry wood and do

errands. If the boys can stay, I can too."

Mama had planned on taking the boys to the harvesting fields and keeping them around to help with chores. Sending me off to Elise's gave her, she said, one less child to worry about. Even at six years old, I understood that she chose me to go because I was a girl. To my six-year-old mind, she liked the boys better and thought they blended in better with her rhythm. I felt badly that Mama thought that being a girl was a burden or something to be ashamed about. I became angry and wanted her to know that I knew she favored the boys over me.

"Why can't I go to the field with you, if the boys can?" I asked.

"The field back there is no place for a little girl," Mama replied.

"It's no place for little boys either," I retorted, fighting back tears. "I hate it at Elise's," I shouted angrily. They treat me like a *restavek*."

Mama looked up at me from the kitchen and paused. She moved from her low chair and took a few steps toward me. Standing in front of me, she reached for my chin and gently but deliberately shifted it upward.

"You are a *restavek* only if you consent," she said, looking directly into my eyes. "You help me with chores around here. Does that make you a *restavek*? You are God's beautiful and capable child. Act like it."

Despite my protest, Mama took me to Elise's house the next day.

Part II

"Bear You on the Breath of Dawn"
—Michael Joncas

Fish Stew

We entered through the front door the house where Mama grew up. To me it was Elise's house. It was the very next morning after I learned I'd be staying with Mama's relatives for what seemed to me an indefinite period of time. Mama grew up in that house, the same one her parents moved into after their marriage over half a century earlier. I walked across the cement front porch and stepped into the front room, following closely behind Mama and carrying my suitcase. We made our way through the spotless rooms with multi-colored shiny tile floors and neatly arranged antique furniture, passing through the living room, two bedrooms, the dining room/guest room, and the back porch.

Freshly painted white, the spotless walls looked barren, almost deathly, in the sparsely but otherwise elegantly furnished living room with furbished wooden chairs and coffee tables. One unusually large room, adjacent to the living room, was furnished with two single beds with iron headboards painted white. Each neatly made bed with a white cover was pushed against an opposite wall of the room, facing each other. A wooden *armoire* as tall as the ceiling leaned against the wall, between the two beds. Men's shoes polished to shine on a pad under each bed gave away that Mama's two older brothers shared that room.

The next room, a fourth of the size of the brothers' room, seemed more like a large passageway with a pink linen-covered bed pushed against the south wall. A pair of women's platform shoes with laces rested on a pad under the bed. A tall but smaller wooden

armoire brushed against a wall next to the doorway leading to the back room. I called the back room a dining room because it contained a table with chairs, a glass chest full of formal and casual dining-ware, cups and drinking glasses, and the family congregated around the table for meals three times a day. Strangely enough, Elise used the back room as a guest room. A queen size antique bed with a wooden headboard (the largest bed in the house) and covered in spotless white linen brushed against the south wall. I always slept in that bed on all the countless long and short occasions I stayed with Mama's relatives. As I passed the bed with Mama that day, I wondered how in the world I was going to keep that bed this neat every day for an extended time period. The stuffiness of the Tanabet's lifestyle sharply contrasted with our primitive and relaxed ways of living at L'arsenal.

As we made our way through all the rooms in the quiet house, it felt deserted and lifeless, as if no one lived there. Someone had to be home, I thought, because the front doors were open. My heart sank at the thought that Mama was going to leave me in that house. There was no escape for me. I had entered a jailhouse to serve a sentence that would probably include hard labor.

Mama and I eventually found Elise in the kitchen outside to the north of the house. Elise stood over a pot of broiling fish stew on a hot charcoal grill. I could hear through an open door the cuckoo clock against the wall in the brothers' room strike eleven in the morning. Lunch time in the Tanabet household would be timely served at eleven-thirty on the dot. Elise's fish stew simmered on schedule. A few steps to the right of Elise, a ten-year-old girl, Christiane, stood over a large basin of water washing dishes. Both Elise and Christiane looked up at Mama and me without saying a word. Mama moved close to Elise and gave her a kiss on the cheek.

I stood for a minute and looked at Christiane. She seemed older. I had not seen her since I visited briefly with Mama the Christmas before. The last time I lived at the Tanabet house for a few months, I was just four years old. Christiane was eight. We were playmates then. For a minute I felt hopeful that things won't be that bad with Christiane as a playmate. But something about Christiane had changed. The way she stared at me this time frightened me. My hope for a playmate quickly dashed when my eyes

met hers. Her eyes were unmistakably hostile, and I sheepishly rushed to hide behind Mama's skirt without taking my eyes off Christiane.

"Where are your manners? Won't you greet your aunt Elise?" Mama said to me.

I understood Mama's request. In the Tanabet family, greeting family members meant giving them a kiss on the cheek. Even then I could not quite understand why Mama would let members of her family greet her with a kiss on the cheek and make me do the same. A kiss on the cheek from Elise was, to me, sort of like Judas greeting Jesus. But I knew Mama always showed deference to her relatives, especially Elise as the eldest in the family, despite her differences with them. But Mama acted particularly deferent at the moment that she was about to drop one more of her offspring on Elise's lap to care for once again. Given my set of circumstances that day, I had no alternative but to follow Mama's cue. I approached Elise and gave her a kiss on the cheek.

"I expected you'd be coming to stay with us for awhile, Quiquine," Elise said to me. "I wondered how long it was going to take your mother to realize she can't raise you all in that god-forsaken L'arsenal she calls home."

When I heard Elise's words, I moved closer to Mama's skirt and stole a look at Elise's face. Strangely, Elise always expressed a kind of fondness for me compared to her feelings about Joseph and Bertrand. She unapologetically disliked them, not because these two boys did anything to her, but because, as part of the ongoing feud between Elise and Mama, Elise had vowed never again to care for another child Mama produced. Elise broke that vow when it came to me. Not sure why, except I suspect I was a little girl and Elise said she always wished she could have raised a little girl. So when she called me *Quiquine* (the closest she came to calling me honey-child), it was kind of loving, even though she laced the name with vitriolic insults for Mama. She could not help herself. Once she called me that nickname, all Mama's other relatives started to use it too, even though they all knew Mama did not. People often nicknamed girls with my first name with that silly word. I hated it when my mother's relatives adopted that name for me, as if they thought my given name was too dignified, and that a dumb word like that

seemed more fitting. The name sounded like a bad medicine.

I draped myself in my mother's skirt and covered my face. I hoped that she'd realize how scared I was to be left with Elise and Christiane. As long as she remained there with me, I held out hope that she'd change her mind and take me back home. It did not work. The Tanabet house became my home for now, and I had to figure out on my own how to make the best of it. Mama quickly explained to Elise that she brought me to stay for a short time while she attended to the many chores at L'arsenal.

"She's a strong and sturdy girl, she'll be very helpful to you," Mama added.

With those words, Mama transferred my custody to Elise. She gave me a kiss on the cheek and hurried out on the cement walkway on the north side of the house.

The long cement walkway separated through the middle the improved half of the property on which the house sat from a vacant strip Elise used as an herb and flower garden. Soon after Mama exited the side entrance, standing next to Elise in the entrance of the outdoor kitchen east of the garden I scoped the outside part of the property. Just beyond the kitchen, a small shed used as a makeshift shower room shared part of the kitchen's wall on the east side. Mama's father had built two smaller houses in the back directly behind the main house. My mother's aunt on her mother Julia's side, eighty-five-year-old Angeline, lived in the smaller house until her death. A female launderer named Melanie had rented the other smaller house and lived there for more than twenty years. A few yards to the right of that smaller house stood an outdoor brick oven that Elise used to bake large batches of cakes and cookies for her business. Across from the improved south side of the property east of the kitchen and shower, began another large garden used exclusively to grow a kind of plant with deep roots that Elise turned into a powdery substance similar to grits. Elise sold and used this powder to make gentle types of meals like hot cereal.

The outhouse was tucked out of the way beyond the second smaller house and blocked the view of the remainder east portion of the property. Another large empty lot used as a vegetable garden stretched to the east of the outhouse. This vegetable garden con-

nected as a backyard to yet a fourth house my mother's father had built and whose front and entrance abutted a different street from the main house. That house, they said, belonged to Nomis, Mama's oldest brother. Nomis had redeemed the mortgage on that part of the property a few years before. He now rented that fourth house to another family.

So there I stood, stuck with Elise and Christiane, and my mother was gone.

Chilly Stare

As soon as Mama left, I felt again the chill of Christiane's stare. Elise asked that I put my suitcase in her room, the little one with the pink linen-covered single bed. While I'd sleep on the bed in the dining room, Elise said I should keep my things in her room where I was to dress everyday. Christiane continued to stare at me as I turned to enter the house. Her hostility frightened me. Mama had abandoned me, I thought. I did not understand why she'd force me and not my brothers to stay at Elise's. It all seemed so unfair and cruel.

Living at Elise's in my mother's childhood home turned out just like I expected it. Elise tolerated me as my mother's child, a step above Christiane, her *restavek*. Christiane made it her business to make my life as miserable as she could. I could not escape her as the only other child with whom I interacted. A long-standing Tanabet family rule forbade any child in the household from ever playing or interacting with other children in the neighborhood. I was not allowed to visit with neighbors or their children and none of them were welcome on the Tanabet property. I spent my time counting the days until Mama would come back for me.

Christiane, the second generation of *restavek* at the Tanabet household, had lived there since she was five. Her father, Hermando, and his brother, Michel, lived with Elise as her *restaveks* for many years. Elise raised Hermando and Michel, along with Charles and Guy, until they each turned eighteen. Elise claimed all four boys as her own and referred to them as "my boys." When Hermando and Michel turned eighteen, Elise returned them to their parents' village in a rural area outside of Cayes.

Hermando became a father shortly after he left Elise's house, when Christiane's mother gave birth to Christiane. When Christiane turned five, Hermando and Christiane's mother brought her to Elise under the same arrangement Hermando had spent his childhood years in the Tanabet household. Elise would give Christiane shelter, food, and clothing in exchange for Christiane's services around the Tanabet household. Elise assigned specific daily chores and errands and directed her to perform other tasks as Elise saw fit. Christiane's parents did not discuss when or how Christiane would return home, nor did they require Elise to provide Christiane with any form of education. But it was understood that Christiane would stay in the Tanabet household as a *restavek* throughout her childhood until she turned eighteen. Of course, if for any reason at any time Elise did not want to keep Christiane, she could simply return her to her parents. Elise did not even have to (and never did) travel to Christiane's village to personally return Christiane to her parents. Elise could simply send word to the parents to come back for their child.

Christiane, a precocious ten-year-old, exhibited a rebellious streak. As the only child in the house when I did not live there, she acted territorial. She understood well the family politics, and used them to her advantage. She resented that the family treated me as a blood relative within social beliefs, a step above her. She evened the score by mimicking the pathetic belief family members perpetuated that my mother and her offspring were outcasts. She had overheard many conversations critical of Mama. Keenly aware of my position in the family, she took every opportunity to let me know all the negatives she had overheard about us. Christiane's perception of me as the child of the bad apple in the family remained a constant undercurrent throughout our childhood interactions.

She took every chance to leave the house and roam free in town. She ran errands in the afternoons for Elise to and from the house of two other Tanabet sisters, Eve and Clara on *Grande Rue*. Selling Elise's baked goods door-to-door, a core element of Christiane's responsibilities, took her out of the house for several hours most days. She looked forward to the afternoons away. When Christiane had too many bundles to manage without help,

Elise would ask me to shadow her and help. Christiane did not like my company. She liked to stray to other parts of town where Elise strictly forbade us from venturing, and threatened me with physical harm if I told. Yet she never really trusted that I wouldn't tell Elise some day. My presence cramped her style and interfered with her plans. So she hurried through the stops with me and returned me to the house as quickly as possible. She'd then find a reason to leave again and return hours later, sometimes well after dark.

Despite the strain in our relationship, Christiane's presence in the Tanabet house softened the often harsh interaction with my aunt and uncles. Her rebellious propensity intrigued me, and I loved her I-can-take-care-of-myself attitude. In some way I looked up to her because she was older. Nonetheless, I also deeply resented her exploitation of the family division. But on occasion, even Christiane acknowledged the strange behavior of the adults in the house.

A Strange Bunch

Nomis and Stuart, along with their sister Elise, lived in the house all their lives from the time they first saw daylight. Mama's parents produced a total of ten children—Elise, Nomis, Bella, Eve, Stuart, Clara, Prosper, Marie (Mama), Emanuella, and Leonard. Prosper and Emanuella died early. Four of the siblings, including Mama, left town to find work or moved away to start their own families. Clara moved in with Eve, her favorite sister, and her husband after their wedding. Eve's husband died early. Clara became chief breadwinner and head of Eve's household, much like Elise at the Tanabet parental home. Clara spent her entire adult life until her death in her eighties working and providing for Eve's family.

Elise, the first born, by default ran the Tanabet household from the time she was old enough in her early teens. Their mother Julia, a traveling merchant, was almost never home. Elise shouldered early the responsibility to care for her younger siblings and her father. She cared for her elderly parents until they both died. Nomis and Stuart never left the parental home, and Elise remained in the house and continued to care for them.

Elise was a complicated woman. Her attractive, round-shaped face with high cheek bones displayed two prominent bunches of dark freckles on each cheek. A mild-mannered, petite, gray-haired sixty year old, Elise wore the same uniform everyday. She aspired to sainthood somehow, and tried to portray her concept of purity and sacrifice in her manner of dressing. She was always groomed in a puritanical black or gray below-the-knee skirt, a gray or white long-sleeved shirt and black laced shoes with platform heels. She dressed this way first thing in the morning and remained dressed

until her bedtime. She almost never left the house, except for her religious attendance to daily early morning Mass, followed by a quick coffee visit to her sisters Eve and Clara on *Grande Rue*. She always put on a black hat every time she left the house, as if to hide her neatly pinned and pulled back graying hair.

Elise never married and did not give birth to children. She said that she had always wanted to marry and raise lots of children. As fate would have it, Elise could not follow her dream of marrying. When she turned eighteen, she became engaged to a man named Edouard. But soon after their engagement, Edouard left town for a couple of years to work in a neighboring country. Before he left, Elise and Edouard had set a date for their wedding exactly two years from the day of his departure. He told Elise he needed to make money to buy a house for their planned family.

Elise did not like the idea of Edouard's move, but did not think about it too much. Not much was changing for her anyway, still comfortably sheltered in her beloved family home. She liked the steady, predictable way of living in the same house she was born in. It was her territory. She had learned how to defend her rights to be there and fight off everyone and anyone who dared to challenge her. She enjoyed her privilege as the first born of her parents' family of ten children. She relished the authority and power she wielded over her siblings and their offspring.

Two years came and went. Edouard never returned. Elise waited dutifully. Through word-of-mouth from other workers who had gone away with Edouard, she eventually learned that he was killed in some tragic accident shortly after his arrival. Elise resigned herself to God's will as she understood it. She took it all as a sign from God, and decided never to seek marriage to anyone else. She moved on with life in her parental home as it had always been.

In spite of her misfortune, Elise realized two of her dreams. First, she continued to run the Tanabet household, the official replacement of her mother Julia who gradually lost her eyesight, and eventually died at the age of eighty-two. Second, Elise's position in the family allowed her to raise, at different times and under varying circumstances, every one of her sixteen nieces and nephews over a span of two decades. It was unclear, however, as to which of the two unmarried brothers, Nomis or Stuart, became the male head of

the household. It seemed that Elise controlled that too. Depending on the outcome she wanted on a particular decision, Elise would consult one or the other and that way chose for each situation which brother she wanted to play head of household. Otherwise, she was devoted to both brothers equally as their older sister.

An angry, frustrated, irascible little man, Stuart, the youngest of the three, never married and never fathered children. He never even had a girlfriend or any close companion that any member of the family knew about. Invisible even when he was in the house, Stuart spent all his time in the living room. He claimed that room as his exclusive territory during the day, off limits to me in particular. He lay on a *chaise longue* by the double doors that opened along the long side walkway of the house, always reading magazines or large volumes of books, while chain-smoking cigarettes. He moved from his *chaise longue* only when Elise would ask Christiane or me to tell him it was mealtime. A few times a day, he'd walk to the yard to the outhouse. Other than for these two purposes, a non-communicative Stuart never left his *chaise longue* while in the house.

People in town respected Stuart's image as an intellectual. He taught at the local *lycée* and a few other private secondary schools, and served for many years as administrator and sole professor of the only law school in town at the time. His unpredictable disposition and angry outbursts in the classroom earned him the reputation among his students of an angry and mean-spirited man. Nonetheless, everyone in town deferentially referred to him as *maitre* which, translated literally, meant master. The word *maitre* as used had the double meaning in town of revered professor and respected barrister.

Townspeople and family members whispered that Stuart was as rich as crazes. I heard anecdotes that he went on two extended vacations to Europe at his own expense before I was born. While that may sound normal to the life standards in more economically advanced parts of the world, in that little southern town of an impoverished nation, only the very wealthy few could afford such luxuries. Stuart's largess and generosity with "friends" were also legendary. Elise gossiped that he had financed trips abroad and school tuition for children of two very wealthy families in town he called his "friends."

It was not surprising that Stuart would have some money stashed away. He lived all his life in his parental home and never had to pay any living expenses. Elise, with the meager income earned from her home-based business, like her mother had, covered food expenses, and never made any demands for contribution from either of one of her lifelong housemates. On rare occasions when her pastry business underwent dry spells and she temporarily became short of grocery cash, she'd apologetically request a modest contribution from each of her brothers. They usually responded just as modestly, contributing just enough to get Elise through a few days before the next batch of pastry sale brought in plenty of cash for Elise to cover grocery expenses. Other than these few occasions, Stuart did not even have to pay for his meals. The parental home he lived in was paid for long ago with money Mama and her sister Clara contributed to pay off the mortgage owed.

He owned two fancy suits. Elise bragged that he purchased them in Paris during his last vacation in that city. He rarely wore these suits. Elise said he'd never need to buy another suit again in his lifetime. He planned, she said, on being buried in one. As far as I know, Elise was right.

I learned early never to disturb Stuart and never to speak to him, except on the rare occasions he would ask me a question, such as "Where is Elise?" On the few occasions when I played outside his door on the side walkway and made the slightest noise, Stuart would angrily jump off his *chaise longue* and yell at me in an angry tone of voice. "You naughty little rascal, get away from here now!" I was terrified of his temper.

Stuart did not like it when Mama left me at his house. He tolerated it only because Elise made it clear that she wanted me there. He did not like me and did not want to hear from me. He never addressed nor talked to me in a friendly way. If I touched anything in his room or near his workplace or if I laughed too loud, he quickly put me in my place by pointing out how inappropriately I was behaving and by demanding that I get out of his sight. By contrast, when the cousins (sons and daughters of his siblings other than Mama) came to visit, Stuart turned into a different person. He became jovial and horsed around with the boys in particular. He called them fondly with special nicknames he made up for

them, such as "old buddy." He teased the girls affectionately and pointed out how intelligent they were. These cousins experienced a different Stuart because he chose to display a different aspect of himself to them. Even at six years old, I knew I was being treated differently; but I could not fully understand why.

Nomis, the second born and first male child of the Tanabet family, never married either. But he was a well-known womanizer and fathered at least one child the family knew about. Neither the family nor the church nor anyone else in town saw anything wrong with a man womanizing and fathering children outside of "blessed" matrimony. Had Nomis been a woman like Mama, the rules would certainly have been different. A quiet, mild-mannered man, he appeared friendly on the surface. He at least exercised more restraint than Stuart in his treatment of nieces and nephews. But despite his friendly appearance, I knew early that Nomis was not fond of me and Mama. He especially did not appreciate my presence. Every time I passed by his workplace, he would mumble under his breath words that I much later made out to mean "shameless little witch."

Just like Elise perpetuated her mother's role, Nomis followed in his father's footsteps. Elise ruled the household and cared for the family through a home-based bakery business her mother started many years before. Nomis carried on his father's trade as a saddle, bridle, and leather goods maker. He spent hours in the front room on his work table, the same table his father used years before. Like his father, Nomis also worked as a land speculator and traveled regularly to rural areas to buy and sell land. He managed, as did his father, the other half of L'arsenal south of Mama's property on the other side of the river. Townspeople and family members also believed that Nomis was a wealthy man with no living expenses.

Nomis did not terrify me to the same degree Stuart did. But he made me feel uncomfortable and unwelcome. I'd hide for hours in the back of the house behind the kitchen waiting for him to leave the house for work so I could go to the front and play. He too tolerated me there because of Elise. Spending time with any of these three relatives when Mama left me with them challenged me to walk a tight rope of tolerance and restraint, impossible and unsafe for any six-year-old.

SONG OF PRAISE

The tortured conversations around the table at the Tanabet family meal gatherings isolated me even more. Mid-day meals brought together every member of the household. Elise, Christiane, and I spent all our mornings in the kitchen, planning and preparing meals, culminating to the high point of the day at eleven-thirty on the dot when Stuart and Nomis showed up to eat.

Elise usually planned the menu the day before and seemed particularly concerned with Stuart's diet. She planned every meal around his dietary needs. A demanding and picky eater, Stuart ate only bland foods with little or no salt or fat. Keeping Stuart on his bland food diet consumed much of Elise's time, focus, and energy. Stuart's dietary restrictions affected every member of the household. Everyone ate only what Elise decided Stuart could have. Particularly fond of steamed rice, broiled fish, and plantains, he only liked this meal the way Elise prepared it. Both he and Elise believed that he suffered from some kind of an incurable ailment they could control with a low fat, sugar- and salt-free diet. Interestingly enough, Stuart never suffered from as much as a cold or received a diagnosis of any ailment. He enjoyed himself chain-smoking all day, everyday and got away with it. He lived well into his nineties.

One day as Elise, Christiane, and I rushed in the kitchen to meet the eleven-thirty appointed mealtime for Stuart and Nomis, two of my cousins, Oscar and Ellen, unexpectedly dropped in to visit. They entered through the cement walkway and stood at the entrance of the kitchen until Elise became aware of their presence. They flanked Elise on each side to greet her with a kiss on the cheek.

"My goodness, what a blessed day today is to see you both," Elise said.

Oscar replied that they had been visiting with family on their mother's side the last few days. They missed Elise, Stuart, and Nomis and stole a few minutes to visit with them. Elise could hardly stand it and beamed with joy when she saw two of Leonard's children. As Oscar and Ellen conversed with Elise, I moved closer to them and stood at the entrance of the kitchen. Christiane, trying hard to attract attention, kept on moving back and forth between Oscar and Elise, fetching a plate, spoon or whatever else lay on the table in front of Elise. Christiane and I might as well not have been there. Oscar and Ellen acted oblivious to our presence even though Christiane and I stood in very close proximity to them. Annoyed at the intrusion on her conversation with her niece and nephew, Elise turned to me and motioned dismissively.

"Why don't you go back to the table and set two more places?" she said.

I obeyed and felt somewhat relieved to find an out from the awkward moment. Elise invited Oscar and Ellen to stay for midday meal. As Nomis and Stuart entered the dining room at eleven-thirty, Elise escorted Oscar and Ellen to the table. Visibly delighted to see their niece and nephew, Nomis and Stuart took their usual seats at the table. Elise invited Oscar and Ellen to sit across from Stuart and Nomis. I took the last available seat at the edge of the table.

Elise served each individual plate in the kitchen, and gave each to Christiane to carry to the dining room until she had served everyone at the table. Elise then arranged a plate for Christiane who took a seat on a bench in a corner of the kitchen to eat. With the few scraps of food left after serving everyone else, Elise arranged a small meal for herself on a saucer. She walked into the dining room. Everyone around the table had been waiting for her return from the kitchen before starting to eat. She stood against the window to eat, even though there would have been enough room to squeeze an extra chair around the table, had she elected to sit.

While eating, Stuart kept a lit cigarette on a small tray next to his plate. After just a few bites, he would pause and take a puff.

"You're entering secondary school at such an early age. You're

brilliant, kid...just brilliant...a true Tanabet," Stuart said turning to Oscar with an unusually happy and satisfied smile.

Elise chimed in, shamelessly playing favorite. She commented that Oscar ranked once again at the top of his class. Nomis joined the song of praise and remarked that Oscar was headed straight for medical school.

"The Tanabet family badly needs a doctor," Elise said.

Stuart noted that Oscar was the family's best hope for a doctor. Elise approached the table and stood close to Ellen.

"And you, Ellen my dear, you're following in your big brother's footsteps at the top of your class too," Elise said.

Stuart turned to Ellen at that moment. For the first time I noticed a gentleness in Stuart's face that I had never seen before. He reached across the table and touched Ellen's hand. He lowered his glasses.

"Your grandfather, Joseph, would have been so proud, Ellen. I wish he was still here to see his dream for the family come true in Leonard's kids," Stuart said in a gentle voice with a half smile.

Ellen lowered her eyes, a little embarrassed at the attention. Oscar straightened himself in his chair with the self-confident air of a brash, privileged teenage boy. I could slice with a knife the sense of superiority and 'look at me now' in the air around the table.

I sat through this entire conversation, starring at my plate while trying to eat. It seemed that everyone deliberately ignored me. The compliments directed at Oscar and Ellen seemed delivered as if to make me feel as though I wasn't measuring up to a certain family standard. I was only six. I was not sure what exactly they expected of me, whether I should find something to say just to join in the conversation or just to leave the table altogether or just sit there without saying a word. I opted for the latter. I did not dare look up and make eye contact with Nomis or Stuart and become humiliated further if they chose to ignore me.

"Why don't you clear the table and wash the dishes? Christiane is outside in the kitchen, she'll help you," Elise said to me curtly after everyone finished eating.

I obeyed Elise's command without saying a word. I was relieved to escape from the table.

HOLY FAMILY

Restavek children in the Tanabet house attended Holy Family church school. It was now Christiane's turn to follow the tradition. Holy Family Church, a Catholic Church by the seashore several blocks southeast of the Tanabet home, sponsored a neighborhood school. The school taught basic reading and math skills. A half-day non-degree neighborhood program not regarded as a serious academic commitment, the school offered a convenient means for families who cared enough to allow time to their *restaveks* to learn basic skills.

"Girls, we need to hurry and finish everything by ten-thirty this morning. We have an errand to run so we can be back in time for Nomis and Stuart at eleven-thirty," I heard Elise say to Christiane and I as we attended to the chores of preparing the Tanabet midday meal one morning.

A solemn Christiane suddenly perked up when she heard Elise's comment.

"Where are we going?" she asked.

"I need to enroll you two at the Holy Family School for next October. We have to get that done today," Elise replied.

I could not believe what I heard. Of course I could not possibly understand then the implication of her suggestion for my life, but I immediately felt sorely disappointed. Mama had talked about her plan for me to attend to another elementary school, *Sémiramis Télémaque*. I had been thinking about going to that school since my last conversation with Mama the day before she brought me to stay at the Tanabet house, and held out hope that she would come back for me, like she said, before the school year started. I looked for-

ward to my first day of school so I could wear my new school uniform just like other girls in town. *Mama, as excited as she seemed about my attending Sémiramis, would not leave me with Elise when school started*, I thought to myself. I felt barely tolerated at Elise. I longed to go home, and counted the days for Mama's work to finish and for her to come for me. I told Elise that she did not need to enroll me at the Holy Family School. I tried to explain that Mama had already made other plans.

"I am sure she has plans, like she always did for Charles and Guy," Elise replied. "Listen, you're my responsibility now. I am doing what's right and best for you."

I bit my tongue and complied with Elise's wishes. I did not know then that a way to my home, my school, and my right place would open in front of me, in spite of Elise.

Upside-down Chicken

Returning home to L'arsenal came sooner than I expected. A couple of weeks after Elise registered me at the Holy Family School, as I helped clean the water well in the yard behind the kitchen, I heard Mama's footsteps coming toward the kitchen on the cement walkway. I turned and ran in her direction. She walked toward me, gripping two bags full of vegetables, rice, and fresh eggs with one hand while carefully securing upside down in her other hand the tied legs of a live chicken. She quickly bent to my level when I reached her. I greeted her with a kiss on the cheek.

"I thought you'd never come back for me," I said excitedly.

"I told you I would," she replied lovingly.

Mama entered Elise's kitchen, gave her a kiss on the cheek, and delivered to her the two bags. She then moved toward Christiane and gave her the live chicken to handle.

"Marie, thank you, dear. But you shouldn't have. I know you have your hands full over there with the other two children," Elise said.

"Oh, I'm managing with God's help," Mama replied.

Then Mama turned to Christiane apologetically for being distracted and not greeting her immediately.

"Hello, Christiane. Look how you've grown. How are you?"

"Fine," Christiane replied curtly.

"Don't be such a stranger!" Mama continued. "Come to L'arsenal and visit sometime. The mango trees are full these days and there's always sugarcane. I know you love sugarcane."

Mama then abruptly turned to Elise and explained that she

could not stay long. She had come to collect me to take me to *Sémiramis* to register for kindergarten. I had turned six, she said, and had to begin school at the start of the next month in a few days. Elise told Mama that she did not need to worry about registering me for school because she had already enrolled me at the Holy Family School. She thought that she would take care of this detail for Mama to make things easier in these busy times. Mama jerked quickly closer to Elise. Visibly taken aback, she tried to maintain her composure.

"Where did you say you registered her?" Mama asked Elise in a trembling voice.

"Holy Family. You know,—the church school. Christiane will be going," Elise informed Mama.

"I know all about Holy Family. That school has been there since were we growing up, Elise," Mama remarked.

"Michel and Hermando graduated from there," Elise said.

Mama grew increasingly offended, annoyed, and angry.

"You don't have to tell me," Mama said. "I know. They both went all the way up to the third grade, and could barely write their names on graduation day."

Mama grew sarcastic in her comments. She told Elise that Elise perpetuated the destructive current in a culture that cares nothing about children and the future. She accused Elise of not valuing Michel and Hermando enough to send them to a respectable school. Mama questioned the *restavek* practice as an evil institution that dehumanized the weakest and most vulnerable members of the culture.

Elise became just as angry at Mama's tone, but she characteristically controlled her remarks better than Mama did. She tried to be gentle with Mama as the older, more reasonable sister. She asked Mama to be realistic about what she could accomplish with Joseph, Bertrand, and I at this stage of her life. She told Mama that her desire for the kind of education she sought for the three of us was not possible. She added that she knew that Mama could not deliver on these high aspirations given her current situation.

"You made a choice, Marie, when you decided to have these children," Elise kept on repeating to Mama. "Nomis, Stuart, and I are not going to help the way we did with the first two."

"Go get your bag and things," Mama turned to me and snapped. "We're leaving. We have an appointment with the principal of your new school. We can't keep her waiting."

Elise continued to talk to Mama as an older sister trying to bring a stubborn little girl to her senses.

"I only have your best interest," Elise stressed. "I raised your first two sons, didn't I?"

When Mama heard these words, she became even more agitated. She lashed out in a loud voice at Elise.

"I'll never stop saying thank you to you, even though these boys paid you with the sweat of their brows for every meal you ever gave them. Let's face it, Elise, let's stop the pretending. Charles, Guy, Hermando, and Michel, all four of them were your *restaveks*, your and the family's unpaid servants. You did not raise them. You took advantage of their circumstances to run your business, your errands, and clean your house and Eve's and Clara's too. They weren't your nephews. They were your servants and you know it. Then by the time they reached eighteen, they were on their own, fending for themselves. You all could not even see them through adulthood safely. No Elise, not this time! I am in charge of the education of these three. I will fight you and everything else in the way to get them a full and complete education. You just watch me."

Elise was astonished and shocked at Mama's diatribe.

"Well, what a fine way to say thank you! After all we've done for you!" Elise said calmly.

Mama then turned to Christiane and complimented her as a very bright young girl who still could learn. She invited Christiane to seek permission from Elise so she could register at *Sémiramis* with me too. Christiane looked at Mama blankly.

"My mother and father left me with Miss Elise. I have to do what she says. That's what my mother told me," Christiane said precociously.

I stepped down from the back porch in front of the kitchen, carrying my little suitcase. Mama grabbed my hand.

"Let's go," she said. "We're late. Goodbye Elise. Goodbye, Christiane."

I left the Tanabet house one more time and I did not look

back. As it turned out, Mama's rude push to enroll me at *Sémiramis Télémaque* for elementary school proved to be an inspiration that set my education on the right foundation for later success and fulfillment.

THE MERCILESS CURVE

As much as I hated Mama's daily tutorial sessions after school, they helped me avoid the terrible teacher whippings for spelling and math facts errors. Mama followed my school textbooks and taught me first about a topic before the teacher covered it in the classroom. Joseph, Bertrand, and I sat at a small table with a pencil and notebook in front of each of us most days after school, and during the summer months when we were in elementary school. A small blackboard rested on the table, leaning against the wall.

"When you're in school, it should all be review for you, if we work hard here," she'd say to Joseph and me.

She worked extra hard with us to prepare for tests. I did not particularly enjoy the added schoolwork she made us do. But every time I scored well on a test and avoided the teacher's whipping with a wooden stick, I appreciated Mama's painstaking tutorial sessions to keep us ahead of the merciless curve.

The set-up in elementary school reflected the social setting in the Cayes community at that time. Every pupil wore a school uniform of a navy blue skirt, white shirt with sailor collar, and navy blue bowtie in the front around the collar. Mama washed and pressed my only white uniform shirt everyday. She styled my hair every morning, separating it in three neat braids with a white or navy blue bow in the middle. I always felt dressed up in my uniform on school days. Mama made such a fuss over every detail of my school attire that you'd think I was dressing to attend my own wedding every day.

"School is important business," she'd say. "You must look your best."

The school building itself surrounded the playground in a square. Filled with sand leveled by years of footsteps and bordered by open classrooms, the playground looked barren with no trees, vegetation, or equipment. Affixed on the back wall of the principal's office on the north side of the playground, one water fountain served the entire school. But water almost never flowed from the always out-of-order faucet. When absolutely necessary, students and teachers used the outhouse, located to the east of the playground, a few feet away from the water fountain. Otherwise, everyone congregated as far as possible to the western edge of the playground to avoid the nasty stench coming from the outhouse on the east side.

At eight in the morning every school day, the principal walked out of her office, holding and shaking a large bell, signaling the start of the school day. Each girl quickly found a place in a file of students in front of her classroom. With low walls, open windows, and no doors, the classrooms resembled large boxes with no upper sides. I quickly took my seat in the first row. My close friend, Renée, sat directly behind me. The classroom experience in elementary school terrified me most of the time.

"There is a spelling test today," Renée whispered to me. "Did you study for it?"

"Yep. Too scared not to," I replied.

"We also have a math test later this afternoon," Renée reminded me in a low voice.

"All we do is take tests," I whispered back.

The teacher walked up and down the isles in the classroom as she began to administer a spelling test. Once she completed her dictation of the words, she sternly and authoritatively announced that she would grade these tests right then and pass them back to us. Then she added that she would handle those students who did not study for the test.

"Did you hear it?" Renée whispered to me. "Handle the students who did not study. You know what she means, don't you?"

"Oh, yes," I replied under my breath. "One blistering blow with the wooden stick for each word misspelled."

"You don't have to worry," she added. "You never miss a word."

"Oh yes, I have," I said. "You forgot last year, I got a bad whip-

ping. My hands still hurt. That's why I study so hard now...I am so terrified. I don't want to ever miss a word again."

The teacher walked past my desk as she handed me back my sheet, marked one hundred percent in red. She handed Renée her sheet with a marking of minus two.

"Now, you know the drill," the teacher announced. "Those of you with more than three misspelled words, line up by the blackboard."

"Whew! I dodged this one," Renée said to me under her breath.

"We both did!" I replied.

The teacher opened her desk drawer and took a thick wooden stick as a line of about ten students filed in front of the blackboard.

"One blow with this stick in your palm for each word missed," she told the first student.

With a stern look on her face, the teacher sat at her desk, waiting for each student to walk up the desk so she can administer the punishment. I lowered my head on the desk and put my hands over my ears as the teacher lifted the stick and delivered the blows in the palm of each girl. The first half of the morning session ended on this somber note.

At recess time, the school principal walked out of her office with the ringing bell. Our class exited the classroom in a file for recess. Outside on the playground near the entrance of each classroom, we ran into a file of young girls, dressed in old worn clothes and some with their heads wrapped in handkerchiefs. They were holding covered baskets of snacks, waiting. Each of these young girls, a *restavek*, stayed with a family of the more affluent students in the classroom. The girls waiting came to serve these students their mid-morning snacks. Their mannerisms and clothing were in contrast with the students at the school, and told the story of their subordinate situation in that community.

Students from the classroom quickly found the *restaveks* waiting for them, and ate their snacks. A few other students with pocket change on occasion ran to the candy merchant at the front entrance of the school to buy a piece of candy. Renée and I and some other girls, with neither pocket change for candy nor servants to bring us snacks, made a run for the principal's office. We asked

for permission to go across the street to one of Mama's friends for a glass of water. We'd return in a flash before the end of recess. I spent a total of eight years at *Sémiramis* from *Enfantin I* (kindergarten/first grade) to *Moyen II*, the final grade in elementary and middle school and the equivalent of eighth grade. My school days during the eight years followed more or less the same daily routine.

What's in a Name?

My relationship with Miguel never developed beyond knowing each other existed. I did not relate to my father as a parental figure. He nonetheless participated in our lives. We called him by his first name, the same way everyone else did. He seemed very comfortable with that and never insisted on any other way. He behaved much like a visitor or one of Mama's business associates. I cannot remember ever having a conversation with Miguel, but I admired his calm demeanor and his gentle ways in contrast to Mama's confrontational and cuttingly critical approach to everything.

I could, however, neither trust nor rely on Miguel for anything. His gentle ways and mild manner could not feed, nor clothe, nor educate us. I felt resentful of his detachment, which was obvious to me from the time I was very young. His failure to meet his parental obligations toward us at the most basic level in the traditional sense, and to alleviate the pressure on Mama, contributed to her instability and occasional volatile conduct. Mama shouldered all the responsibility, both hers and his, and he eagerly let her do it.

One day my mother told us a story that helped explain Miguel's behavior and softened my resentment. In time I learned to love him, appreciate, and celebrate his accomplishments in the face of extraordinary circumstances. Mama recounted the most bizarre story about how Miguel and the three of us came to carry our surname. Prior to meeting Mama, Miguel shared his mother's maiden name of Nalro. Mama had learned from Miguel the identity of his father. Surprised that Miguel's father was a well-known family man, equal in community stature to her own father, Mama decided to let Miguel's father know about her marriage to Miguel

and our births. After the four o'clock in the morning wedding ceremony that Mama masterminded to cover up her shameful decision to marry a man she didn't love, she wrote a letter to Miguel's father, Redanx, and specifically asked that we, Miguel's offspring, take Miguel's father surname. To Mama's great surprise, Miguel's father replied to her letter. He not only agreed that we, the children, will bear his surname, he initiated the process so Miguel could also bear his father's surname. Redanx did not acknowledge in this fashion any of Miguel's three younger siblings. Their surname and that of their offspring remained Nalro for the rest of their lives. Mama believed that her own family community stature played heavily in strong-arming Redanx.

Many years later when I recalled this story, I contemplated changing my surname to something entirely different with the thought that I would distance myself from this bizarre tale. I later decided against it. My motives felt like anger, resentment, or even shame. Considering how most people of African heritage in the Americas have acquired their surname and managed to forgive and move onward, I chose instead to pursue the same path of acceptance and reconciliation, and leave behind the distorted thinking that threatened to suck me into the absurdity of this farce. As time passed and my sense of self strengthened and deepened, I came to realize that my human history, including my name, does not define my identity. I did not change my surname even when the opportunity came through marriage. I proudly bear it, however it came to me, honoring in some way both parents. This story helped me appreciate better the larger life lesson Miguel's experience was meant to teach me, and allowed me to put into context the role he played in my life. Despite his peculiar ways, Miguel made a profound impact on me and taught me life lessons about love and work ethic.

His involvement with my two brothers and me was either adventurous or playful, not unlike visits from playmates in the neighborhood. He'd help us break Mama's rules. For example on occasions he'd buy us a cooked meal. Such a great gesture of generosity would happen after he arrived at L'arsenal very late at night and discovered that we had not had anything to eat all day, because Mama either had no food to cook or no money to buy

food. He'd then leave and return in a flash with a cooked meal for everyone to share well after our bedtime. This behavior infuriated Mama. To her, he was irresponsible, selfish, disruptive, and above all undermining of her authority over us. She did not appreciate it and let him know in no uncertain terms as soon as the occasion presented itself. But as children we loved the adventure. Eating a delicious meal practically in the middle of the night was great fun, considering how hungry we were.

Taciturn and reserved, Miguel never had much to say unless the line of conversation concerned lottery numbers. One evening after supper shortly after I started going to school, Miguel joined in a conversation with a few passersby who had stopped for supper. Miguel's basic understanding of his world was somewhat mystical. He seemed to believe that everyone carried a little bit of advance knowledge about what will be, specifically when it came to winning lottery numbers. Even if he had little else to say to anyone, he was always asking just about anybody what they were sensing upcoming winning lottery numbers would be.

"What number do you think will be the winner at the lottery this coming Sunday?" Miguel asked the gathering that night.

"I'd bet on thirty. It's due now," one man replied.

"If it's thirty, you have to go zero-three, the reverse," Miguel volunteered. "But I'm going fifty and zero-five this time. That's always my lucky number."

"Fifty just came out not too long ago," the man continued. "I would not bet on it."

Mama had been busy serving everyone supper. As this conversation progressed, she became annoyed at the direction of the exchange in our ears.

"Hurry, children," Mama said. "Let's clear up this mess right now."

"What's the hurry? It's still daylight," I replied.

"School tomorrow! You have to get ready," Mama said.

The five adult guests took the hint and stood up from their seats. They thanked Mama, took their hats off, and said goodbye. Miguel remained seated, fidgeting his crossed leg nervously on a chair on the porch, seemingly oblivious that everyone else had left and still thinking, it seemed, about numbers. His *laissez faire* men-

tality sharply contrasted with Mama's take-charge and purposeful way of life. Miguel remained quite visibly on the side line, as he watched Mama take on the enormous responsibility of raising the three of us under the dire circumstances of life at L'arsenal. But it was ultimately Mama's example that provided us the necessary tools to break free from the limitations of our birth circumstances.

The Sixty-Year-Old Bride

Mama's convictions underlay her thinking, her actions, and interactions. She believed that every experience and every situation fulfilled God's purpose in some form. She understood her mission to serve as God's instrument in the fulfillment of His purpose. But she viewed God's purpose in a limited way as furthering the church's teachings and assuaging suffering to the extent possible. She referred to this work as her ministry, and believed deeply that she was placed at L'arsenal to fulfill this mission. She felt privileged that her faith in God and the church had been nurtured sufficiently to provide her an anchor in times of crises, and felt compelled to share with others what she had been given.

Her stay at L'arsenal, in the context of the totality of her particular human history, to her, was no accident. By her way of thinking, God brought her to safety at L'arsenal and gave her what she most wanted, a family. In return, she felt obligated to serve the people in the region the best way she was taught: to be and do good. Running the farm, raising us, and relating to the people in the region all flowed from her concept of God as she was taught in the Catholic tradition. The work she undertook reflected her deeply held beliefs.

Deeply religious and a devout Catholic, Mama weaved her church work into every activity. She and her longtime friend Gabrielle worked as lay helpers of the chief administrator of the Sacred-Heart Church. They headed the church's *legionnaires*, a group of devout women who assisted the head priest in furthering the church's mission. The main activities of the *legionnaires* included outreach to the spiritually needy and charity work. Mama

took this work very seriously. She relentlessly encouraged people in the region to attend church and participate in all the Catholic sacraments. She focused her outreach activities on behalf of the church on increasing participation in two recognized sacraments: Marriage and Baptism. She encouraged unwed couples, targeting those who had lived together for years, to bless their union in the church. In many instances Mama would not take no for an answer from these couples. If the reasons couples gave to Mama for not marrying in the church concerned the costs of a wedding, Mama would plan and organize the wedding at her own expense, as she did for Estelle, the region mid-wife.

Mama's beliefs translated into some fun times for us children. The main social and recreational events in our lives at L'arsenal, such as Estelle's wedding, always centered on church activities in one form or another. Wedding and Baptism celebrations were familiar happenings at our place because Mama made them part of the routine of our lives. One such memorable event occurred when Estelle married—in our front room—her long-time companion at Mama's urging over several years.

Mama and Gabrielle planned the wedding and reception. The Sacred-Heart Church administrator and a handful of friends, mostly women from the region, dressed in their best Sunday clothes, gathered in our front room and porch on a bright and sunny Saturday morning at ten o'clock in the morning. Mama had bought light blue material for the wedding dress, and Gabrielle, an accomplished seamstress, sewed the dress for Estelle free of charge. Estelle, well into her sixties on her wedding day, was a radiant and beautiful bride. With her graying hair pinned back in a bun, crowned with a matching blue bow, her high cheek bones dominated her emaciated ebony face. A tall and thin elderly woman, Estelle looked positively dignified on her wedding day. Her groom, also in his sixties, wore a plain white shirt and regular pants.

"Do you Gesner take this woman to be your wedded wife?" The priest asked the groom as the two joined hands in front of him.

With a grin on his face, Gesner said yes. When it came to Estelle's turn, she giggled hysterically, like a teenager on a first date, showing the gap left by her two missing front lower teeth. Everyone joined in the silly laughter. Eventually, Estelle blurted out the right

words and put an end to the ceremony. The reception followed immediately and took place on the front porch. Mama had decorated the front area with freshly cut wildflowers in glasses of water wherever she could let the glasses rest. A square table, covered with a checkered tablecloth Gabrielle brought along, garnered the front porch. A tray of cookies and a cake rested on the table along a large bowl full of punch, a mixture of coconut and orange juices. Estelle's wedding was a joyous occasion.

With the same fervor Mama encouraged participation in the sacrament of Baptism. Her tradition of faith taught her to view Baptism as an essential element of salvation, without which the soul remains in limbo. She believed this with all her heart. Everything she engaged in, whether in her contacts with her sharecroppers, laborers, and merchants or her conversation with passersby, Mama found and coaxed young mothers into baptizing their babies in the church.

For many mothers who agreed to the Baptism but were otherwise either unable or unwilling to attend to the details of the christening occasion, Mama took on the responsibility of planning and executing the christening event. She would plan these events at her own expense, including purchasing the christening attire for the baby and planning food for the celebrations. She organized receptions to follow these Baptism ceremonies in our front room and porch, serving cakes, cookies, and juice. Organizing these events were fun activities for Mama and the three of us. Mama believed that her efforts to support these celebrations encouraged young mothers and, on occasions, fathers as well to stay connected with the church and to teach their children to do the same.

The church at the time required designated godparents for each baby being baptized. Mama and the three of us after our first communion, around age seven, became godmothers and godfathers to a host of children in the region as a result of these Baptism events Mama constantly planned.

Her concern for the people in the region also extended to the lack of basic education. Shortly after her move to L'arsenal, Mama became concerned that children at L'arsenal did not go to school. Parents put children to work very early in their young lives. Boys followed their fathers as laborers or journeymen. Girls helped their

mothers with the chores of running a family and as traveling merchants in the iron market. Survival was the primary focus. That meant securing a meal every day. Most people at L'arsenal and the surrounding communities could not read or write because survival was the sole preoccupation.

Deeply troubled that children did not go to school, Mama became single-minded about the education of the three of us. Joseph, Bertrand, and I were the only exceptions among L'arsenal children to go to school. Mama feared that we might fall to the same pattern of school drop-outs, and worked relentlessly to set us apart and keep us in school. While she tutored the three of us every day, she also at the same time taught the basics of reading and math to other children in the neighborhood.

Her education and upbringing, coupled with her genuine effort to be of service to others, helped Mama carve a uniquely popular position in that community. People from the entire rural region sought her out for counsel, advice, information, drafting letters, and filling out forms (such as applications for Marriage or Baptism). People dropped by our place to consult with Mama on a daily basis about practically every potential issue in their lives from banking to Baptism. Mama enjoyed her position and delivered gracefully. She was revered, respected, and loved far and wide in the rural communities surrounding L'arsenal.

The Missing Red Hen

L'arsenal shined beautifully in the daytime and turned mysteriously peaceful under the moonlight. But mischievous things always happened under cover of night. Invisible hands came out in darkness, it seemed, and snatched away the few little joys that came our way in the daytime. I experienced the harsh reality of invisible cruelty at L'arsenal one day when Esther, my sheep, waltzed in and out of my life within less than twenty-four hours.

I spent one summer with my mother's cousin, Esther Tanse, on her farm in beautiful Camp-Perrin, a village near Cayes. Esther raised sheep and let me take care of one. I was so intrigued with her sheep that she promised to give me one when she closed out the farm and moved to a smaller place. Esther kept her word. She came to visit one day out of the blue several months later. She brought me a sheep.

One morning, I entered the storage hut where we kept a jar of corn to feed the chickens and chicks. Mama raised chickens for the eggs for our meals, to share with neighbors and friends, and regularly send to her sisters' households in town. Mirlande and Rose stood outside the hut, making the usual sounds—*kit, kit, kit*—calling the chickens to breakfast. Chickens, chicks, and the rooster all flocked toward us. It was a daily routine.

"Let's count them so we know all of them are here." I said.

"We're missing one hen, the newest reddish one Mama bought the other day," I alarmingly exclaimed.

"I just saw her yesterday afternoon over there," Mirlande remarked, pointing toward the front.

"I did too before dark last night," I replied.

We looked everywhere for the hen and did not find her. Tears streamed down my face. Defeated, sad, and angry, I headed toward the front porch of our place with Mirlande and Rose. Once again, I became infuriated with the constant struggle to hang on to the few possessions we managed to earn or find at L'arsenal. We did not have a way to keep the chickens confined. The minute we let them loose, they disappeared. Someone had most likely snatched them for a quick meal.

We told Mama that someone stole our reddish hen.

"Leon did it," I shouted, my voice trembling with both anger and fear.

"We saw him hanging out around here yesterday with his machete," Rose added.

"He probably caught the hen and chopped her head off," Mirlande commented graphically.

"And probably ate it for supper last night," Rose finished.

"He's a thief," I said.

In my anger and with the horrific thought that Leon had chopped off the hen's head, I did not notice Esther Tanse standing there. She had just stepped on the front porch as the three of us and Mama moved toward her. I still clung to the thought that this could all be a misunderstanding and that our reddish hen would walk back anytime. Esther immediately noticed my distress, and she moved closer to me.

"I'm sorry about your hen," Esther said.

I then realized that I had not even greeted her. I walked over to her and gave her a kiss on the cheek.

"I've moved. One of my sheep needs a home," she said.

"Really?" I replied.

"You seemed to so enjoy taking care of her last summer, I brought you a surprise," Esther continued.

She then took my hand and led me to the side where she had secured the sheep to a bush.

"For me?" I asked as Esther and I moved close to the sheep.

"Yes," Esther replied. "I told you. I closed out the farm. I don't have the large field of grass for them to graze anymore. So I brought you one, like I promised."

Mirlande and Rose moved closer to me to admire the animal.

Mama had acquired a small herd of animals, mostly pigs with piglets, chickens, ducks, and one cow. We did not have sheep and no other farmer nearby raised sheep. Esther's gift was quite a novelty. Joseph, Bertrand, and Paul heard the commotion from the back and came running. Everyone surrounded the sheep and me admiringly. My sadness about the lost hen had quickly dissolved. The warmth and softness of the sheep's fur as I petted her rejuvenated my heart. At that moment, a sense of love and protection within the safe circle of my family enveloped me. I loved the sheep, and I felt loved as well.

"What do you say to Esther?" Mama asked me.

Mama's question brought me back from this dreamy blissful moment. I felt a little embarrassed for forgetting to say thank you. I moved even closer to Esther.

"Thank you. We'll take good care of her," I said to Esther.

"What will you call your sheep?" Rose asked me.

"Our sheep," I replied. "I don't know."

"How about Esther?" Rose proposed.

I looked over at Esther. My eyes rested into hers for a brief moment. Her love and generosity radiated in her warm smile. I smiled back at her.

"That's a good name," I said without taking my eyes off of Esther. "Her name is Esther."

We decided that we should keep Esther tied to a tree with a sturdy long rope the same way we secured the pigs in the back. Mama thought that the rope should be very long so the sheep could venture as far as possible in the back to graze. She found us an extra long rope in the storage hut. With Joseph leading, we found a spot to tie Esther under a fruit tree, several yards beyond the pig pen.

I could hardly sleep that night; I was so overwhelmed with joy. Children did not receive nor give gifts at L'arsenal. Whatever I received, be it food, clothing, pencils, books, or chalk (whether it was from Mama, members of Mama's family, neighbors or friends) was given to me because I had some kind of a need for it. It was always about survival. Mama did not encourage gifts-giving other than cooked or uncooked food from the farm. She viewed gifts-giving as a luxury we could not afford. I was not accustomed to expe-

riencing the sense of love, acknowledgement, and caring Esther's gift brought me.

I tossed and turned all night, anticipating daylight so I could see Esther again. I woke up before sunrise. Mirlande had come over early and waited by the front door. I asked her to come with me to find out how Esther fared on her first night at L'arsenal. She followed me as I headed to the back to the spot where we left Esther the night before.

From the back of our place past the fruit grove a few yards away, we could see as far as possible beyond the northern boundaries of our property. I did not see any sign of Esther from a distance. I ran toward the tree where I thought we tied her, thinking perhaps she settled somewhere on the ground underneath the hay. I saw no sign of Esther. Mirlande straggled behind me. As she reached the tree, she noticed the frightened look on my face.

"Let's look around. She must be here somewhere," Mirlande said in a concerned but encouraging voice.

We searched every inch in the immediate area around the tree. We found no sign of Esther. I moved several yards farther, close to the edge of the rice field toward a creek, the farthest point of the northern edge of the farm. Mirlande continued to look closer to the tree. As I moved close to the edge of the rice field, I noticed a white spot under a mango tree that stood alone in the rice field near the creek. I moved closer. I was horrified to discover the skin of a sheep still covered with wool. *Someone skinned Esther,* I thought.

"Mirlande!" I screamed from the deepest point of my bowels, as if to immediately release the evil and injustice my heart just experienced. My voice echoed through the open air.

"What's wrong?" I heard Mirlande say in the far distance. I started to run as fast as my legs could carry me. I ran past Mirlande. Through fits of sobs and pain, I kept on repeating aimlessly, "They skinned her! They killed her."

Mirlande ran in the opposite direction to find out what had so frightened me. I ran back to our place. I pushed through the side door and crashed in a corner of the front room behind a straw chair. I sat in the fetal position, sobbing. Mama, Rose, and Joseph rushed behind me into the front room.

"What's wrong? What happened?" Mama asked in a worried voice. Unable to speak, I kept on pointing in the direction where I saw the sheep's skin. I then stood up abruptly. I ran to the side door and began to vomit.

"What is so upsetting to you, child? Speak," Mama ordered in a tone that told me she too was just as terrified as I was.

Mirlande walked in. She looked distraught and confused, but more composed as she entered the front room.

"We saw a sheep's skin back there," Mirlande explained to Mama.

"Esther," Mama said immediately.

Mama and the other children ran toward the back, leaving me alone. After vomiting everything that could have possibly been in my stomach, I went back to my little corner behind the chair in the front room. I sat again in the fetal position, feeling more alone and lost than ever. I felt ill.

Somehow, I knew I'd be spending the next few months at Elise's house. Mama always sent me to Elise's after an illness. I did not know why. Maybe it was that she didn't like anyone clinging to her, especially children. Hurt, sickly, and wounded children are usually needy and clingy. I couldn't be either at Elise's. Maybe Mama was trying to teach me how to be tough. Only tough people can survive, she must have believed. I didn't know why, but I knew I was going to Elise's soon. That was just the way it was. I waited for the time to go, like a criminal awaiting a jail sentence.

The Other Girl Child

I learned about Martine from Elise. Mama never mentioned Martine, the other girl child Elise said my mother gave birth to years before I was born. For a long time I believed that I was Mama's only daughter. Being the only girl in a family of boys attracted attention, especially from older women who could not think of anything good about being a girl other than having brothers.

"You're so lucky to be the only girl with so many brothers to protect you," they'd comment.

Since that's about the only sort of compliment thrown my way when I was little, I hung on it as truth because it made me feel rather special. One morning after Mass during one of my stays at Elise's house, she shattered the myth that my mother produced only one female child. She took me with her to visit an elderly sick woman. Two girls, one my age and the other several years older, sat in the front yard of the house playing with a doll. Elise asked me to visit with them while she walked upstairs to spend time with their grandmother. We played and conversed together until Elise returned. On the way home, I mentioned to Elise that I so wished I had an older sister. I would not be so lonely if I had an older sister, I said.

"You have one," Elise said without hesitation.

I continued talking as if I hadn't heard what Elise said even though I had heard. I ignored it because it made no sense.

"You have a sister, a half-sister at least. Her name was Martine," Elise said again, interrupting me. I stopped and asked her what she meant.

Elise explained that my mother gave birth to a little girl in the

house directly in the back of the Tanabet main house several years after she returned home, following Andre's death. She found a teaching job in a nearby rural village and worked there during the week. She traveled back to the family home on weekends as often as she could to see Guy and Charles. The boys, Elise said, looked forward to seeing her and waited impatiently for her.

Mama, Elise continued, stopped coming home. She did not write to explain. Several months passed without word, and then, Elise said, the rumors started flying in town that Mama had become pregnant. The gossip about Mama's pregnancy became intolerably embarrassing for her mother Julia and the entire family. Julia, Elise, and Eve, as pillars of the church, could no longer show their faces.

Eve had aspirations that her boys would some day become men of the cloth. Mama's mother and Elise looked forward to the day when a Tanabet offspring would preside over Sunday Mass at one of the churches in town. After all, a man of the cloth presiding over Mass behind the altar occupied the most powerful ego-gratifying position in town at that time. The latest scandal Mama threw them in, Elise lamented, threatened the family's reputation as a model Catholic family and their aspiration for the family to produce the next generation of men of the cloth in town.

The family made the decision that Leonard should travel to find Mama and bring her home. Leonard made the trip alone on horseback. In the last stage of pregnancy, Mama returned to the parental home with Leonard. She entered the front room of the main house and found a room full of waiting family members. Overwhelmed by shame and embarrassment, Mama fell backwards and fainted. Leonard caught her, and later helped her settle into one of the smaller houses in the back.

When Mama recovered from her fainting spell, she had lost her mind, Elise said. She became crazy, Elise emphasized. She alternated between sleeping all day and becoming incoherent, angry, and agitated. She talked often of killing herself and had tried to swallow kerosene, Elise said. Leonard stayed at the door of the little house to watch her every move. To Elise's greatest dismay, everyone in town talked about the misfortune at the Tanabet house because her sister Marie had gone crazy.

A few days after her arrival and in the midst of her emotional

breakdown, Mama gave birth to a little girl she named Martine. Her mental exhaustion and incoherence intensified after Martine's birth, Elise said. She could not care for the child because she either slept through her feeding time or she was too upset to handle a fragile baby. She again talked of killing herself to end her pain, Elise said. The family became frightened and decided to confine her for her own safety.

Again the family turned to Leonard. Leonard summoned the local police, who came and took Mama into custody to the infirmary of the local jail. There was, Elise said almost apologetically, no suitable medical facility with a psychiatric ward to handle such a case. The jail infirmary, of course, had no doctors or nurses on staff that could have examined and provided a diagnosis of her condition. The family left Mama there, and apparently felt relieved that they'd achieved complete control.

Meanwhile Mama's mother and Elise had put Martine up for adoption. Within days of Mama's confinement, her mother Julia gave away the newborn baby, a few weeks old, to a man who claimed to be Martine's father. Mama stayed confined at the infirmary for several days until she sent for her close childhood friend, Gabrielle, who came right away and secured her release. With Gabrielle's love and nurturing, Mama began to recuperate after several months. She became well enough to venture out. She walked to L'arsenal every day while still living at Gabrielle's. The fresh air did her good. She needed time alone and away from the brouhaha of family obligations.

She started working on various cleaning projects and gardening at L'arsenal during the day. The family had all but abandoned L'arsenal. No one attended to the Tanabet property. L'arsenal proved to be the perfect refuge for Mama. She began spending all her days there to lessen Gabrielle's burden of caring for her. She went to Gabrielle's at night for a few weeks. She tried to return to the family home for a brief period, but it could not work after all that had transpired. She met Miguel at L'arsenal a few months later, and then ultimately moved permanently to L'arsenal.

"What happened to Martine?" I asked Elise.

"It's not your concern," she replied. "She belongs to another family now."

I asked Mama about Martine a few weeks later.

"That's the longest tale I've ever heard," Mama said curtly. "Elise made up that story to upset you. You are my only daughter. There is no Martine."

Mama and I never again spoke about Martine.

Ferocious Roar

A hurricane devastated our town and surrounding region in 1964. It hit L'arsenal suddenly one summer afternoon when coconut and mango tree branches began to blow to and fro under the force of strong winds. I lifted my head. The head of the rooster at the top of the Sacred-Heart Church had shifted and faced north. A hurricane was headed our way.

The sky suddenly turned black. Heavy clouds hung low. Mama rushed to the front looking for my brothers. She asked me to find them and return back home right away. Thinking that they might be playing soccer on the playground behind the church, I ran toward the little bridge searching for them. The wind gusts intensified, and the high top of the coconut trees bent under their force. Leaves detached from branches and danced rapidly in the wind. As I approached the bridge, a crowd of merchants headed my way from the iron market. I could barely walk, pushed by the blowing winds. Heavy drops of rain hit my face as I tried to cover my head with my hands.

"Little girl, where are you going? Does your mother know where you are?" I heard a woman say to me.

"Yes," I replied. "Have to find my brothers."

"Don't you know a killer hurricane is on the way?" the woman said. She grabbed my arm and dragged me in the opposite direction.

"Come little girl. Your brothers aren't stupid. They'll find their way home," the woman said.

The group of merchants rushed passed me to safety at Mama's home. I wondered how all these people would fit into the tiny

place. I heard someone say that they had tried to find shelter inside the Sacred-Heart Church first, but it had already filled up. The church administrator had closed and locked the doors. The rain poured with intensity, and branches and leaves flew about overhead. Mama stood at our front door, motioning to people to come in for shelter. As I entered through the door in the press of the folks seeking shelter, a gigantic thunder opened the sky. It felt as if the thunder landed on the roof of our place. I hid under a table in the front room and Mama closed the front door.

I heard the fury of the wind outside as the house swayed side to side for a brief moment. The usual soft chatter of leaves on the trees flirting with the wind in good weather had turned into a ferocious roar. Heavy winds whipped the branches and leaves, and the rain drops sounded like gun shots over the roof. Awhile later, Mama opened the front door and peered outside. Water overflowed everywhere. Tree trunks broke and large trees were uprooted completely. I was frightened. I prayed, asking for God's protection. The roof detached from the frame and lifted upward, but miraculously it fell back in place. I was awed.

"We have to get out of here, now! Let's go to the Manuels' place!" I heard Mama yell at that moment.

She pulled my arm from under the table and yelled for Joseph and Bertrand. Mama took my hand and Joseph's hand, as Joseph held Bertrand's hand. Through large currents of water sloping from the west side of the property, we ran to the Manuels' place. Everyone followed. Just as we left our home, before we reached the Manuels' front porch, our roof blew away. When we reached the Manuels', Mama stood in the front for a minute. Visibly shaken, she looked over from a distance at her ruined home. We all huddled inside the Manuels' tiny hut. Smaller than Mama's and with a straw rooftop, the Manuels' place settled in a grove of wild bushes nearly as tall as the hut itself and stood lower than Mama's. Less exposed to the force of the winds, the Manuels' place felt safe. High winds and heavy rains continued through the night.

The intensity of the storm had passed when daylight returned. Mama opened the Manuels' front door and peeked outside. The frame of our roofless shack stood in the middle of a lake. Branches and debris floated in the dirty water. I followed Mama outside onto

the Manuels' front porch. It seemed incredible that a storm that lasted just a few hours could have caused such devastation.

"We'll have to rebuild," Mama said, "we'll just have to rebuild."

The news about the extent of the hurricane devastation trickled in slowly. The damage made the paths to and from L'arsenal impassable for several days. Marguerite had returned from the iron market early on the day of the storm, before it all started. She said that she had left several neighbors from across the creek and beyond at the iron market. We hadn't seen Miguel since the storm, and we wondered what happened to him and the neighbors who did not return. So we waited.

A few days after the storm, as we helped Mama begin the clean-up inside the frame of our ruined home, Miguel appeared. We all were relieved to see him, even Mama. We learned from him the extent of the devastation in town. He explained that the heavy iron roof of the market had collapsed inward and killed hundreds of merchants who thought they would be safe under the roof. The Sacred-Heart Church's roof had also collapsed and killed those who had sought shelter inside. The local police drafted able-bodied men, including Miguel, to help clean up.

"Did you see anyone we know?" I asked.

"No," Miguel said. "Couldn't recognize anyone! Too many body parts."

All of us wondered at that moment what had happened to the neighbors Marguerite left at the iron market. Some eventually returned a few days later. Others never did.

The hurricane brought for me another involuntary stay at Elise's. I found out shortly after the storm, as we began the clean-up, that Mama counted me out of the recovery period. The frame of our home remained standing, but rain water had soaked everything inside. The force of the wind had pushed backwards the little straw kitchen in the back. Fortunately the calabash tree directly in the back of the kitchen propped it up. Mama, Joseph, Bertrand, and I bent low and entered inside what remained of the kitchen.

"Well, there is room here for a bed," Mama said. "This is where we're going to sleep until we rebuild our place."

"How are you going to fit everyone in?" I asked, fearing the worst.

"That's just it," Mama replied. "I am sending you to stay with Elise for a few months until we finished cleaning up and get back on our feet."

My eyes welled with tears. I turned to Mama in disbelief. How could she think of sending me away at a time like this?

"You'll be able to sleep in a warm bed and there'll be plenty of food. It'll be one less mouth for me to feed around here and one less body to put to bed. Besides, you're a girl, you need to be comfortable," Mama remarked without any thought of my feelings.

I could no longer keep it all inside. I burst into tears and cried uncontrollably.

"Listen, Miss," I heard my mother's voice, warning me that there was no place for tears. "Dry your eyes right now. This is no time for tears. We have to do what we have to do. Look around you. I need to find a place to sleep with the boys and I need to help anyone else I can find one. You have somewhere to go. It's not to your liking, but you got it. Help me help them."

I was off to another round of doing time at the Tanabet jailhouse, with Elise as the warden.

CRAZY IDEA

I could never characterize any of my stays at Elise's as uneventful. Invariably, I learned some lesson that impacted the direction of my life in ways I could not possibly have understood at the time. At one mid-day meal, I sat at the dining room table with Stuart. Elise stood as usual across the table by the window, holding a tiny plate of food. Stuart looked his usual angry self. He seemed preoccupied with eating fast and staring at the food on his plate, as if annoyed and hurried, suffering the company. He ignored both Elise and me.

"How is school going these days?" Elise asked me, straining to make conversation and break the awkward silence.

"Good," I replied, afraid to say more.

"Any ideas what field you might go into someday?" she asked, clearly not interested in my response. "How about a teacher, like your mother used to be?"

"I haven't thought about that yet," I replied. "But the other day I ran into Ms. Yacinth. She's a lawyer. She spoke to me about what it's like to be one."

"Renée Yacinth?" Elise asked. The name I dropped suddenly piqued her interest. "Wasn't she one of your students at the law school, Stuart?" Elise asked, turning to Stuart.

"Yes," Stuart replied with his angry and annoyed facial expressions.

"She must be really smart," Elise said admiringly.

"I would not say that," Stuart remarked. "But for a woman, she's okay, I guess."

"What did she say it's like for her to be a lawyer?" Elise asked me.

"She said she loved the study of law, but it was more an exercise than a practice," I told Elise.

"She's right about that," Stuart interrupted. "The study of law is a serious intellectual discipline. Studying law requires brains."

"Ms. Yacinth says the law is about rules to maintain order and justice in communities," I interjected. "That part intrigues me a little. I think I'd like to study law someday."

Upon hearing these words coming from my lips, Stuart became annoyed and agitated.

"What a crazy idea," he said. "Did your mother put a crazy idea like that into your head? Can't you think of something useful to do?"

"Stuart is right," Elise said, always trying to be on both sides to keep the peace. "Being a lawyer is not becoming for a woman. Renée Yacinth is kind of strange, sort of manly. She's so pushy…I would not want to be like her."

"What would you do with a law degree as a woman?" Stuart added. "All Renée Yacinth will ever do in this town is teaching at the *lycée*."

"All lawyers in this town end up teaching," Elise finished Stuart's train of thought. "You can be a teacher without having to go through all that."

"Eloquence, wit are what make lawyers," Stuart added disdainfully. "I don't know any woman who has these qualities. Not even Renée Yacinth."

I became intimidated by Stuart's reaction. I felt sorry for revealing my thoughts. I stared at my plate and said nothing for fear of provoking more outbursts. I remained subdued for the remainder of the conversation. But at that moment I made the important decision that I would become a lawyer one day.

WATCHFUL EYES

"Don't repeat what you see and maybe you'll live." We learned how to survive living this motto Mama kept on repeating to us to cultivate how to maintain an attitude of safety. One night, the sun had disappeared beyond the trees as a wave of merchants rushed single file on the narrow bridge on their way home. Mama sat on a straw chair on the front porch, reading to us from a story book.

"Madame, you'll need to close your doors and blow out your lamp soon," one man yelled at Mama from the pathway as he passed our place.

"It's still early. We'll close up soon," Mama replied.

"Haven't you heard?" the man continued as he kept pace walking away. "There's a curfew from dusk to dawn. Trouble far away in the capital! Serious enough for a curfew all the way here!" the man said.

"Thank you," Mama replied. "Be careful."

Mama immediately closed the book and coaxed us inside with a nervous urgency.

"Can't we play in the back for a little longer?" Bertrand asked.

"No, you heard the man," Mama said. "There's a curfew."

We went inside. Mama closed the door and ordered us to bed. I must have fallen asleep right away that evening, because I was awakened by sounds later that night of running footsteps on the pathway in front of our place. Shortly after that I heard the clock of the Sacred-Heart Church strike eleven times.

"Isaac!" I heard a male voice yell outside.

The thumping sound of running footsteps continued from up and down the path in front of our home.

"What's that?" I whispered in a frightened voice.

"Shush!" Mama replied.

I could hear the sounds of heavy blows and moaning, as if a person was being beaten outside. The sounds continued for what seemed like an eternity. Then the blows stopped. I heard hushed voices from a distance farther away, but I could not make out the words. It became very quiet. Whoever the people were on the pathway had walked away.

We all lay awake, tossing and turning most of the night. We learned the next day that Isaac, the son of one of our neighbors on the other side of the creek, received a beating. Neighbors rumored that he ventured out after dark to buy supper for his sick mother. Mama ordered us all to stay under her watchful eye at all times after this incident. More importantly, she instructed us not to ever repeat to anyone what we heard the night before.

"You never know whether anyone is friend or foe," Mama said. "It's best to never try to find out. Just keep your mouth shut. Maybe you might live."

The Only Safe Place on Earth

Word of a curfew in the region persisted. Mama did not want to take any chances, so she closed our front door early that day before dark, and did not light the kerosene lamp. She gathered us in the back for evening prayer, reciting the rosary, broken with her intermittent prayerful petitions.

"Watch over us and keep us safe, Father. Take care of Guy for me in these scary times," she prayed.

"Are you worried about Guy, Mama?" I whispered in her ear.

"Shush! We can't talk. You never know who might be listening. You all need to go to bed now anyway. I'll leave the side door open for air for a little while."

Joseph, Bertrand, and I went to bed in the dark. Mama sat in a chair in the front room with the east side door open halfway. I snuggled in bed listening to the sounds of crickets and frogs. I lay there a long time before falling asleep, thinking about how much fun we used to have when we could play hide-and-seek before going to bed. With word of a curfew that day, it was not Mama's fault that we could not play.

As I began to doze off, I heard faint stumping footsteps coming from the front. A few moments later, I heard knocking on the door. Mama slowly moved from her chair and carefully pulled the side door to close it shut. She tried to keep the door from making a sound that could attract attention. The rusty door hinges screeched anyway. The knocking on the door persisted, a little louder, but still low enough as to not attract attention. Then I heard a whisper.

"Mama, Mama, are you up? It's me, Guy." Mama recognized

Guy's voice. She immediately opened the front door and saw Guy and the shadow of another man.

"Guy? What are you doing here?" Mama said in a concerned voice.

Guy and the man quickly slipped into the half opened door.

"What's the matter? Are you in some kind of trouble?" Mama asked anxiously.

"There's a student strike in the capital. They're cracking down on students," Guy explained quickly.

Lesly, the man with Guy, one of his classmates, and he could not sit and watch, he told Mama. They took part in the strike. He and his friend were not the only ones. Students wanted reform. Mama quickly secured the front door and lit the kerosene lamp. She walked calmly and deliberately back and forth in the tiny room, as she often did when nervous so she could think about what to do.

"Knowing you, Guy, you must be in front of the bandwagon, leading the charge," Mama elucidated, as if she suddenly understood the gravity of Guy's fix.

Mama sat down for a minute. She tried to convey to Guy that he must change the way he viewed how he could help. She stressed that his first and only priority was survival. If that meant that he had to let everyone else behave as they pleased, that was what he had to do. She looked straight into Guy's eyes and told him that the only option he had left was to keep his head down and survive.

"We can't do that, Ma'am," Lesly said after Mama's lecture.

"It's not right, Ma. And you know it," Guy chimed in.

Angry and discouraged that she could not succeed in steering Guy to another point of view, Mama asked another question.

"How did you make it here anyway with the curfew? Just last night, a neighbor's son was beaten right outside on the pathway. We heard it all from here."

Guy and Lesly took the bus from the capital early in the morning, he explained. He figured the danger for them was to stay in the capital where the strike occurred. They sat separately on the bus and didn't talk to each other during the trip. They passed through every check-point and made it to L'arsenal. He said he was sure no one paid attention to them.

"God is protecting you," Mama said. "But don't push your luck anymore."

Guy said he wanted to stay safe. The only safe place on earth he knew was L'arsenal.

"Safe?" Mama said. "I would not count on it here. Safety is an attitude. For people with nothing better to do, it's big news that I live here at L'arsenal. Everyone knows you're my son. If people want to find you, this is the first place they'll look," Mama lectured.

"This place is all I've got, Ma. Do you have another idea?" Guy asked.

Mama stood abruptly from her seat. She announced that she had an idea. She'd help Guy and Lesly blend in after a good night's sleep, but only if they could play by her rules so long as they stayed at L'arsenal. She blew out the lamp, opened the back door, and brought in a couple of straw cots from the storage hut.

"It's not going to be comfortable. But that's how I live," Mama said in a whisper.

Early the next morning, shortly before dawn, Mama walked into the front room with two pairs of old beat-up laborer's denim pants, two torn shirts, and two old and heavily used straw hats. She gave a set to each Guy and Lesly. She ordered them up on their feet and to put on the clothes and hats.

"There are two old hoes in the back. You each get one. A team of six laborers will arrive soon to turn the rice field into a sugar cane field. With you two, now there will be eight men on the team. It's hard work. You get into it and blend in. I expect an honest day's work out of you," Mama ordered.

Guy jumped up from his cot and followed Mama's orders. Mama took a step out of the room, but returned quickly.

"One more thing," she said. "Again, you play by my rules here. Neither one of you can utter a word about strike, students, politics, injustice anywhere, anytime as long as you're here. The only talk around here is about rice field, sugar cane, soil, water, and food. If you have thoughts, keep them just that—thoughts. You two cannot even talk to each other about anything other than our work and lives right here at L'arsenal. I have three minor children I'm responsible for. I'm here to survive. Please respect that. Do you understand me?" Mama said pointedly.

"Ma, you got it. Don't worry," Guy said gently to Mama as he gave her a kiss on the cheek.

Since Guy came back, I took on the responsibility of watching closely everyone's coming and going in L'arsenal. I worried we were being watched. I was terrified for Guy and became suspicious of everyone I didn't immediately recognize. I sat strategically on the front porch, carefully examining each passerby.

Disguised in laborer clothes, Guy and Lesly resembled any local farmer struggling for a meal. They worked tirelessly for Mama on the farm. They gave her free labor in the field as well as helped her with other administrative and work activities of running the farm and the family. They cleared overgrown areas, cutting trees and branches, and chopping wood for the fire pit. They managed the irrigation work and laborer assignments and anything else Mama asked them to do. Mama became alive around Guy and relished his presence on the farm.

One day, as Guy and Lesly worked, blended in a team of laborers hoeing the rice field at the northern edge of the farm, I spotted two men wearing dark sunglasses crossing the little bridge, heading for our place. I had never seen these men before. Men in uniforms rarely frequented L'arsenal. I became extremely concerned as they approached the front porch. Terrified, but composed, I stood up to greet them.

"Good morning, sirs," I said. "Can I help you?"

One of the men informed me that they came to inspect the property. Both moved past me unapologetically on the porch, and entered inside the door to the front room. Terrified still and unsure as to what to do, I decided to cooperate as best I could.

"Come in," I said after both of them were well inside the house. "Are you looking for something specific?"

"It's none of your business what we're looking for. Got that?" one of the men snapped.

"Yes sir!" I replied, positively frightened by then.

The men moved through the front room, inspecting each piece of furniture and making notes in a small notebook without ever taking off their sunglasses. They looked in both the front and back rooms, including the wooden box we used as a closet. They seemed oblivious to my presence. Not knowing what they were

looking for, I nervously kept an eye out on the field to stop Guy in case he or Lesly decided to take a break and come back inside.

"What's back there? Why are you so nervous?" one of the men asked.

"I'm not nervous," I responded. "There's nothing back there, just Mama and some laborers!"

"Nothing for us back there," one of the men repeated after glancing quickly toward the back. "We took an inventory of everything inside here. Beginning next month, you all are going to have to pay taxes on this place and everything in it."

"Taxes," I replied, relieved but feigning surprise. "We never had to pay taxes in these parts before."

"You will now," one of the men said firmly.

No one at L'arsenal ever had to pay taxes. We had no roads, electricity, running water, or sewer facilities at L'arsenal. A completely rural area, each resident bore responsibility for figuring out his or her own services. Although relieved that these men did not come for Guy, I still felt imposed upon by their presence to levy taxes on us. I wondered how Mama would come up with the money to pay for taxes on top of everything else. Raising money for tuition, school supplies, and maintenance for the three of us seemed such an agony every year. It all seemed so unfair and difficult. I nonetheless felt grateful that Guy and Lesly were still protected with us at L'arsenal.

Torn to Pieces

One evening, after sitting on the front porch daily for nearly two months to keep watch for Guy and Lesly, I saw fourteen-year-old Theophile, hurriedly and excitedly crossing the little bridge.

"They've lifted the curfew!" he proclaimed loudly.

"How do you know that?" I asked.

"The radio said it," Theophile told me.

Relieved at the news, I ran to the back where a group gathered for supper and Mama sat in the kitchen serving food. I told Mama that the curfew had been lifted.

"That's fine and good. But I don't want anyone running around after dark. I need you all here," Mama snapped sharply.

Joseph asked whether we could stay up later and play quietly in the back. Mama made clear that she did not want us to do anything or make any noise that would attract attention.

"It's kind of boring to go to bed so early," Joseph said plaintively.

"You just keep busy during the day and you'll be too tired at night to think about it," Mama said.

Later that evening after the three of us had gone to bed, Guy and Lesly stayed alone with Mama in the back. It was pitch dark except for the occasional fire bug. Mama, Guy, and Lesly sat in a small circle on straw chairs that Guy had huddled together, indicating he wanted a conversation with his mother and friend.

"Ma, I think it's time we head back," Guy announced.

"Head back where?" Mama replied, stunned and frightened. She had dreaded this moment for weeks.

"Back to the capital, back to university," Guy replied.

Mama became nervous and tried to reason with Guy that his plan was premature and reckless.

"Ma, things have quieted down," a naïve Guy told Mama.

"How do you know that?" Mama asked. "We're here, cut off. We don't even have a radio. You don't know what's going on out there."

"They lifted the curfew," Guy reminded Mama.

"Maybe it's a trap to smoke out hiding students," Mama warned.

"Ma, I've got to go back to my activities. I can't stay scared the rest of my life," Guy said.

Mama attempted every possible way to reason with Guy.

"There is a time in life when laying low is the best thing one can do," she said to Guy. "Look at my situation! What do you think I am doing here? I came here when the world out there became too tough for me. I needed to get away from all the formalities, obligations, and trappings. Then God gave me these children. My job now is right here. My job is to forge a life for them, and help some of the folks out here when I can. Why can't you stay here and forge a life? It doesn't have to be forever. A year or two! Just long enough to make the world forget about you and have time to think," Mama pleaded.

"Ma, I am not you. Besides, there are people counting on me, like my friend here. I can't just disappear," Guy reasoned.

"Disappearing to save your life, I would think your friends would understand that," Mama countered.

"Ma, I got to go," Guy said definitively.

Mama became tearful. "Of course, you have to do what you feel you have to do. But it's ripping my heart apart. You sound just as brave and determined as your father did those many years ago. God rest his soul! I cannot change who you are and I am very proud of you. But you should know that my heart is torn to pieces. I have a very bad feeling about this," Mama said in a resigned voice.

Guy approached Mama and gave her a hug.

"You and your premonitions again! C'mon Ma, old girl! It'll be fine. You'll see," Guy said gently, comforting Mama.

Tears streamed down Mama's cheeks.

"That's what your father said too, just before he traveled away and left you in my arms… Well, I can't fight fate. I love you, son," Mama told him.

Guy hugged Mama again and tried to reassure her that all would turn out well.

"Then why do I have the feeling I'll never see you again?" Mama mumbled.

The days that followed Guy's departure, Mama alternated between depressive moods where she became solemn and noncommunicative and overactive periods where she talked incessantly and uncontrollably. She spent her nights seated on a straw chair at the back door, talking to herself. The three of us listened while we lay in our beds, trying to follow the logic of her train of thoughts. She jumped from one subject to another, but focused most of her tirade on her anger at and fear for Guy. The words she uttered resonated as disappointment, fear, and guilt. What seemed strange was that she would have never uttered those words, had Guy been there. In his presence, she expressed clear, lucid, and logical ideas even if she disapproved of his point of view. The minute he left and as she despaired about his situation, her mood and words changed to anger, fear, and despair. We felt bad. Eventually, we tuned out her voice and fell asleep.

During the daytime, she went about her daily chores with furious dedication. She seemed to have the strength of an ox, and tackled every hard project on the farm as if everything had to be done that instant and perfectly. Whenever she slipped into these moody spells, she became unapproachable, cuttingly critical, and dictatorial. The end of the summer approached. I could not believe that I actually looked forward to the day I would return to school. L'arsenal never felt the same again.

Fait Accompli

I passed the national examination after the eighth grade. I officially completed my primary education and received my *certificat d'etudes primaires*, a significant milestone according to Mama. She spent a lot of time painstakingly preparing me for that exam. One morning during one of our tutorial sessions, she talked to me about secondary school, now that primary education was about to be behind me.

"I have to find a way to send you to the *College St. Francois d'Assises*, Mama said as if it was already a *fait accompli*.

"What school is that?" I asked. I had never heard the name and had no context for Mama's comment.

"It's a new secondary school just for girls," she replied. "A Canadian order of nuns built it in Port-au-Prince."

My mouth dropped open and my eyes widened at Mama's comment. I could feel my stomach tighten at the knowledge that she contemplated sending me away again, this time really far away. Whenever Mama used the words "find a way" to do anything, it meant she had already made up her mind. Only the details of her plans remained to be executed.

"That's faraway in Port-au-Prince," I said incredulously.

She turned to look at my stunned face. I must have looked amazed at the matter-of-fact manner she gave me this piece of news.

"I know," she said. "It's a private school and for us very expensive, but you know me. Where there's a will, there's a way. I'll find a way."

She explained that she had originally planned for me to attend

a local private secondary school for girls in town, the school she herself attended as a young girl years ago. But that school had closed its doors the same year I completed the eighth grade and consolidated with the newly-built *College St. Francois d'Assises*, a bigger school in the capital. When she heard about the new school a few months before, she began to think about sending me there.

"Where will I stay?" I asked curiously.

"You can stay at Leonard's," she replied with confidence. Leonard and his family had moved to Port-au-Prince following his appointment to an important position.

"You are not serious about sending me to his house, are you?" I asked Mama in a cracked voice, still in disbelief that she'd even think about sending me to Leonard's house.

"Relax," Mama tried to reassure me. "Leonard will be so proud if you're accepted at the college. It will be just fine. If you are accepted, you could not pass up such an opportunity, could you?"

Mama's mind was made up. The details, and most significantly my feelings about her decision, no longer mattered.

PART III

"Make you to shine like the sun"
—Michael Joncas

Cloud of Dust

Traveling to the capital meant taking a bus at three in the morning. Buses congregated at the town station near the Sacred-Heart Church. Mama and I walked in the dark of the night from L'arsenal to the bus station. I strolled along her side carrying a duffel bag. The bag seemed bigger than my size. I was still a gaunt and skinny thirteen-year-old. Mama carried a medium-sized suitcase. The bus was already overflowing with passengers as we rushed along the last few steps by the black river toward the station. Luggage and boxes fastened from the top hung to the sides of the bus. The driver sat on the roof of the bus, harnessing more boxes and luggage. As we moved closer, he spotted us walking and yelled at the top of his lung in the quiet three o'clock in the morning.

"If you want to get on this bus, you'd better move fast. Roads are impassable. We have a twelve-hour drive ahead, if we're lucky. Move it kid."

Mama quickly grabbed my hand, tears streaming down her face.

"Walk faster," she said, sensing my reluctance.

I felt a little intimidated by the commotion. I moved closer to Mama and tried to walk faster. We reached the back of the bus to climb in, but there were no more seats. From inside the bus, Mama's longtime friend, Cleopatre (Cle), stretched her head out through a side window.

"Marie, I am in here already. I have been waiting for you two. Your daughter will have to squeeze here between Jessie and me," Cle yelled to Mama.

Mama was relieved that Cle had already boarded. She could not absorb the costs of traveling with me and also pay for the expenses that came with sending me away to school. Cle had also enrolled her only daughter Jessie at *St. Francois*, and was accompanying her daughter on the trip to settle her into her first year away. Cle agreed to pilot me through the administrative details of settling into a new school as she handled them for her own daughter. Mama pushed me up in the back of the crowded bus. Cle reached for my hands and pulled me toward her. She guided me to a seat. Squeezed between her and Jessie, I sat down and sank into my thoughts. Streams of tears rushed to my eyes as I tried to look through the window for a last glimpse of Mama. I spotted her standing by the side, waving. She noticed my sad face. She put her hands over her mouth for a second as if forcing back tears. The driver shut his door.

"Move back or I'll run all of you over," he exclaimed.

The intimidated crowd moved back. The driver then sped away, engulfing everyone standing around the bus in a thick cloud of dust. I could no longer see Mama.

The Windowless Back Room

I soon learned that I was not a welcome visitor at Leonard's house. As we began the slow journey to the capital, Cle made every attempt to cheer me up. We agreed that, once I arrived in the capital, I would take a taxi to Leonard's house. I then would meet Cle and Jessie the next morning at the school to complete my enrollment and other administrative details. Mama had mailed a letter to Leonard the week before, explaining everything.

Cle started a conversation by asking me whether I looked forward to seeing Leonard. I confided in Cle that Leonard terrified me. I hoped that he had received the letter Mama sent and that he expected my arrival that evening. Cle told me that the mail from our hometown to the capital at that time took an average of three weeks, sometimes longer. She doubted that a letter Mama mailed the week before would have reached the capital before my arrival there that night. I knew Cle was right. That thought made me feel apprehensive about what awaited me later that night. The fear of what awaited me tormented me for the remainder of the trip, despite Cle's repeated attempts to cheer me up.

After a long and slow drive to the capital, the bus finally reached its final destination that night. Cle hailed a taxicab and put me in it. She closed the door of the old beat-up car and told me that she'd see me the next day at eight in the morning at the *College St. Francois d'Assises*. I gave the taxi driver Leonard's address as Mama wrote it for me on a piece of paper. After what seemed a long ride through strange neighborhoods, either dilapidated and run-down or plush and maintained, the taxi stopped in front of a gated house set back several yards from the entrance. I

searched my shoulder bag for money and paid the fare. The driver placed my suitcase and duffle bag in front of the iron gate of the house and sped away. It was about nine in the evening on the same day of the trip that began at three in the morning in my hometown.

For a minute I stood alone on the deserted street. The house looked dark from the front, as if no one lived there. I was not sure whether I wanted to enter the gate and ring the bell or run away. But there was no place to run…no L'arsenal nearby. I tried to loosen the latch of the iron gate to see if I could open it. A woman in her late forties or early fifties emerged from the dark alley from the left side of the house.

"Can I help you with something?" the woman asked.

"Good evening, Mrs. Tanabet," I replied. "This is Marie's daughter, Leonard's niece… Remember me?"

I tried to give all my credentials quickly so she did not think I was a prowler or something. Mrs. Tanabet, wife of Leonard, looked confused, surprised, and taken aback.

"Ah, yes," she said finally. "My! Have you grown! I saw you last seven years ago before I moved here. You were just six. What are you doing here?"

With this last question, she confirmed my worst fears. My mother's letter never made it. They were not expecting me. I stood still on the street in front of the gate, terrified. Mrs. Tanabet did not ask me and my suitcase to come in. I felt uneasy. Her facial expression told me to tell my story fast. She was growing impatient. I explained that my mother had sent a letter by mail last week to Leonard that I was accepted at the new *College St. Francois d'Assises*. The old girls' school Mama and her sisters attended years ago in my hometown, the only post secondary school Mama felt would meet the needs of our particular situation, had closed its doors last June. After passing the eighth grade national exam, Mama decided to send me to school here in the capital.

"Why didn't your mother send you to the *lycée*?" she began to ask.

"Don't answer that," she interrupted abruptly. "I think I know the answer. The *College St. Francois d'Assises* is a very prestigious school, you know" as if commenting to herself rather than talking to me.

"Does your mother know what she's getting into?" Mrs. Tanabet asked. Before I had a chance to answer her last question, the light on the front porch of the house switched on suddenly. A man in his fifties walked out of the house. He had a stern, almost angry look on his face. I recognized him as Leonard, my mother's younger brother. Leonard saw his wife, but he did not notice me at first.

"What's going on out here? Who are you talking to?" he asked his wife.

"You have a boarder," she replied.

She then told Leonard that his niece, Marie's daughter, had come to live with him. Leonard looked stunned, as if a ton of bricks had just hit his head. He moved down the three steps of the front porch into the small garden entrance toward the front gate. He motioned to me finally to come in.

"Come in, what are you doing standing on the street? The world does not need to know what's going on at the Tanabet's," he said impatiently.

I sheepishly picked up my suitcase and duffel bag, pushed in the gate, and moved a few steps beyond it. A young man, my age, stormed out of the front door of the house, seemingly oblivious to my presence.

"I can't find the money you gave me to buy..." the boy began. Leonard interrupted him.

"What do you mean you can't find the money? Find it! Leonard thundered.

He then turned to Mrs. Tanabet and mumbled in an angry tone something I did not understand. Both Mrs. Tanabet and son stormed out of the front entrance and back into the house. Bewildered, tired, and hungry, I was left alone with Leonard. I fought back tears and tried to look and feel brave. Leonard moved closer to me.

"So your mother thinks you can make it at *St. Francois?*" Leonard asked in a disingenuously calm voice.

I tried to provide all the information I knew Mama had written in the letter to him. She had been in touch with Liliane, my father's niece on his father's side. Liliane made the arrangements with the school. The school asked for my report card and felt that

my grades indicated I could succeed in the secondary program. I tried as hard as I could to sell my strong points to Leonard.

"Well, do you or your mother know what the college is like and who attends there?" Leonard asked, raising his voice in a crescendo as to make a point.

"No," I replied, "other than what Liliane had written to us about."

"Then, why didn't your mother send you to Liliane's? She lives a lot closer to the school than me," he demanded again in a sarcastic but softer and slower manner this time.

I did not really know how to answer this last question. Mama never considered my living at anyone else's house. Leonard had moved to the capital in the last seven years. Staying at Liliane's never offered an option to Mama. Liliane was the daughter of Miguel's half sister on his father's side, and a helpful acquaintance. But Mama did not include her in her concept of family the same way she viewed Leonard.

Despite the nasty family feuds among the Tanabet siblings, a strange bond tied them together in certain situations. In my particular set of circumstances, for some odd unexplainable reason that only the Tanabet siblings understood, Mama felt compelled to exhaust the option of sending me to Leonard's first before going to "strangers." It never occurred to her to ask anyone else to shelter me. It simply was not the Tanabet way. Leonard knew that.

While talking to Leonard that day even at the age of thirteen, I knew I had to walk a tight rope with him about Liliane. A staunch supporter of the current political regime of the time, Leonard occupied a visible and highly sought after appointed position. A gentle and beautiful woman, Liliane married a man the political regime had identified as an enemy. Liliane's husband had been living in exile for years because of his political views vis-à-vis the same regime that appointed Leonard. Given the political realities at that time and Leonard's position, he was very aware of Liliane's circumstances.

Mama had trained me never to utter a compromising word that would even unknowingly imply a political position, one way or another, regardless of the person I was talking to, even a family member. I became concerned about what information, however

innocuous, I gave about Liliane so as not to aggravate her already precarious situation. At the same time, I also felt I had to carefully handle what I said so Leonard would not feel compromised by my relationship to Liliane. I did my best to change the subject away from Liliane's involvement as quickly as possible.

I filled in other details I believed Mama included in the letter to Leonard. She had paid in advance the first three months of the school tuition. She gave me money for school supplies and uniforms. Cle would help me with those details. Mama had also included in the letter to Leonard money to cover my food expenses for the first two weeks, with the promise that she would send more within two weeks.

Nothing I said sufficed to satisfy Leonard. He felt trapped by the idea that I somehow became his responsibility. He felt ambushed with my surprise arrival and the idea that I would live in his house on a semi-permanent basis. No matter what I explained about my mother's point of view, he simply could not understand why she would push my education beyond what my hometown offered. After the excruciatingly long conversation to fill Leonard in on my plans for secondary school, he made clear he had enough hearing from me. He stormed back into the house.

Again I was left alone with my suitcase this time wondering how the saga would end, and where I would be going at this late hour in a strange city. A few minutes later, Mrs. Tanabet returned to the front of the house and ushered me through to a small windowless back room, attached to the dining room.

"You can stay here for now," she said and walked away immediately.

The tiny room looked more like a back closet with a door leading to the dining room. Left alone again, I piled my suitcase and duffle bag on top of each other in front of a tiny iron bed that looked more like a prison cot. I knew I was not going to be there for long. I sat on the bed and sobbed, while making sure that no one saw me cry.

Winding Staircase

My enrollment at the *College St. Francois d'Assises* ushered in a new phase in my life. The school, a white and blue building, sat imposingly on a hill and occupied a good portion of the block in a prestigious residential neighborhood in the capital. I had awakened early after a tumultuous first night in the capital and went to Liliane's house a few blocks east of Leonard's house with directions Leonard had giving me. Liliane then gave me directions to the school, located a few blocks up the hill from her house. I walked up the hill and arrived at the newly built school facility.

The school had opened for its first year of operation the year I entered. A tall iron gate secured the front entrance of the facility. The gate opened to a carefully landscaped and manicured playground, with trees and flower bushes in the center and along the edges. A long winding staircase cascaded from the building down to the playground. Elementary school children on the playground wore pink checkered jumper skirts and solid pink shirts. Secondary school girls my age and older wore a navy jumper skirt and a solid white shirt with a navy bow at the collar.

I stopped for a moment to catch my breath before starting up the long winding staircase leading to the administrative offices. A Canadian nun, dressed in traditional long white convent garb with a veil covering her head, greeted me with a broad smile and an extended hand. She ushered me inside the administrative office where Cle and Jessie had been waiting for me. My secondary school experience had begun at the *College St. Francois d'Assises*.

Later that day, I met again with Cle and Jessie outside the gate of the school. I asked Cle to help me find a way to connect with

Mama and let her know that I could not stay at Leonard's. With no telephone or reliable telegraph services, we could not contact Mama quickly, Cle said. I could write her and mail the letter, but Mama would not receive it for three weeks. I could not wait that long. I knew I could not concentrate on schoolwork while living at Leonard's. I recounted for Cle blow-by-blow the events of the night before at Leonard's house. Cle understood that I could not stay there. She made the decision to find me another place to stay and would explain it all to my mother later.

Cle made arrangements with two sisters for Jessie and me to live in a boarding house they ran for students from our hometown. We moved in that same day. The living arrangements felt a bit crowded for me, with several girls sharing a small living area. I so missed L'arsenal's open air. But the atmosphere in the home was warm and welcoming as compared to the tone at Leonard's. I felt like I had a fighting chance for a reasonably successful first academic year in secondary school.

Jessie and I shared a bed in a small room, with another bed for another boarder aligned next to ours. A small table with a lamp was tucked in a corner of the room. I used the little table to study and work on homework. I tried to stay current with homework like Mama taught me to do. I stayed up late every night after all the other girls were asleep to study at the little table. The rigorous curriculum at *St. Francois* kept me alert and diligent. Mama had stressed that I should put real effort into maintaining an academic standard of excellence.

"Cut down on unnecessary worry," she said. "Do your work every day and you'll have one less thing to worry about."

Her advice worked for me. Working hard, even if it meant long hours of study, made me feel better, one less battle to fight. To study for tests, I used the method Mama taught me when preparing for the eighth grade national exam. This strategy worked.

A Class of One

Heartbreaking news during the summer that followed my first year in secondary school rocked my world. I exited the bus at the station after a long day of travel in late June, returning home for summer break after my first year in secondary school. Mama and Joseph had been waiting for me at a friend's house across the street from the station. I saw them walk toward me as I stepped off the bus. Joseph picked up my suitcase, and Mama my duffle bag. I greeted them both with a kiss on the cheek. I noticed right away how unusually solemn they both seemed.

"Why is everyone so serious?" I asked.

Mama's eyes welled up with tears. She put her arms around my shoulders, a very unusual gesture for Mama, who hardly ever touched anyone except for a quick customary greeting kiss on the cheek. With all this mushiness, it seemed like an eternity before Mama finally blurted out the words:

"Mirlande is dead."

"Dead!" I repeated like a parrot.

"Yes, dead," Mama replied. "She was buried two weeks ago. I didn't want to write you about it because I knew you were coming home."

I looked at my mother in disbelief, feeling somewhat betrayed that she did not tell me something so important as soon as she learned it. This was about Mirlande, my playmate, my childhood pal. I had saved so many stories to tell Mirlande about the capital, school, and everything else. For a moment, I thought it was a mistake. Maybe I was hallucinating or Joseph was pulling another practical joke on my first day back and he convinced Mama to help

him. But I knew that Mama never joked. So what they were saying had to be true. I regained my composure and finally asked them to tell me what happened.

"She died during childbirth," Mama began to explain. "Neither Mirlande nor the baby survived."

"How could she have been giving birth to a baby?" I said naively.

"She was pregnant, stupid," the old Joseph snapped, trying to bring me back to reality.

"Pregnant?" I repeated. "How did she get pregnant?"

"What kind of dumb question is that? How do people get pregnant?" Joseph replied smartly.

A heavy silence followed this exchange. We all became solemn again. I had seen Mirlande during Christmas break when I came home after my first semester away. We had chased each other around the pig pen in the back of the storage hut. Mirlande promised to take care of my animals until I returned again. I promised to bring her a special kind of melt-in-the-mouth fudge made only in a little town on the way to and from the capital. She might have been pregnant then, Joseph thought. I did not see her when I came home for Easter. Rose told me that she was away helping her grandpa recover from a fall.

"If Rose told you that, she lied," Mama said. "Mirlande was pregnant and had been in hiding for several months."

"She's only sixteen," I said as if talking to myself. "Who's the father?"

No one knew for sure who the father might have been because Mirlande would not talk. She was terrified, Mama said, to say anything. Folks suspected that it might have been Leon.

"Leon?" I said. "Mirlande hates Leon."

Mama and I exchanged a long knowing look.

"Are you thinking what I'm thinking?" I asked Mama.

"I'd bet my bottom penny on it," Mama replied.

Leon, in all likelihood, had threatened to kill Mirlande if she told, I thought.

Mama tried to help by giving me information as best she could about the physical condition that caused Mirlande's death. She assumed that it would help if I understood what went wrong phys-

ically. Mirlande became ill about seven months into her pregnancy. Her feet began to swell up. As the weeks passed, her vision became blurry. Her mother sent for Estelle, the mid-wife.

It never occurred to anyone to take her to a hospital. No one ever went to the hospital at L'arsenal. Even if someone thought about taking her to the hospital, it would have been difficult to transport her there. The only means of transportation would have been by mule or horseback. By the time folks figured out that Mirlande was in danger, she could no longer travel. She had become so ill that her case was beyond Estelle's mid-wife skills. Mama and Estelle believed that no doctor could have saved Mirlande. Many women died the same way all the time, Mama said.

Mirlande's death deeply saddened me personally. Girls who lived and grew up at L'arsenal and the surrounding communities followed the same path of early pregnancy, early childbirth, and for some, early death. Many of them, like Mirlande, died during childbirth.

The news of Mirlande's untimely passing deepened my gratitude for Mama. It also brought to the surface how close I brushed with a dangerous precipice at L'arsenal. I was in a class of one among girls who grew up there. I had finished the eighth grade, passed the national examination for my *certificat d'etudes primaires,* and was attending secondary school in one of the most prestigious educational institutions in the nation. I turned sideways as Mama walked by my side. My eyes fell into her sad and weary eyes. We looked at each other for a long minute, as if we knew that we both were thinking about the same thing. *How different my life would have been, had she not been my mother!* I thought.

CRUEL FATE

As if the news of Mirlande's death was not enough, I learned more sad news weeks later. On my way to town from L'arsenal to visit Gabrielle that summer, I crossed *Grande Rue*. I spotted the back of a young girl who looked just like Rose. It seemed odd to me because I knew Rose lived with her grandmother somewhere in the L'arsenal area. The girl emerged from the side gate entrance of the house next door to Gabrielle's. She tried to balance a heavy bucket full of water on her head. She spotted me and quickly turned back into the side gate entrance.

That girl looks just like Rose, I thought.

It was indeed Rose. I recognized her cadenced walk from the back.

"Rose! Rose, wait!" I yelled.

She hurried and disappeared behind the gate. I rushed and entered behind her.

"Rose, Rose! Why are you running away from me?" I asked.

I walked briskly down a long cement walkway to the back of the house. Water flowed from a fountain into a large cement basin. A wooden closet stood just behind the water fountain. I searched behind the fountain. I slowly opened the door of the closet. A makeshift shower room, the wooden closet provided privacy for washing. Rose sat on the cement floor in one corner of the closet, staring at the back wall of the room. A large bucket full of water rested on the floor next to her.

"Rose," I whispered gently.

"Go away. Leave me alone. I don't want you to see me like this," Rose replied through sobs.

"Rose, it's me," I pleaded, "I just want to say hello. That's all. We are friends. Aren't we?"

Rose turned toward me suddenly, one side of her face visibly swollen.

"Who did this to you? What are you doing here?" I asked, alarmed and concerned.

Rose lifted herself up from the floor. "I did not want you to see me like this," she said. "I'll explain it all. But we need to get out of here. If the people who live here find us, we will both be in lots of trouble," she said almost in a whisper.

She picked up the bucket full of water and placed it over her head.

"Let me help you," I offered.

"You can't lift it," she countered, "it's really heavy."

"Why do you have it so full?" I asked. "Pour out some of the water to make the pail lighter. Let me help you."

When I said those words, Rose suddenly became frightened and hysterical.

"No, please," she pleaded. "If I don't bring a full pail of water over there, the other side of my face will be slapped just like the swollen one. Please, let me be," she said plaintively.

"What happened to you?" I asked.

"Let's get out of here and find a private place," she replied. "I'll explain. But I can't stay long."

Gabrielle lived in the house next door. Rose agreed to go to Gabrielle's yard to talk. I walked beside her as she carried the heavy pail of water on her head. We entered Gabrielle's gate next door. We sat next to each other on a small bench in the back.

"Remember how I used to say I'll never be a *restavek*?" Rose began.

Despite the disturbing sight of Rose's swollen cheek, it felt like old times when we played together under L'arsenal's soft moonlights.

"We talked about it a lot," I said.

"Well," Rose said "too many of us for Grandma to feed! Besides, I'm a girl. Girls always carry more than one mouth. We always become pregnant sooner or later. So Grandma chose me to give away to be a *restavek*. So I'm a *restavek*...a *restavek*, that's what I am."

She tipped her head down and folded her two hands over her lap. She had resigned herself to a cruel fate that so terrified her years before. Tears rolled down my eyes as I reached to touch Rose's hand and held it. We looked into each other's eyes for a long time as the tears pumped down. I reached with my other hand and touched the swollen side of Rose's face.

"Where your hand is," she said, "is where he slapped me this morning with his bare hands, after doing the same thing yesterday," Rose told me.

"Who? Why?" I asked.

"The man in the family I stay with," she replied. "I made the coffee too strong again this morning. It tasted like mud, he said. So he slapped me right across the face so I can remember to do it right next time."

"Rose," I said, "you can't stay there. We need to go find your grandmother and tell her. If you don't want to go to her, let's tell my mother."

"I ran away once and told Grandma," Rose replied. "Only that same day, the woman of the house found Grandma. She told her a terrible story about me. She said that I was a bad girl. They were trying to straighten me out and I did not like it. So, they said, I made up lies about them so I can be free to do bad things and become pregnant. The worst part is that Grandma believed her over me. She took me back to the woman's house that night."

"Oh, Rose! What about my mother? Let's talk to her," I said, almost in despair.

Rose explained that she had thought about talking to Mama. But Rose was afraid of retaliation for everyone.

"I can talk to Mama," I said to Rose.

"No," Rose said emphatically. Don't. That will make it worse."

She stood up abruptly and started to lift the heavy pail of water.

"I must go now," she said. "I've spent too much time talking to you. I am going to pay for it as soon as I set foot in that house."

"Wait! Where do they live?" I asked. "I'd like to see you again before I leave."

"No," Rose said firmly. "I must go. If you go over there and ask

for me, they'll beat me. If you tell your mother, they'll find out and they'll beat me. If you want to help me, stay away," Rose said sharply.

She then hurried away, balancing the pail of water over her head.

ONE GIANT HAND

The harsh reality of Rose's fate haunted me for weeks. I felt numb. I moped around L'arsenal for days, alternating between crying inconsolably and being furious at everything and everyone. One morning, I sat alone on the cement floor on the front porch. My back rested against one of the pillars. I played catch with the small rocks alone, no more Mirlande or Rose to play with. I abruptly stopped, overwhelmed with a deep sadness. I stared at the ground. Lost in my grief, Gabrielle's voice startled me.

"Good morning," said Gabrielle as she bent to sit next to me on the cement floor.

"I did not expect to see you," I said.

"I know," she replied. "I didn't expect you'd still be in town until your mother told me this morning you refused to go back to school."

"Did Mama send you here?" I asked her.

Gabrielle explained that my mother did not send her. But she knew Mama well enough to know that she was deeply hurt watching me throw away everything she had ever worked for to try to give me an education. Gabrielle told me that she was concerned because Mama told her that I did not talk to anyone and moped all day.

I heard Gabrielle. But I did not feel like talking to her either. How could I make her or anyone understand how I was feeling? I felt that we all failed Rose and every little girl like her. Despite Rose's sharp protest, I told Mama about Rose's situation. Mama understood well what happened to Rose. She felt powerless to do anything about it. She could not fight another battle, she said,

because her hands were full after taking in two young men, Gerard and Anthony, both in their early teens. Gerard had replaced Christiane as Elise's newest *restavek,* after Christiane abruptly and prematurely returned to her family. Gerard did not like it at the Tanabets and experienced a difficult relationship with Clara. He started first to spend long hours at L'arsenal helping Mama. Those long hours turned into days until finally Gerard asked Mama if he could stay with her at L'arsenal permanently. Anthony, a little younger than Gerard, came to live with Mama after the hurricane. His mother asked Mama to care for him because she could not feed all her children in the aftermath of the devastation.

Whatever the justification Mama offered, her detached response about Rose's situation infuriated me. I was tired of hearing how unfair life was and that God, and not people around Rose, was responsible for her fate. Everyone around me seemed so boxed in with accepting things the way they were, washing their hands off every injustice and walking away. No one was ever accountable. I was angry. Both Gabrielle and I stayed silent for a moment.

"What's the use?" I said finally. "What's the point of going to school? Mama thinks education is the end all and be all...the key out of this hell, she says. Well, out to what? I've had to leave everything important to me for an education; my friends, my family. Look what happened to Rose and Mirlande! I could not help them."

Gabrielle reached to stroke my hair. "I know how you feel," she said. "I know how devastating what happened to Rose and Mirlande is to you. But there is not much you can do about that by staying here and moping."

I thought if anyone really understood how I felt, they would try to do something about Rose. They would gather a group of vigilantes and go fetch Rose. No one understood how I or Rose felt.

"What are you going to do?" I finally heard Gabrielle ask me.

"I don't know," I replied. "I can go live at Elise's and be her *restavek.* At least I know I won't be slapped and beaten."

"Now, how crazy is that?" Gabrielle remarked.

"Why is that so crazy?" I snapped. "Rose does not have a choice about it."

"You are not Rose," Gabrielle reasoned gently. "You have been

given a different path. I don't like what happened to Rose and Mirlande either. I wish there was something I could have done to make it different for them. So many things we don't understand and never will. But one thing I do know...you have to do what God asks of you each moment."

"How do I know what God is asking me to do?" I asked.

"What's in front of you to do that's constructive and good is what God is asking you to do," Gabrielle replied. "Staying here and doing nothing or going to live with Elise is neither good nor constructive. All you'll be doing is becoming part of the problem and not the solution. Is that what you want?"

Gabrielle moved closer to me and put her arm around my shoulders. She explained that life gave no guarantees. She told me that no one could tell me that going back to school would change anything for me or for anyone. But she believed that I had to trust that my only real choice is to try to always be constructive and good.

"You can't change things for Mirlande and Rose, but you can be constructive and do what is in front of you as best you can," Gabrielle said.

I stared blankly at the ground, emotionless. I sensed Gabrielle's concern for me. I could not at that moment help alleviate her worries. I had reached the end of my rope. I could no longer see the point of doing anything. I somehow felt connected, bound to Rose in a strange way, as if what had happened to her happened to me or should have happened to me. Worse than my anger, I felt guilty that I was spared a fate Rose could not escape. I felt I deserved that fate more than she did. She was such a kind, sweet, harmless child. I felt worthless and defeated. I felt like Rose and for Rose, utterly humiliated with no reason to live. I wanted to die.

Gabrielle sensed my despair. She gave me a hug.

"This is very hard for you," she said. "Why don't you come and stay with me for awhile? I promise I won't talk about this at all anymore and I won't let your mother in to pressure you about anything. Just stay with me and rest for as long as you want. We'll see how you feel in a few weeks."

I took Gabrielle up on her offer. I didn't feel like doing anything anyway. Staying at her house for a few weeks would give me time

to clear my head and get Mama off my back.

The second night of my stay at Gabrielle's, I had a dream. I saw myself standing under a mango tree. A few feet away I saw a cliff. Leon, enlarged ten times his normal size, stood near the edge. He looked as big as a giant. He gripped by the neck with one giant hand a very pregnant Mirlande, and clutched Rose's neck with the other giant hand. Both sides of Rose's face looked swollen. Mirlande's face twitched in pain.

"Come and save…save…save them, if you can. Save…save…them…come, come," I heard Leon's voice echoing.

I put my hand over my face and turned the opposite way in horror with my back toward the cliff. I saw facing me in the distance Mama and Gabrielle running in place toward me, but not able to come any closer to me.

"You have a chance," I heard Mama's voice echo. "You can escape…free your mind…study…learn."

I awoke suddenly and sat on the bed. Grief and sadness overcame me. I missed Mirlande and Rose so terribly. I cried softly and talked to them through my tears.

"I am so sorry," I said. "I am so very sorry. I'll carry you both in my heart always. Rose, if you can balance that heavy pail of water over your head, I can find a way. If you can endure slap after slap on your beautiful face, and still turn the other cheek, I can find a way. Mirlande, if you could carry that baby in your little girl body, I can find a way. I can find a way to finish my education. I will finish it for all three of us."

Undeliverable

Heartbreaking news never seemed to stop for our family. I had come home for Easter break in the middle of my second year in secondary school, when we faced devastating news about Guy. Shortly after he'd left L'arsenal, Guy sent Mama a note to say that he made it back to the capital, and returned to his normal activities. Mama wrote him back. The letter was returned as undeliverable. When I went to the capital for school, I did not see him and did not know how to contact him. Mama had not heard from him since his note.

Fearing the worst, but hoping for the best, we did not talk about him. Every now and then when I asked Mama if she had any news of him she would answer: *"Pas de nouvelles, bonnes nouvelles"* (no news, good news). She would then change the subject. It was my cue that she was terribly worried about him, but could not speak of anything negative for fear it might come true. So I stopped asking.

One Saturday afternoon shortly after I arrived home for Easter break, Mama and I decided to visit Clara and Eve on *Grande Rue*. Mama was sitting in the front part of their boutique when the bus pulled in front of the house. Eve had just returned with her granddaughter, Clarisse, from a trip to the capital visiting family. Clara, Mama, and I stepped outside to greet them. The driver unloaded several suitcases and boxes and placed them by the entrance door. A petite woman in her early sixties, Eve stepped off the bus, holding little Clarisse's hand. Clarisse and I immediately went to each other in our big-girl-little-girl fascination with each other. I greeted Eve with a kiss on the cheek and took Clarisse's hand. Clarisse and I went off to a corner to play.

As Mama, Clara, and Eve walked inside the house, Eve became aware that the suitcases still lay on the floor at the entrance.

"Where is Monique?" Eve asked. "I need someone to bring in the suitcases." Mama immediately volunteered to move the luggage.

"You don't need to," Eve said. "Monique will do it. That's why we have servants."

As Eve made her point, Mama lifted one suitcase and brought it inside the house. Meanwhile, Clara yelled Monique's name toward the back of the house, calling her to come out.

"These folks are never around when you need them," Clara said impatiently. "One wonders what they do all day."

As Mama entered the house with a second suitcase, she overheard Clara's lament about Monique.

"Monique is way in the back finishing laundry. I saw her a moment ago when I peeked in. She's rushing to finish a large laundry load so she can be free to help you with other chores following your trip," Mama remarked.

A tall, thin, and dark-skinned fifteen-year-old girl emerged from the long hallway into the room as Mama, Eve, and Clara talked. The deep sadness in her eyes made her seem a lot older. She was reserved, as if she had overheard all of what was just said.

"You called Miss," she said directing her attention to Clara.

Clara motioned to her dismissively to move the suitcases to the living quarters in the back. Mama offered to help Monique carry the suitcases. As soon as Mama left the room, Eve and Clara began talking with a low voice as if whispering. Eve mentioned Guy's name.

"Is something wrong?" Clara asked Eve in a tone of insatiable curiosity rather than concern.

Eve replied that she had heard that Guy had been detained and that no one could find him anywhere. They continued to whisper as Mama walked into the room. Mama immediately sensed Clara's and Eve's uneasiness. They both stopped whispering like two naughty children caught with their hands in the cookie jar.

"Are you two still mad because I helped Monique?" Mama asked almost jokingly.

"Not at all," Eve replied. "We all know what a do-gooder you love to be."

"Then why do you two look like you've seen a ghost?" Mama asked them.

"Have you heard from Guy lately?" Eve asked disingenuously.

"No," Mama replied. "I was hoping you had seen him while you were in the capital."

"No, I didn't," Eve said.

"Too busy with the grandchildren, I suppose," Mama blurted out sarcastically.

"Marie, please…this is not the time to start a fight. I'm trying to give you a piece of news."

Mama suddenly noticed the serious look on Eve's face and asked Eve directly if she had heard something about Guy. Eve told Mama what she knew and added that she feared the worse for Guy. Mama became visibly saddened, but did not seem surprised. It seemed that somehow she knew something terrible had happened to Guy. She turned toward the corner where I sat and motioned to me to come with her. We immediately left Clara's and Eve's house in a hurry. Neither one of us uttered a word on the way home. We never saw nor heard from Guy again.

Fresh Start

The news of Guy's disappearance changed our lives forever. Mama later received a letter from a close friend in the capital, confirming her worst fears. Guy had disappeared for several months and believed to have been killed. He succumbed to a typical fate for many during that era. No one doubted what had happened to him. He was never seen nor heard from again. Dark and depressed days of desolation colored our moods after the reality set in that we would never see Guy again. We could not mourn his death and bring closure to our earthly relationship with him. We also knew better than to hang onto hope that he would return someday. Guy was gone forever, just like many other people we knew and many we did not know.

We did not dare talk about him. The gruesome images of his possible final days and moments haunted and tormented me for years. I worked hard for many years to eliminate a recurring dream depicting violent acts that resulted in his death. Each member of our family had to find a private way to mourn his death. We each moved around handling our grief alone, unable to acknowledge even to each other how much we hurt. No one outside the four of us and Charles, not even Mama's brothers and sisters, ever acknowledged our loss of Guy. It seemed as if Guy never existed outside of our little family. But he lived on in our hearts, etched forever in youth and vigor, as we had seen him the last time.

For the three of us children, the thought that we would never see Guy again was unbearable enough, but living with Mama every day grew worse than our grief. Her unpredictable mood swings ranged from frequent episodes of angry outbursts followed by de-

pressed and non-communicative bouts of unproductive self-pity. She tackled project after project with an unreasonable urgency that everything had to be completed at the speed of light. If we could not move as fast as she expected us to or did not conceive the project the exact same way she envisioned it, she became even angrier. A few days later she'd switch to a taciturn and depressive period. She withdrew into herself and detached herself from us. We wondered what would become of us.

The days passed quickly. My return to school approached fast. As the days passed, Mama's moods slowly improved. She resumed her normal daily activities, even though her characteristic enthusiasm had vanished. She kept herself moving with various activities to raise tuition money. But she seemed preoccupied, not quite herself, as if something weighed heavily on her mind.

"I made a decision," Mama announced to me one morning, as the two of us were alone attending to household chores.

Her calm and measured demeanor had returned suddenly. I was relieved, but curious about her announcement.

"I'm heartbroken over what happened to Guy. But worse things will happen if I don't take measures," she said resolutely.

"What are you going to do? What will happen?" I asked.

Mama reached for my hand and steered me in the direction of a chair. I sat down as she stood next to me with her hand resting gently on my shoulder. She seemed pensive, even subdued, but resolved as if she had come to terms with her situation. Her calm and collected demeanor reassured me. For a moment, I felt protected in the assurance that I had a mother. She'll always come through, I thought at that moment, take charge, and take care of me.

"Guy isn't the only son I have in this situation. I have Joseph and Bertrand. I cannot allow this to happen to my other sons," Mama remarked.

"Do you think something bad will happen to Joseph and Bertrand?" I asked incredulously.

She continued to talk to me as if she didn't hear my question.

"Not to mention you," she said. "I have you too. Life here is grim for us women. The future doesn't look bright for us here. I am going to try to save as many of you as I can."

"What are you going to do?" I asked again.

"I have written to Charles in New York. I asked him to begin to make arrangements for me to join him in New York so I can send for you and your brothers soon after I arrive there," Mama explained. Continuing as if talking to herself, saying her thoughts out loud, she said: "Thank God I had Charles and he had the good sense to leave this terrible environment when he could."

I did not know what to think about Mama's plan. On the one hand the idea sounded adventurous and intriguing. On the other hand I became immediately concerned over details, those small things I knew Mama simply was not concerned about until they'd explode. Once she had an idea she wanted to execute, she moved swiftly to accomplish her purpose, without much thought of the small everyday matters that formed the foundation of normalcy and that could create havoc when overlooked. Moving into an abandoned hut during late pregnancy did not exactly show prudence and planning. I was still shell-shocked over Mama's decision to send me to live at Leonard's in the capital, so far away from home, without considering the practical implications of her decision given the circumstances. Shipping me to Elise's house time and again, without considering how her decision affected me, left me wondering whether she did not care or did not think.

All things considered, Mama actually cared deeply, but did not think much beyond her first intuition, preferring to perceive reality as she would like it to be rather than how it was. Most of the time, her first intuitive decision turned out to be the right one. But in that particular instance, the magnitude of her proposition—contemplating a move to a foreign land with no apparent sense of the implications—made me feel skeptical and a little frightened.

"Will we all go with you at the same time?" I inquired.

She did not seem to have thought about that detail, of where and with whom she would leave us. But she knew it would not be possible for all of us to go together at once.

"The only way this plan can work is for me to go first and send for you later," Mama explained. "It has something to do with American immigration law. I won't even be able to send for you and your brothers at once. It may take a year or so before I send for the first one."

"What will happen to this farm? The kids who practically live

with us and the animals?" I asked.

Mama could not have known at the time that, once we moved away from L'arsenal, we would forever lose any right to return. We learned years later that the title documents to both the L'arsenal property and the family property in town mentioned neither her name nor the monetary contribution she gave to Clara to redeem the mortgages. Clara registered herself as sole owner of both properties. Mama did not learn this until many years after she had left L'arsenal to live in the United States. Clara died childless and apparently left both properties to other nieces and nephews, except Mama's children. Mama must have assumed that L'arsenal would always remain her property when she replied to my concern about leaving our home.

"One thing I've learned, dear, is that one must leave all sooner or later," Mama replied to me. "The farm and all will be taken care of. But I must go...."

"You would really leave L'arsenal?" I probed further, as if I was still hoping she would change her mind.

Mama didn't answer the question. She seemed past all these details. She was already in New York as far as I could tell. I began to resign myself that life would soon turn even more chaotic and uncertain for my two brothers and myself. It seemed inevitable. Mama had it with L'arsenal and the town. She wanted out. She needed a fresh start and yearned for a clean slate. She clung to the comfort of her hunch that by doing all that was possible to improve our lives she was fulfilling her mission. She convinced herself that all would turn out well.

Part IV

"And hold you in the palm of His hands"
—Michael Joncas

War Zone

Mama and Charles came to meet me when I arrived at New York's Kennedy Airport in October 1970, about eighteen months after Mama left. I stepped off the airplane and walked inside an American building for the first time. I felt so tiny in such fantastically gigantic and complex surroundings. After what seemed a long and exhausting walk among fast-moving people, I finally saw Mama and Charles waiting for me at a gate. Mama looked the same, but something had changed in her demeanor. She seemed more subdued and reserved than the feisty hurricane Marie I remembered. We found our way through complicated ramps to Charles' car. I climbed in the backseat of the car. In the front seat, Mama turned to me and said that life for us had changed dramatically.

It didn't take me long to understand what Mama meant once we stepped into Charles' and his wife's three bedroom apartment in Brooklyn. I learned that three separate families, all recent immigrants from Haiti, in addition to Mama and I lived in the apartment. I felt restrained inside that apartment, much of the same trapped feeling I experienced when Mama left me at Elise's. Except this time it was the physical surroundings that felt like a prison. Perched on the fourteenth floor of a tall building in a densely populated American city, Charles' apartment was nothing like the free outdoor lifestyle at L'arsenal. The only window in the apartment that was not somehow blocked overlooked the dull side of another building.

"You're going to have to adjust fast, dear," Mama said to me when I finally settled into the room I shared with her the first night. The following days were lonely. Everyone left for work at the crack of dawn. I stayed in the apartment alone for several days. I hardly saw Mama. When I finally could spend a little time with her, she seemed exhausted, anxious, and frustrated that I had not yet started attending school. Charles gave us a complex explanation of school districting and why I could not attend the high school of his choice. His explanation made no sense to either Mama or me. Mama spoke very limited English and did not understand enough about the complexities of schools and addresses and safety to make the necessary arrangements herself to enroll me in school. She depended totally on Charles to handle my school registration details.

But Charles seemed extremely nonchalant, if not downright disinterested and indifferent, to follow through with the steps necessary before I could attend school. Following through meant that Charles needed to take a day off from work and take me to the high school in the right district and register me there. He seemed to be stalling. He gave Mama the excuse that he could not take time off from work, but reassured her that he would find a way to enroll me in school as soon as he could.

Besides the monosyllabic words Charles used to respond to Mama's questions, he was otherwise totally non-communicative. He seemed preoccupied, unhappy, and otherwise disengaged. The few times I saw him in the apartment, he was always staring at a newspaper in front of his face, deliberately it seemed, discouraging any conversation with me. His demeanor reminded me of Stuart's.

The end of October approached fast. School had been in full swing since early September. I had now been living in the United States for a full three weeks. Still, I was not enrolled in any school. Mama became visibly agitated one Saturday morning and confronted Charles.

"Don't you think I am just as concerned about this as you are, Mama," Charles snapped at Mama angrily. "Look at this girl, less than one hundred pounds, frail, and naïve. She'll be eaten alive in those schools around here. This is a war zone, Mama, don't you get it?"

Charles then picked up his newspaper and stormed out of the apartment. Mama came into the room where I sat on the bed listening to her conversation with Charles.

"It's God, you, and me, little girl. No one is going to help here. It's time to start praying," Mama told me as she gently touched my shoulder. "We'll find a way," she said reassuringly. "You'll see."

I heard Mama well and began praying in earnest. The confining way of life in such close proximity with mostly total strangers became unbearable day by day. I stayed away from everyone in the apartment by hiding in the room I shared with Mama. The tension between Charles and his wife further strained interaction between all the dwellers in the apartment. Charles' wife's public confrontations of him became personally disconcerting to me. It took all my strength to stay behind the closed door of the room so as to not become embroiled in the altercations.

Charles' behavior toward me grew more taciturn and distant each day. His demeanor, speech pattern, and overall attitude patterned that of Stuart. But Charles' love and devotion for Mama and I were evident. Despite his obvious frustration with the overall circumstances, he remained as gentle as I remembered him when he left our hometown. He had always expressed to me a special big brother love I experienced from no one else. He continued to call me fondly "little sis." I now realize that the period I stayed in his apartment was a particular trying time in his life. He did the best he could under very difficult circumstances that I did not totally appreciate at the time. I fully recognize the significance of the role he played in my life. Ultimately, Charles carried out alone Guy's promise to Mama, a promise Guy could not keep. Charles undertook and succeeded in helping Mama restore her middle class upbringing for her three younger children. He characterizes his role in uplifting our little family's standard of living as the greatest realization of his life. I too view his support and love as a significant and meaningful lifetime achievement that has touched many different people.

Despite the distress I experienced with my living conditions those early months in the United States in Charles' apartment, I remained hopeful. Deep down I knew somehow that the circumstances would pass and I would be on track again. The month of

November came and went. Still, I was not enrolled in school after living in the United States for almost two months. I used the time during the day to pray incessantly, asking for direction for Mama and me and a way out of this impasse. The answer to my prayers came in mid-December, in a way I didn't expect and didn't really recognize at first.

Drastic Measures

Mama worked for a French woman, Sara Nibul. The woman hired Mama because they could communicate in French, and it was not necessary that Mama speak fluent English. Mama and Sara became good friends. She confided in Sara about the impasse we found ourselves in, regarding further schooling for me in the United States. Sara had heard Mama brag about me for nearly the entire preceding year. All of this bragging paid off in our hour of need. Sara became alarmed when she learned that I, a seventeen-year-old, had been in the United States for close to two and half months in the middle of the school year, and was still not attending school. Mama, although frustrated, did not quite appreciate the implication of the potential danger for me if we didn't resolve the situation quickly. Sara understood well that we needed drastic measures to ensure that my education stayed on track.

Sara and her husband lived in Greenwich, Connecticut. She told Mama that the Greenwich school system offered an excellent education, and suggested that Mama consider sending me to live with a family in Greenwich so I could attend high school. Sara herself lived in a remote part of Greenwich which did not have access to the town's school bus transportation system. For this reason, staying with Sara's family, an otherwise easy solution, was not an option. Sara believed that certain families she knew would be open to offering me employment as a mother's helper, teaching French to their children in exchange for room and board. If Mama was interested in the idea, Sara assured her, she would make it happen in a flash.

I had never heard of Greenwich, Connecticut and had no idea

what moving there meant for me in the short or long term. Mama, of course, was delighted. To her, the suggestion was no different than sending me off to Elise. The proposal fit well with Mama's usual modus operandi. After all, for my seventeen years of existence, the best discharge of her parental responsibility toward me consisted of shipping me off to live with other people for my own good, she believed. She felt relieved when it became clear to her that Sara's idea could be workable. She had received the blessed answer to her prayers.

I did not share Mama's point of view about this solution. However short-sighted it now may seem, I was terrified. I had become accustomed to life as it turned out to be at Charles' in the two and half months I had spent there. From my point of view, finding someone to enroll me in a school in that district offered me greater emotional security than going to live with complete strangers. Removing the only security base I'd known in this new country, in addition to the stress of a new school, threatened me at the core. No one around me thought for a moment of the magnitude of the life change I underwent when I arrived in New York or of its impact on me at age seventeen. No matter how I felt about it, Mama had set in motion her unstoppable will. I knew that the outcome was inevitable. I was about to move to Greenwich, Connecticut to live among strangers for an indefinite period of time, whether I liked it or not.

When Mama shared the news with Charles, his reaction deepened my fears. He flatly told Mama that it was far more dangerous to send me to live in Greenwich than to enroll me in any school district in the city. He felt that I had a greater chance of surviving potential physical harm than the long-term psychological destruction of racism. Neither Mama nor I, up until Charles' lecture, ever thought of ourselves as anything other than plain old Marie and plain old me. We could not conceive how the color of our skin had anything to do with our identity, or how it could form the basis of any decision we made, or for that matter force us to alter a course of action that seemed otherwise logical.

Mama, of course, naively dismissed his concerns. She callously dropped on him the reproach that if he was so concerned, why didn't he move from his dead center and enroll me in a school right

away? Her resentful remark, however cutting, seemed fitting in light of the recklessness of Charles' behavior. From my point of view, Mama would not be contemplating shipping me off to strangers had Charles acted sooner. Action speaks louder than words. It seemed, despite his expressed skepticism about the wisdom of Mama's decision, that he too received the outcome he wanted.

On my part, I did not dismiss Charles' concerns. They made me feel apprehensive, even though I did not fully understand them until close to a decade later. His expressed concerns, however, did not offer any solution to my dilemma, but worsened it. During the week that preceded my scheduled move to Greenwich, I cried inconsolably night and day. The cultural, social, and spiritual demands of the changes thrust upon me had become overwhelming. I was still only seventeen. I prayed and hoped that God would remove this bitter cup from me. Deep down, I sensed the potential danger of my living conditions. Anything that would put me back on a constructive track of schooling had to be an improvement. Yet, my long-term yearning for emotional security made me want to cling to the familiar within some semblance of family, however dysfunctional. This yearning collided head-on with the crucial requirement of furthering my education.

For most of the week prior to moving to Greenwich, the magnitude of the dilemma swallowed up any measure of rational thinking I could muster. As the date of my move approached, I resigned myself to my fate and fell back on the guiding principle Mama continuously repeated to us at L'arsenal. "The only responsibility you have," she would say, "is to give your best effort to whatever task is placed in front of you today—the rest will take care of itself." I went through the motions of doing whatever seemed logical to carry out the move. Everything else was out of my hands. I moved with the flow, one step at a time.

The Pregnant Silence

In early January 1971, Charles and Mama made the trip with me from New York City to Greenwich, Connecticut. The trip over long bridges and gigantic highways and along fast moving cars seemed long and dizzying. I felt somewhat disoriented with the fast pace and the sheer size of the fast moving cars, trucks, and trains. None of us in the car uttered a word to each other. I could slice the pregnant silence with a knife. Charles and Mama planned on dropping me off at Sara's house, where my host family would pick me up. Sara had made arrangements for me to live with Elizabeth and Dan Marshall and their two daughters, who were eight and eleven years old. The family had agreed to provide me with room and board and the opportunity to attend high school, if I worked as a mother's helper and taught French to the girls.

When we finally arrived at Sara's house, Elizabeth had already been waiting for me. As I exited Charles' car, Sara followed by Elizabeth, came out of the front door. Sara opened her arms and gave me a hug as if she had known me forever. I extended my hand and shook Elizabeth's hand. Charles approached behind me with my little suitcase.

"Why don't you put your suitcase in the car ahead," Sara suggested to me, pointing to a parked car we understood to be Elizabeth's car.

Sara and Elizabeth rattled off English words I did not understand. Finally, Sara instructed me in French to go sit in Elizabeth's car.

I knew the time had come to move on. I took the few steps toward Elizabeth's car and opened the front door to enter. I felt

Mama's presence behind me. I stopped and turned. She stood inches away from me, with eyes welled up with tears. I didn't cry. I was done crying. I gave her a kiss on the cheek and gently wiped the tears off her face, as if I had now grown up. I had become the reassuring parent telling her that all would be well, even though I had no idea how things would turn out. I felt right then and there that Mama and I had reached a turning point in our relationship. I turned and entered the car unceremoniously as Mama pushed the door closed behind me.

We looked into each other's eyes through the glass window. Her eyes told me that she had accomplished her mission. She had done all she could possibly have done. She didn't have anything else to give. It was up to me now. I gently nodded my head as if to reassure her that I was ready to push on with the journey she started long ago. I tried to let her know that I was up to the task ahead. She had done well. I'd take it from here. We will triumph somehow.

Pink Elephant

Living at the Marshall home opened up a brand new path of growth and experience that neither Mama nor I could have planned. Kind, caring, and gentle, Elizabeth thought of everything to make me feel welcome. We entered her estate through the garage. She helped me with my suitcase and bag. She led me up two sets of stairs to a suite directly above her garage. We entered a room as large as Charles' entire three bedroom apartment. With large glass windows on two sides, the room overlooked a large manicured yard on both sides. Branches of a weeping willow tree dangled outside the largest window. I immediately felt a sense of tranquility and peace that I thought I could only experience at L'arsenal. A large piano sat directly under the east window. Elegantly furnished with sofas, lazy chairs, an oriental rug on the wooden floor, and artwork on the walls, the room looked like the living room of a queen, or at least a princess.

From this beautiful and spacious room, a small hallway led to a carpeted bedroom with its own bathroom attached. The curtains on the bedroom window matched the rest of the room's décor. Elizabeth ushered me into the bedroom. She opened the door to a closet and put my suitcase and bag inside.

"This will be your room," she said.

I did not understand enough English to fully grasp what she said. She immediately sensed my distress and that I might not have fully understood all she meant. She opened her shoulder bag and pulled a notebook with a pen attached and a fat little book. She wrote down in the notebook the sentence she had just uttered and showed it to me. She then opened her little book, which turned

out to be a French-English dictionary. She looked up the word "room" and showed me the French translation. I understood immediately what she meant. We looked at each other and smiled. She reached to me with open arms and gave me a hug. My communication with Elizabeth continued like this for several weeks, until neither one of us no longer needed the French-English dictionary to understand each other. I felt loved and protected in the Marshall home. Despite this wholesome feeling, I still longed to be with Mama and the boys the way it used to be at L'arsenal. Even in the first few busy days, I could not escape the overwhelming loneliness and sadness that I experienced at times.

The first few days were filled with errands. Elizabeth took me with her everywhere—the grocery store, the mall, restaurants, church, meetings, and parties. She did her very best to include me in all the family activities. She took the girls and me shopping for new school clothes and shoes. In the car to and from these errands, Elizabeth would turn on the radio. She and the girls would sing along and coax me to join in. Even though I felt awkward and out of place, I had fun.

I did the best I could to try to fit in, but I learned quickly that that was impossible. I could never blend in. I stood out like a pink elephant no matter where I went. I was the only person of color anywhere in any of the places the Marshalls took me. Added to that, I spoke very little English. The Marshalls' friends and acquaintances were curious and asked lots of questions about my background, some of which I understood enough to reply. I mostly smiled and everyone quickly moved on.

I didn't fit in with young people my age either. My perpetual survival mode mentality distanced me from the affluent and privileged lifestyles of my peers. I felt lonely, isolated, and strange. Yet deep and profound changes began to occur within me, altering my perception of life possibilities. It took me years to really appreciate the impact of these first crucial months I spent in Connecticut and their place in shaping my experience. The move to Connecticut to live with the Marshalls not only opened the door for me to complete my education, but it also played a significant role in shaping the person I would become.

The Marshalls were deeply committed to nurturing their rela-

tionship with God. They worked at it systematically every day through the study of Bible lessons and inspired readings. Whatever the nature of the challenge they faced, they turned to God on a daily basis for answers. I immediately connected with that aspect of their lives and found immediate comfort. They took me to church where I met Helen, my Sunday school teacher. She became a close friend, and turned out to be one of the most influential figures in my life. Helen immediately detected my thirst for spiritual growth and generously devoted time to lengthy discussions with me, as I sorted through questions of my life purpose and relationship with others. She helped me think about practical ways of exercising my trust and reliance on God. We pondered passages in the Bible and other inspired writings and related them to my day-to-day challenges. My appreciation for prayer and its effectiveness in solving every human problem deepened as I learned more about the nature of God.

Helen and Elizabeth found for me the French translations of inspired writings so I could study them in both languages. Reading inspired writings in both languages at that time ensured my complete understanding and facilitated my conversations with Helen and Elizabeth about them. That exercise incidentally helped tremendously to strengthen my understanding of the workings of the English language, when I hardly understood any English when I first arrived in Greenwich. Within three months of my arrival at the Marshalls, neither Elizabeth nor I needed a French-English dictionary to communicate.

As I talked to Helen over several months, she became a strong parental figure in my life. Her devotion to my growth came through to me as genuine with no agenda other than my best interest. She encouraged my independence and respected me as a thinker. She did not try to sway me to her way of thinking, but gently steered my thought from negative pessimistic views to the natural hopeful perspectives I often expressed. She encouraged me to focus on all the goodness around. She taught me how to graciously accept blessings and goodness in my life as the norm rather than random phenomena. She showed me how to stop expecting misfortune, and to claim grace and abundance as my birthright.

Elizabeth and her family played a similar role to Helen's in a

different way. She supported me in every way in my daily contacts with her and the myriad thoughtful little details she lovingly handled during my stay with her family. While we constantly talked as a family, Elizabeth did not delve too deeply with troublesome feelings and issues in the same manner I talked with Helen. Elizabeth was caring and supportive, and delivered with love, generosity, and thoughtfulness the crucial and basic contribution of providing me a loving and supportive environment to flourish and learn. I felt, to say the least, very fortunate.

The journey to consistently maintain a hopeful outlook was long, arduous, and replete with many hours of darkness and despair. But as with any endeavor one patiently pursues, the intermittent break of dawn in my thoughts and feelings opened the way to longer periods of brightness and hope. I began to develop a more confident self-image. This was particularly evident in the area I was focused on at the time—academic ability. Recognizing my God-given intellectual and intuitive capabilities eventually led to professional competence and success.

Helen's and Elizabeth's belief in and expectation of me gave me powerful wings to fly, and I trusted them. They unselfishly mothered me during those crucial years in the United States when the divergent luring paths lay wide open for me to drift in. They took on the responsibility of nurturing me as parents simply because I appeared in their paths. They had no reason to assume this responsibility and certainly nothing to gain. They remained spiritually and morally rocks in my life for many years to come. With each milestone I reached, such as graduation from high school and beyond, I could feel their pride. It gave me the strength to push further. Their selfless love genuinely focused on my best interest, with nothing invested for them other than my successful growth.

CHILLY AIR

I had never set foot inside an American students' hall before that chilly January morning on my first day as a student at Greenwich High School. Within days of my arrival at the Marshalls one morning at seven o'clock, Elizabeth drove me to the school bus stop at a corner a few blocks from her home. Facing and overcoming cultural differences became the focal points of my adjustment the first few weeks of my experience as a student in the United States.

Elizabeth told me the day before my first day of school that I could wear anything I wanted and that the school did not require uniforms. To me that meant that I should dress in my best clothes. For my first day I put on a gold/mustard color dress with a row of gold buttons at the front, nylons, and high-heel shoes. Pulling one's hair in a bun with something of a high rise in the middle had become fashionable among girls my age the last few months I attended school in Haiti. So I fixed my hair in a bun, twisted up the center of my head to look really dressed up for the occasion. I then saddled into a heavy black coat. I did not realize how out of place I was going to look and feel.

When I walked down the steps from my living quarters into the Marshalls' kitchen, Elizabeth and I greeted each other. She looked at me from head to toe in a curious way, but she did not say anything. When we reached the bus stop, several students were waiting there. All of them lived in Elizabeth's neighborhood, an upper middle class, affluent (obscenely so) and exclusively Caucasian community. Absolutely no one looked like me at that corner. There was no escape. I was conspicuous and I stood out like a

white horse as I followed Elizabeth from the car to the group of students. The curious stares cut through me like the chilly air. Elizabeth approached one of the girls she recognized as her next door neighbor.

"Hi, Jennifer," Elizabeth said to the girl. "Let me introduce you to Jacqueline. We call her Jackie. She lives with us and will be attending the high school until she graduates in a year or two."

"How nice," the girl replied, acknowledging me in a somewhat curt and detached manner.

She too inspected my manner of dress from head to toe with an amused look on her face. Elizabeth informed Jennifer that I was a foreign student still learning English. She asked Jennifer as a favor to help me transition at the high school these first few days. Jennifer replied obligingly that she would help. Elizabeth asked her to take me to my guidance counselor once I arrived at the school. Jennifer agreed.

"A *bientôt*," Elizabeth said to me in a strained and heavy American accent as she turned to walk back to her car.

I stood at the corner for another ten minutes after Elizabeth left. The other students talked among themselves as if I was not there. The school bus finally pulled up at the corner. With everyone on the bus staring at my hairdo, I found a seat and sat quietly in a corner. Both numbness and adrenaline ran through my body. I felt like an alien from another planet with the stares from fellow students. I had no idea what to expect when it came time to step off the bus and set foot inside the school. I wished I could disappear. I pinched myself and knew I was not dreaming. Again I turned to Mama's admonition to do my very best with everything put in front of me and "the rest will take care of itself." I hung on to that thought as I moved through the stress of this new situation.

I exited the bus. Jennifer dutifully waited for me and accompanied me inside the building as she promised Elizabeth. She pointed me to the office where I was scheduled to meet my guidance counselor, according to the note Elizabeth gave me. I said thank you to Jennifer and walked into the office. A receptionist greeted me and began to rattle off, a mile a minute, English words I did not understand. A tall bearded man walked out of an office and came to my rescue. He asked me to step into his office. Sara or Elizabeth must

have telephoned him. He was expecting me and he didn't seem to think that I would understand every English word he uttered.

Following a brief one-sided conversation, my guidance counselor accompanied me to my first class. He briefly spoke to the teacher and left. That first class was a History class. The teacher spoke enough French to communicate with me and introduce me to the class. At the end of the period, she accompanied me to the French department where I met the language teacher. Finally, I met a person who spoke French fluently. It was delightful. He expected students to speak French in the department and discouraged communication in English. I felt right at home for that period and even a little competent for a change.

At lunch time on the first day, I returned to the students' center. I felt bewildered and out of place, especially in the way I was dressed. Students in the center mostly wore jeans or short skirts, tea shirts with their hair down for the majority, and afro style for the African-American students. I stopped for a minute in front of the cafeteria and scoped the students' center. I noticed that the majority were Caucasian students that were scattered all over, seated at tables across the center. A handful of African-American students all sat together around a couple of tables in an area of the center. I did not see any African-American students seated at the rest of the many tables. I did not see Caucasian students at the few tables where the African-American students congregated. I was not sure exactly where and how I fit into that picture. With as clean a slate as I had that moment, with no particular tribal attachment and no appreciation of the social politics, only the values I had internalized up to that point guided my initial decisions.

For some reason, when the meaning of the divided seating arrangement in the student center along ethnic background sank in for me, I thought about Stuart and Nomis. Stuart in particular popped into my head because I finally understood what caused his behavior and the incredible long-term effect it had on me. Stuart's behavior for certain occurred in an atmosphere that tolerated biased attitude as an accepted norm. He classified me even at my tender age solely based on the fact that Mama had given birth to me. Whatever the genesis of the resentment between Stuart and Mama, I didn't understand it and could not have been part of it. I

was not even born yet. Yet he succeeded in sending me the messages of his categorization of me. His biased attitude deliberately separated me from the family, and most significantly inflicted profound injuries to my young spirit. My six-year-old reaction to his destructive sentiment was retreat. Seeking self-protection, I didn't want to be with Stuart and Nomis. When Mama forced me to stay at their house, I hid in the backyard as much as I could to avoid the harshness of the interaction with them.

I decided right then at the students' center that first day in an American high school that I would do everything I could never to fall into the trap of separating myself again. I wanted to remain open and receptive to selecting friendships and activities. I resolved to do my best not to allow undermining attitudes and biases to classify, categorize, and relegate based on anything other than my interests, strengths, and healthy aspirations. That resolution, I came to understand over time, became difficult to keep in many instances.

As I stood there, pondering these thoughts, an African-American young man approached me from the back.

"Hey, sister, new in the school?" the young man said to me.

Not understanding enough English to know what he asked me, I replied "Yes."

"My name is Colin. What's yours?" the young man continued.

I only understood the word "name" in what he said. I guessed the rest of the question.

"Jacqueline," I replied, pronouncing my name as it would be correctly pronounced in French. Colin did not understand my name with a French pronunciation.

"What?" he asked me. I again repeated my name with the same French intonation.

"Oh, Jackie," Colin said with a smile.

"OK, Jackie," I said, relieved.

Unfortunately for me and later to Mama's and Charles' dismay, that nickname has stuck with me. I've tried to fix the spelling to make it closer to the French version, but even that did not always work. It seemed that I did not even have control over my own name in this new place. But that feeling passed quickly. Compared to the nickname "Quiquine" of long ago, Jackie didn't seem so bad. It didn't sound like a bad medicine and didn't make

me feel small. I learned to love the new American version of my name and started calling myself by it.

When Colin figured out that my proficiency in English might be limited, he raised his voice to speak louder, thinking that it might help if he spoke louder and slower.

"Come and sit with us over there," he said slowly, almost shouting, as he pointed to the table where the African-American students sat.

He had no idea how stupid he made me feel by shouting. But I took it all in stride, feigning a smile.

"OK," I replied compliantly.

I obliged Colin as I did a host of different other students on many other occasions. I sat with him. I decided to open up more to new friendships. Close friends became my most prized possessions at that time. I tried hard to overcome my loner mentality. I needed to learn to love and appreciate friends and constructively incorporate them more in my experience. Colin introduced me to his friends at the table.

"This is Jackie," he said. "She is new to the school today."

"Hi! Where are you from?" a female student asked.

I did not understand the question. So I smiled at her.

"Where are you from?" she repeated.

Again not understanding what she asked, I smiled at her.

"Is she dumb or something?" a male student turned to Colin and asked.

"I think she's a foreign student and doesn't understand English," Colin replied.

"Then what is she doing at our table? Can't she join them foreigners over there?" the male student said.

"Be nice. She's a sister," Colin said.

I sat nervously at the table. I did not understand the gist of the conversation. But I knew they were talking about me. I felt uncomfortable.

"You want to get some lunch?" Colin said to me finally, breaking the awkwardness of the moment.

We walked together toward the cafeteria.

The following few days at school I slowly became acquainted with the foreign students who congregated around one table in the

students' center. I gravitated toward that group initially because I met three students from France. With no language barrier I became instant friends with the French-speaking students, despite the other obvious cultural differences, such as ethnicity and socio-economic circumstances. Despite language barriers, I also made easy friends among a few first generation Hispanic students from Central and South American nations. The commonality of experience as immigrants from third world nations in a mainstream American environment helped me tremendously. The handful of Hispanic students I became friends with provided me with the only social group where I felt truly accepted, more or less as an equal. However awkward and strange I felt most of the time, my life in Greenwich, Connecticut began to settle into a predictable routine.

 I slowly began to feel less stressed due to new circumstances. I was still uneasy and apprehensive about my ability to speak and understand English, but I nonetheless felt comfortable with the level and amount of schoolwork. My understanding of both spoken and written English developed steadily.

 I was very fortunate to have been one of the first foreign students at Greenwich High School to participate in a newly created school program called Teaching English as a Second Language. The school at the time relied on volunteer mothers and advanced students to staff this support program for teaching English to foreign students. It gave me one-on-one tutorial support with learning English, an opportunity which proved to be a very valuable foundation and springboard for future academic success. Participation in the program also gave me the opportunity to meet and develop close relationships with my two tutors, an adult volunteer from the community and a fellow student. These two tutors provided me with an additional support system. The adult volunteer, a kind, gentle, and down-to-earth woman, loved teaching and sharing. In addition to teaching me English, she assisted me with my regular homework. She also coached me to support my social integration as much as possible. My other tutor, an unassuming and down-to-earth fellow student, turned out to be a genuine friend as well as a competent tutor. The program received local media recognition, and I was featured along with my two tutors in a local newspaper article.

I studied very hard. I used Mama's method of learning to stay on top of my schoolwork. Despite the enormous challenge of understanding sufficient English to stay current with school expectations, I managed to settle comfortably among the serious students group, average in some classes and above average in others. By the end of the school year, five months after my first day of school hardly speaking any English, I scored reasonably well in all my classes, including earning to my surprise an A in, of all subjects, Biology. These first few months set the tone academically for the rest of my career as a student in the United States.

Soon after the Marshalls reviewed my first report card, the talk about my applying to college began. I still did not quite understand all that went into college entrance. Dan Marshall, in particular, took a special interest in encouraging me and planning strategies for me to apply to college. Around that same time, the subject of college entrance also surfaced in conversations with my school guidance counselor. Mama beamed with pride, contemplating the thought that I would pursue higher education in the United States, a step beyond any of her dreams.

Unavailable and Inaccessible

Colin became my good buddy, and kept me company for much of the time I spent at Greenwich High. Preferring one-on-one interaction with the few close school friends I managed to make, I never felt comfortable in a large group. I suspected Colin preferred one-on-one interactions as well. He sure liked to hang out with me. One day I mentioned to him that I didn't like riding the school bus in the morning. He immediately offered to pick me up and take me to school on the days he drove to school. I refused at first, but eventually accepted his offer after he continued to ask every day for a few days.

I looked forward to the days Colin picked me up and drove me to school. We talked about school, his wrestling matches, his family, and his aspirations for college. He dreamed of attending Princeton University. I didn't share much with him about my family and background beyond the basics. He didn't ask questions either, and I loved him for that. I mostly listened to his stories about sports.

He asked me one day about my professional plans.

"I want to be a lawyer someday," I replied without hesitation, even though I had not thought about it in a long time until the second I said it to him. He smiled.

"I am not surprised. I expected that much," he said to me with approval.

I introduced Colin to my close circle of friends. Everyone immediately assumed Colin was my "boyfriend" and was delighted. They thought Colin was perfect for me. He was a good student, had aspirations to attend college, and he was African-American. A

few of my closest friends thought Colin perfect for me particularly because of his ethnic background. Actually, until someone pointed out his ethnic background as a significant consideration in selecting a potential partner, I had never considered racial identity as a value in the selection of the person I would marry someday. But I received the message crystal clear that in that particular situation it was indeed a value, and I had better learned to embrace it.

My relationship with Colin, however, served a very different purpose. He was a bright, thoughtful, and respectable young man, wise beyond his years. My discussions with him opened my eyes to the various forms of bias that sometimes infiltrate interactions with people I genuinely loved and I believed also cared about me. My connection with him marked for me the beginning of a long journey of learning about a profoundly disturbing aspect of American life, resulting from cultural assumptions based on racial identities.

However difficult my childhood years had been, racial identity was not a significant factor. I became aware soon after moving to the United States that racial identity underlay all of my interactions. The implication of this social undercurrent caught me by surprise. I felt unprepared to manage the personal impact of this realization on my self-image. As much as I wanted to avoid it, I could not escape having to confront my emotional reaction to this new reality. The cultural reality that the color of a person's skin could so pervasively define that person's experience at every level utterly confused me, from both spiritual and social perspectives. Colin detected my confusion, and assisted me by comparing notes from his own experience.

Our conversations helped me understand the importance of opening my eyes in everyday encounters to detect patterns of negative attitudes and suggestions that subtly undermined my self-image, if I unknowingly accept them about myself. These attitudes often come insidiously and relentlessly from well-meaning people who might not have even been aware of the destructive nature of their own biases. For example, shortly after my move to Connecticut, I became self-conscious about my hair texture when I learned that it bothered friends enough that one of them suggested that I wore a wig. Not recognizing at first the underlying racially based negative message, I complied with the suggestion for a period of

time. Colin helped me understand the implication of the suggestion. Through his support, I defied the negative message about my hair or any other feature of my physical appearance. The wig quickly found its way into the garbage can.

Exposing to myself the subtlety of biased thinking helped me appreciate and accept my uniqueness, just like it was important to accept that of others. This proved to be a difficult task in the extreme minority situation I found myself in. I could only fall back on whatever sense of self Mama managed to instill, and on a handful of friends like Colin with common experiences and perceptions. Internalizing constructive thought patterns to navigate safely in any cultural environment, embracing the best and challenging where necessary my perception of negative undercurrents, became a lifelong endeavor as I negotiated my niche in this new environment.

Colin remained my wonderful friend for the duration of my stay in Greenwich. I learned one Saturday night that the sole purpose of my connection with him was to ease for me an otherwise unbearable social situation during the time I lived in Greenwich. On a rare occasion when I did not have babysitting duties, Colin picked me up to go with him to the movies. On the way out of the theatre, he reached for my hand and we walked hand-in-hand toward his car. We didn't talk much. I knew there that Colin would only remain a close friend. At that particular juncture in my life, I was in no position to venture into any complicated relationship with anyone, regardless of whether such person was blue, purple, or gray. I did not consciously understand my emotional reaction at the time, but I knew I did not have the maturity and emotional wherewithal to add another layer of concern, given the circumstances of my life at the time.

I was still haunted by the distorted models of non-communicative, silent, and unavailable men (Stuart, Nomis, Miguel), physically present sometimes but always totally unavailable or inaccessible. Waging the battle to dismantle these distorted models of men that I internalized would have to wait until a much later point in my life, after I became conscious of the different forms of their imprints. My priority at the time centered on furthering my education to a point of reasonable accomplishment and closure

acceptable to Mama and me. I still faced a considerable road ahead in the fight to complete my education and adjusting to the complexities of life in the United States. Despite my emotional need for meaningful closeness, circumstances required me to postpone the quest for right companionship. My close friendship with Colin continued throughout the remainder of our high school days. We eventually lost touch after we both moved on to college. The legacy of our friendship carried me far in assimilating as an African-American in the complex American multicultural environment, given the particular set of circumstances of my assimilation.

Family

I applied to and was accepted in three different colleges, and I ultimately chose to attend Principia College. I financed college through a combination of financial aid, loans, work-study, and savings from part-time jobs and summer employment. Principia offered me the academic rigors that my intellectual and intuitive curiosity thirsted for, as well as a chance to quietly and safely sort through many of the difficult life circumstances most of my peers had never encountered. Surprisingly, the academic part, although sufficiently challenging, enfolded rather easily and effortlessly. I had the opportunity to explore and study a diverse array of intellectual, moral, philosophical, and spiritual ideas and points of view.

In English literature, I took classes devoted to the study of African-American authors and poets. I became acquainted with the works of American authors such as Toni Morrison, James Baldwin, Langston Hughes, poet Nikki Giovanni, and many others. The celebration of the human spirit's ability to overcome adversity in the writings of these authors spoke to me at a deep level, and uplifted my aspirations in my quest for understanding life purpose and accepting my own worth. I enjoyed and embraced the intellectual challenge. It helped me to constructively channel my passionate energy.

The continuing and seemingly insurmountable struggle for assimilation lay in my emotional adjustment. The unique set of circumstances of my personal background made it difficult to assimilate into any American community. Strangely enough, however, because of the values Mama instilled, I appeared much assimilated and well-adjusted to everyone around me. No one suspected the

inner turmoil that lay deep inside and that continuously threatened to undermine my outward success.

Day by day, I sought adjustment by seeking and finding ways to accept myself as worthy to receive the incredible goodness all around me, and at the same time to continually challenge, often tacitly, the unacceptable and often unconscious negative undercurrents. I continued to think about children at L'arsenal who did not have the opportunities that came my way. Recognizing and accepting my own self worth and contribution proved particularly daunting when other children I knew at L'arsenal were, to me, just as worthy. It became necessary for me to reconcile within my thinking my childhood years with my current life before I could experience emotional progress, despite my apparent academic and professional adjustment.

Such a task proved to be difficult and seemed impossible at times. Wholesome adjustment required that I remain true to the best aspects of my cultural heritage. At the same time, it was equally important that I accept, love, and assimilate in the culture of the communities I now lived in. I waged many silent battles to understand how to resolve the competing and seemingly irreconcilable differences to achieve harmony within. My further spiritual, emotional, and intellectual development depended upon how well I could harmonize the polarizing emotional forces within to both flourish and contribute more fully to my new community.

The camaraderie I found among a group of friends, including a handful of African-American women, in college offered me a home and belonging I so needed. Through the study and pondering of diverse ideas and as I gained a degree of inner strength, my own point of view, based on the totality of my experiences, began to emerge. The formation of my own point of view assisted me in accepting that my voice counted to contribute to the improvement of the field I was led to pursue. I graduated from Principia in 1975, and moved to Boston where I found employment. I then pursued my dream of attending law school. I enrolled at a law school that offered an evening program and attended while I worked full-time. Other than partial assistance for the first year, I financed law school tuition and expenses from my own funds earned through full-time employment. I graduated three and half years after my admission.

Graduation from law school opened new doors. Following a judicial clerkship in the Superior Court of Massachusetts, I held positions as a prosecutor, staff counsel in a major state agency in one state, an Assistant Attorney General in another state, and later Second Vice-President and Senior Corporate Counsel respectively, in corporate law departments of two major American corporations. I have over the years held many leadership positions in various bar associations and community-based organizations. I became the first black woman president of one of the largest American women bar associations in the country. I was elected by my county bar association to two terms as a delegate to the American Bar Association and held other leadership positions within that organization. I served on many policy-making boards. I led my church as President and Chair of the board through difficult transition times for that church community. I raised two daughters within the mainstream of American middle class standards, with all the bells and whistles a reasonably successful professional life could afford. My oldest daughter graduated from Spelman College, and has recently launched her own legal career with the ultimate goal of pursuing a career in politics.

Our little family from L'arsenal did not escape our birth circumstances unscathed. A year after my arrival to join Mama in New York, Joseph and Bertrand came. The paths that opened up for them turned out to be quite different from mine. They stayed within the small family nucleus and lived with Mama for as long as possible. Because of the work ethic Mama instilled in us, both Joseph and Bertrand experienced success in business. Bertrand today has been running his own successful business for the last twenty years in a major American city where he lives with his family. Joseph found his niche in New York, working for a utility company and as a part-time teacher in a technical school. But the pressure and emotional turbulence of our childhood years and the demand of a fast-paced life in the United States caught up with him. He suffered a massive heart attack while driving home after completing a full week of work on a Friday night at the age of forty-two.

Joseph's passing further splintered a fragile family structure that was already deeply wounded by years of challenges. Bertrand

and I were devastatingly heartbroken. It took me years of relentless prayer to recover from the grief that followed Joseph's passing. Despite major differences between the three of us, we shared the unique experience of growing up at L'arsenal with Mama as our mother. Only the three of us really understood what that meant.

Mama suffered the most dramatic change after Joseph's passing. Prior to his death, she tried all she could to keep our little family together within the cultural traditions of our hometown. Keeping us together that way was impossible because we had become different people as a result of our divergent experiences through the process of seeking survival. We each responded differently to our new environment and our assimilation took different paths. Mama nonetheless spent much of her time scheming, as she did when we were little, to keep the family together and close to her. After Joseph's passing, she simply checked out. She blocked out his life and death. It seemed that the years stopped for her after his passing. She reverted into her own little world, to a much earlier time before her move to L'arsenal. Now ninety-eight years old, the sole survivor of the Tanabet clan, she lives close to Bertrand who keeps a watchful eye over her. Charles has remained in New York.

Epilogue

Inspired study, prayer, and contemplation helped transform my outlook enough to function first and to succeed later. The circumstances of the first few years after my arrival in the United States, although difficult in many respects, supported further the constructive path Mama struggled to steer me into. In particular, these circumstances advanced my spiritual growth. They deepened my adaptability, constructive disposition, and open-mindedness, qualities indispensable to navigate the rough seas of depression and defeatism, the unfortunate legacies of childhood difficulties.

Spiritual insight transformed the deadly undercurrents into more hopeful and life-affirming expectations of triumph. I succeeded slowly over time at cultivating sufficient inner strength to support a healthy attitude. This required me to stay vigilant to detect unproductive thought and feeling patterns, and entertain only those points of view that uplifted a healthy sense of self. When overwhelmed with negative suggestions, I patiently tried to replace pessimistic thinking through prayer with thoughts of harmony, love, and grace. The atmosphere in the Marshall home in Greenwich supported practicing and sustaining this outlook.

The social loneliness and cultural isolation during the first few years in the United States forced me to evaluate at a deep level my spiritual values and commitment to nurturing my relationship with God. Mama's deep faith and her reliance on it as an anchor through the many trials we encountered during childhood provided a foundation for my own faith. Looking back on the many close brushes with danger I experienced and how God protected me each time supplied me with proof of God's presence and further

authenticated my inseparable relationship with God. I yearned for a closer, more conscious and consistent reliance on God to establish predictability in and cope with my otherwise ever-changing life circumstances. I used the time in Greenwich to develop the discipline of consciously learning to turn to God and relying on Him for my every need. I did not realize at the time this discipline was preparing me for greater challenges and continued success.

During the years I spent at L'arsenal, our social life centered on church activities and religious traditions. Mama's reliance on God for just about everything in desperate times made a powerful impression on me. I knew about her faith in those times. In her despair she'd regularly pray and talk to God out loud in the late hours of the evening or the middle of the night, when she thought we were all asleep. On many occasions she would ask me in particular to help her pray. Our survival during and after the hurricane remained etched in my memory as a vivid and dramatic example of divine protection and guidance. My faith became the cornerstone on which I built the strength and ability to not only survive but to thrive, despite the formidable obstacles to assimilating in the American culture. Faith and trust guided my every step through inspiration and discernment to appreciate and benefit from the goodwill and goodness of the many people I encountered.

Sorting through the dichotomy between deeply ingrained biased attitudes and genuine gestures of love and care in the same people became a continuously necessary process, not only in the Tanabet household during childhood, but also as I managed the complexities of life in the United States. Despite the potentially destabilizing influence of the undercurrent of bias I encountered throughout my life, the goodwill and genuine love of many people around me provided me the needed foundation that ultimately took me out of L'arsenal's survival mentality, uplifting my thought to a much more fulfilling experience. It became possible only when, despite myself, I submitted to His will to rise above human logic, conquer fear, and be willing to learn to accept others wherever they stood in their journey.

The sacrifice required of me, to forsake my family and to confront the moment-by-moment challenge to my human ego, opened up larger vistas, stretching me to understand and practice true

grace and dignity. Learning to exercise humility affirmed and strengthened my identity as a person, and deepened my understanding of this quality. Developing the knowledge that only I held the key to my own effectiveness in any circumstance helped me express greater self-confidence. A maturing sense of self-confidence eased my acceptance of human frailty, and also provided me with the emotional tools to forgive, forbear, and embrace others regardless of their shortcomings.

I learned to exercise patience, which allowed me to work through every encounter beyond enormously difficult cultural barriers to meaningful relationships, while challenging as much as possible the misconceptions. When I thought about it, cultural differences aside, any human encounter in any circumstance requires the same degree of patience.

Mama, if she could, would likely characterize the price of her sacrifice in choosing to pilot us to safety to the United States as the breakdown of the little family she fought so hard to have and to keep. During my younger years, I had thought that the cruelest choice required of me as a price for furthering my education was separation from that same little family. I shared a valuable human history with my family of origin as my companions through adversity in the early part of my life. I fully recognize that the proximity of their lives to my own experience highlights my responsibility to love, cherish, and nurture them.

As I evaluate my overall experience, however, my concept of family has deepened to include layers of a broad circle of members from all walks of life, with various ethnic backgrounds and diverse interests. It feels so right to me to have such wonderful brothers and sisters among fellow human beings who appreciate, understand, and love me for the essence of my identity, not because they're forced to through blood lineage. I find my connection with my fellow human beings beyond blood lineage a more authentic and compelling responsibility. Blood relation to me limits my love for humanity and impedes my relationship to the rest of the human family. We often settle for the narrow norm that once we've done what we can for our immediate family, we're done—off the hook. We no longer have to do all that is necessary within our given ability to remove the limitations interfering with human fulfillment.

From my point of view, the legacy of that mentality has contributed to unnecessary suffering. I experienced first-hand the limitless benefits of a broader and more expansive love that embraces all humanity.

I share an equally important history with the members of the family I have chosen through kindred tastes and interests, fellowship, communion, and love. The difficult years have tried and challenged me to a deeper love and acceptance of my fellow human beings regardless of their human origin or their shortcomings. I am a better person than I could ever have been, had I chosen the path of least resistance I contemplated after my encounter with Rose that last time. I consider myself an extremely fortunate person to have encountered and become companions in difficult times with my family members, and such special people like Rose and Mirlande. With equal intensity, I cherish my current family circle. The closest and most influential members of my family inner circle today are few. They consist of those relatives and friends who, beyond the artful articulation of the intellectual difference between history and her/his story, strive continually to learn from and transcend human history. Through this effort, they touch and embrace the essence of the identity of every fellow human being as inseparable from God. Those who value and nurture the unique contribution God appoints each of His offspring to make are members of my family.

Every step of the journey, from birth in a stable on an island faraway to the fancy halls of American professional associations and corporate boardrooms, contributed to the natural progression from perceived human limitations to liberating glimpses of my spiritual identity. I credit my passage through these limitations to two essential blessings—my mother's devotion and loyalty, and her relentless and focused determination to overcome every obstacle in the way of my education. These two essential blessings evidence to me the ever-presence of God, divine Love, and the absolute fact that I am never separated from His Love, even when people and circumstances try to convince me otherwise. No matter how bleak circumstances seemed to have been at any given moment, there was always a window of good to push open and usher in a greater outpouring of blessings. Mama's willingness to seek and find this

window of good and to teach me how to continually try to push it open has made all the difference.

Every crisis, challenge, and opportunity on this journey required me to listen to the ever-present "still small voice" of spiritual guidance and find a way to survive. Beyond survival, deep emotional, personal, and spiritual healing through prayer made possible my ability to rise above human misperceptions. The discernment, however faint, of that divine spark in me propelled me forward beyond formidable obstacles, and kept me safe in the face of dangers I did not even perceive. Individually, I had the absolute and inescapable responsibility to strive and do my part, however difficult it was to assume that responsibility at times. With equal intensity, any success I experienced came about because others in my path also recognized and embraced their inescapable responsibility to uplift and support me. It took both my own efforts and those of the communities in which I found myself to make possible my development to a more effective contributing member of the human family.

Beneath the surface of the turbulent sea of childhood traumas and the resulting distorted emotions lay the strength, beauty, and endurance of my spiritual identity that is inseparable from God. I still today cannot fathom how I managed to first enroll and remain in school, and then succeed beyond my wildest expectations through the extraordinary turbulences I encountered every step of the way. Yet, at a deep level I always expected success and accomplishment. What seems like extraordinary accomplishment to others feels quite normal and effortless to me. This expectation allowed me to remove mountains in the way of my progress. This expectation is the "still small voice" of wisdom that whispers to me every moment in every aspect of my experience. I so longed to listen to it and to act on it in every other aspect of my journey. The ever-present whisper of the divine wisdom of our goodness, possibility, strength, and power liberates. It gives us wings to fly, and makes possible our deepest yearnings.

My story offers a glimpse of how love, kindness, and caring can transform lives, and replace despair with fulfillment. Each of us, including Leon in the story, has an immense capacity to love and care. My mother lived her devotion and love. She gave all she had.

She taught me how love knows no limit to giving of oneself. The Marshalls and Helen showed me that loving, caring for, and supporting a fellow human being don't have to inconvenience us, if we just incorporate them as values in everything we do. The Christian command "love thy neighbor as thyself" means just that. Understanding the full implication of this command and living it to the fullest will transform the world.

They say "it takes a village." I say it takes the world's changed consciousness to the divine apprehension of true Love "to raise a child."